SOLE PROVIDER
30 YEARS OF NIKE BASKETBALL

Words by Robert "Scoop" Jackson

powerHouse Books
New York, NY

Dedication

We dedicate this to all that love the game. To every court idealist, to every playground legend, to every ball player who ever laced up a pair of kicks, to every kid on the streets who had a story to tell about their first pair of basketball shoes, we thank you.

You've inspired us.

Props for giving this book the "air" it needed to come to life.

From the bottom of our hearts to the soles of our feet. Much love.

Introduction

Basketball.

For everything it represents is unlike any sport in America. So contemporary yet so hood; so urban yet so rural; so simple yet so complex; so hurtful yet so truthful; so contagious. For 30 years a large part of the game's life has vicariously lived thru not just the sport, but the culture of the sport. Thru the shoes, the players, the commercials. Thru the drama, the icons, the history. Thru it all a presence developed. A presence unparalleled, unmatched, unheard of and unseen by anyone. Instilled in the minds of millions: nothing can be accomplished, no success earned "without the shoes." Which is why we fiend, collect, respect and spend checks on kicks the minute they hit the store shelves. "You got the new Air Force 1's in?" If the answer is "yes," instant purchase; if "no," instant panic. Eyes bulge, pupils dilate, arms and legs start to shiver, then that one sales person who knows just how you feel goes down to the store's basement and calls out, "We got one more pair!" Instant relief.

And there lies the passion. A passion woven between several institutions, but at its core one between man and a game. Not a soccer-type passion that exists on the international level, but one that is deeper because an additional element (one that soccer fans can't even claim) is involved: shoes. The love for the shoes and the athletes attached to them can not be found anywhere in the world, except for in the game of basketball and in the shoes the game is played in. It is a truly unique, special and endearing relationship. One that if scientifically studied would come up answerless. And because there are no answers or explanations, no questions shall be asked...just appreciation. The relationship deserves at least that.

What lies ahead on these pages is not really about shoes, it's more about the life the shoes have led, the places they've been, the stories they've never shared, the feet they've been on, the super-stars that have beared their names, the trends they've set, the hearts they've broken, the future they'll embrace. It's also about the advertising and how the central nucleus in this sub-culture is not solely about the shoes, but about the marketing of them. About how the shoes themselves became famous, larger-than-life.

There are many that could have written this book, but the honor came here. It fell into my lap, found it's way on my desk, discovered me the same way someone discovered Barkley in a small-assed town in Alabama. After doing *Slam, Hoop, Inside Stuff* and *Kicks* for so many years it only seemed fitting that this journey be taken, documented, written, exposed. Game still recognizes game. *Sole Provider* will remind you of just how deep the roots of the shoe game are in making basketball more than just a sport, Michael Jordan more than just an icon, Lil' Penny more than just a puppet, Ice Man more than just a poster, and the Air Force 1 more than just a shoe.

Which leads us back to the original question of life: "Is it all about the shoes?" To some degree, yes. But throughout this book, you will come to realize, there's just so much more.

Peace.

- "Scoop" Jackson

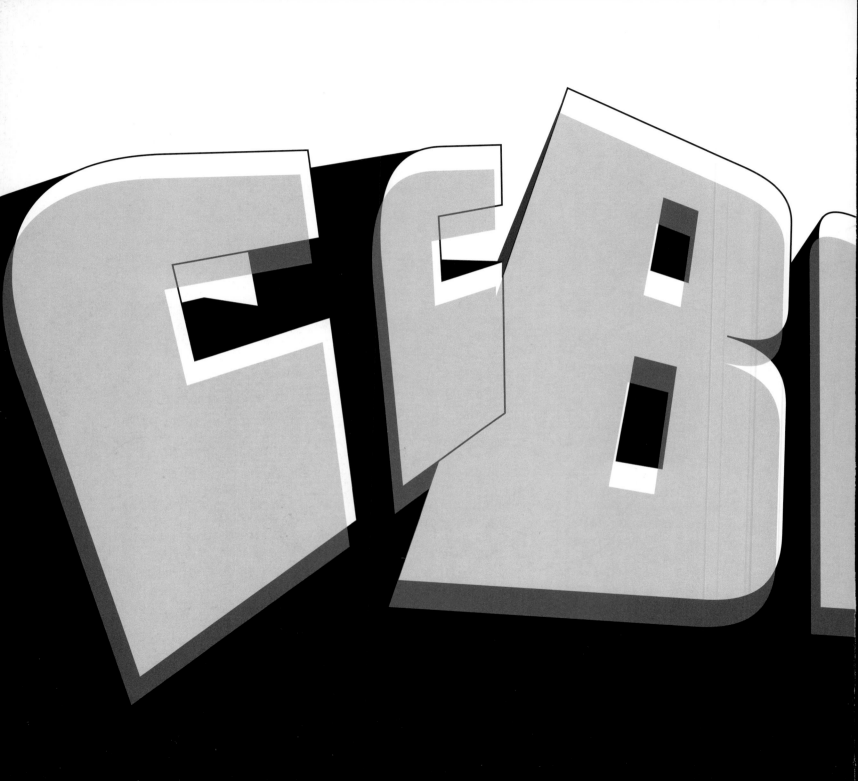

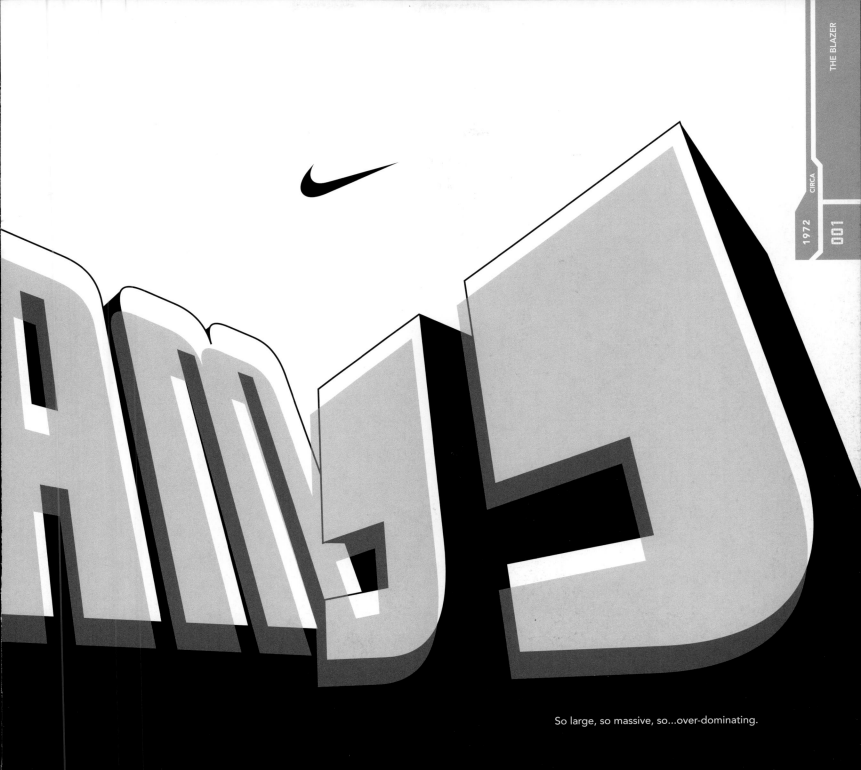

So large, so massive, so...over-dominating.

here it is.

in your face.

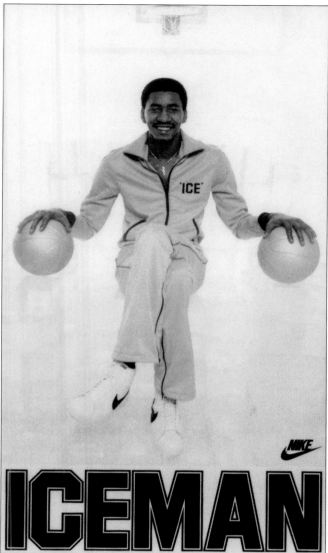

1978—ICEMAN (GEORGE GERVIN) ☝

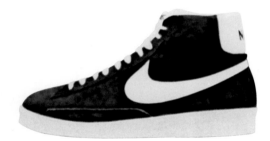

BLAZER ☝

The Blazer

The Swoosh made you look, made you notice. That was the idea, the master plan. Like a woman's skirt, long enough to be respectful, but short enough to make men look twice: that was the theory with the Blazer. Make the Swoosh big so that everyone notices it, but not so huge that people think it was done on purpose. A vicarious life it lived, a b-ball imprint it became. Starting on the feet of Geoff Petrie ending on Ice with George Gervin. Stops in between be it Sidney Wicks or Billy Ray Bates or David Thompson or making weekly appearances on *The White Shadow*, it blazed trails. A championship with the Trail Blazers. There was a funk classic that gave birth to the sound of that time. It's words rang loud: "Damn right, I'm somebody." The Blazer lived its life saying the same damn thing. It was the beginning of an infinite era.

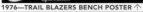

1976—TRAIL BLAZERS BENCH POSTER ⬦

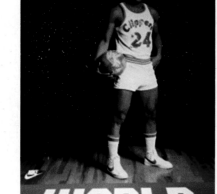

1979—WORLD B. FREE POSTER ⬦

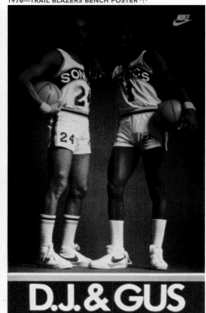

1979—DENNIS JOHNSON AND GUS WILLIAMS POSTER ⬦

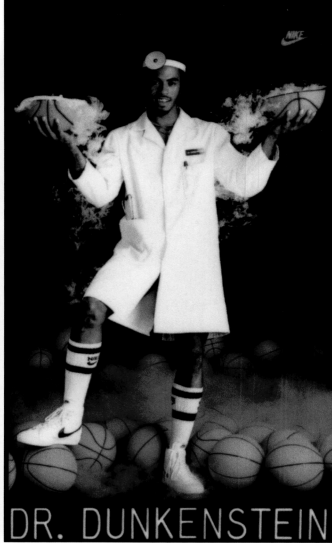

1980—DARRELL GRIFFITH POSTER ⬦

70's STARS DARRELL GRIFFITH
& PAUL WESTPHAL CARRIED
THE POPULARITY OF THE
BLAZER WELL INTO THE 80's

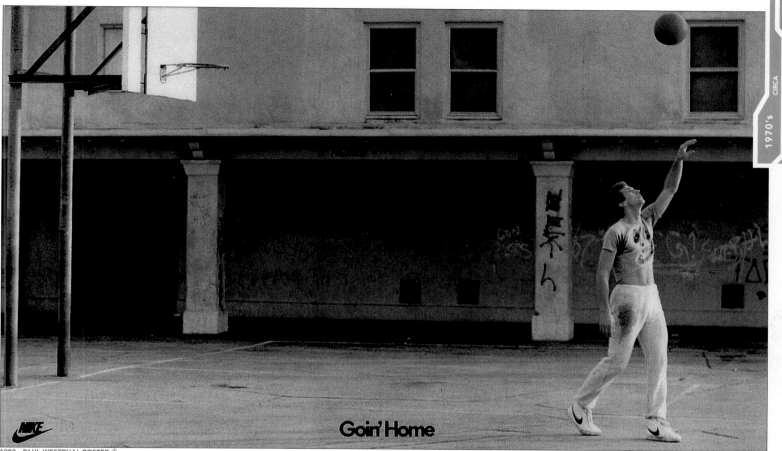

Goin' Home

1982—PAUL WESTPHAL POSTER

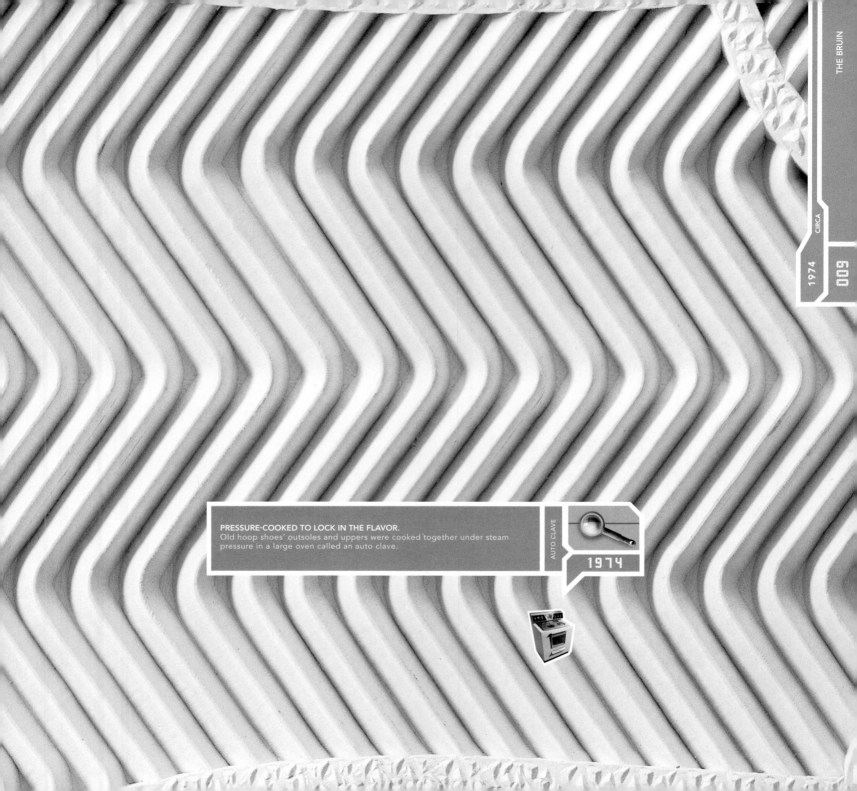

PRESSURE-COOKED TO LOCK IN THE FLAVOR.
Old hoop shoes' outsoles and uppers were cooked together under steam
pressure in a large oven called an auto clave.

AUTO CLAVE

1974

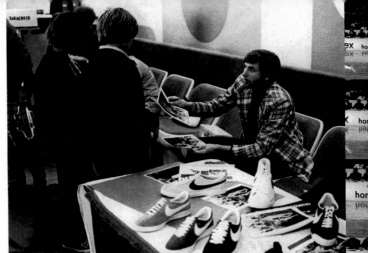

1970s—PUSHIN' THE BRUIN ⚘

the Bruin

It had sole. White. Herringbone. Rubber.

The sole was different. Swerving lines. Groovy. They used to bake the shoes in ovens to get them made. It was called auto clave production. It began the beginning of the post-Chuck Taylor movement. It was that 70's shoe. One that defined an epoch. The move from high canvas to low suede. The variety of colors. Psychedelica. One nation under a shoe. The peace, love and sole of the Bruin was felt everywhere it made appearances. From West-wood to Harlem, from the NBA to ABA. The Bruin socked it to 'em. It was like getting five on the black foot side. You don't get it do you?

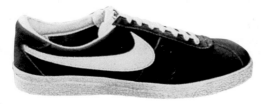

BRUIN ⚘

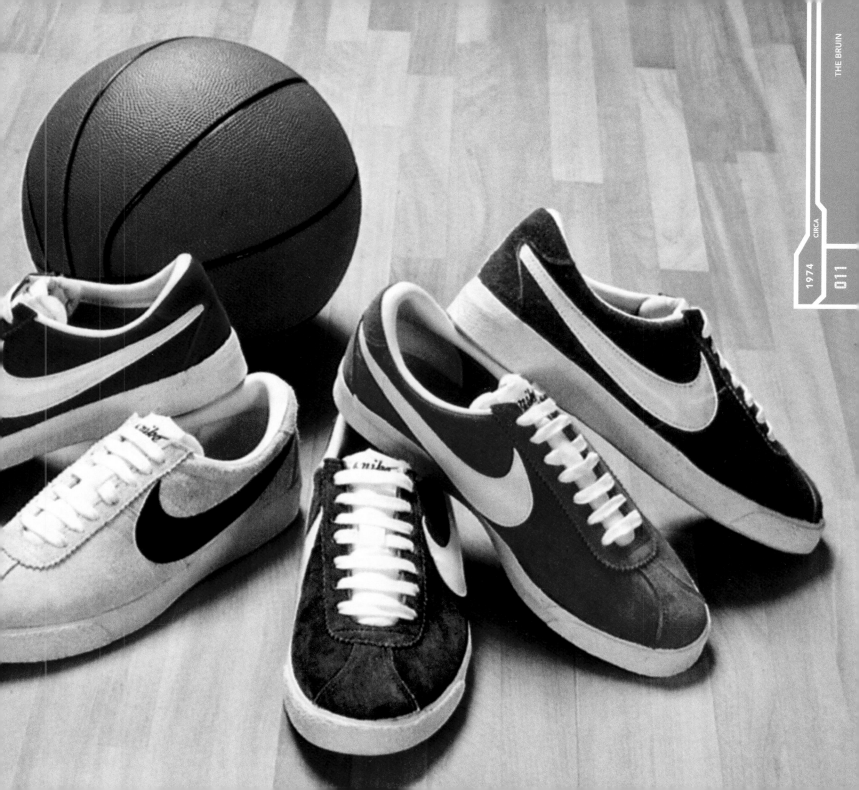

Ebony and Ivory. That was them back then. The first two signees to the company's small basketball division. Sidney Wicks and Geoff Petrie both played for the Portland Trail Blazers, they both played forward and complemented each other with perfection.

Nike took the initiative to realize opposites attract more than the ones that are opposite, they attract audiences. Petrie and Wicks were like the original buddy film or cop series. Together, on the court and in those shoes, they were basketball's lethal weapon.

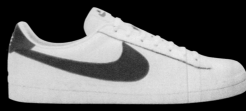

FRANCHISE

Say "Bill," and nobody knows whether you are talking about Russell or Walton.

Say Moses, and everybody knows.

His life is the blueprint of not just professional basketball, but of basketball itself. The scouting, the recruiting, the money, the cars, the talent, the promise and widening eyes of general managers and coaches, the agents, the game. His life is both Jermaine O'Neal's nightmare and dream. And everything in between. He was the first to ever sign a pro basketball contract straight outta high school. Never really considered a prodigy, he had the ability at an early age to score and rebound (especially rebound) better than anyone at every level. No one had what he had: the raw innate knack to get the ball off the offensive boards and score immediately thereafter. As his old coach once said, "I saw a playoff game in his rookie season where he had 38 rebounds, 23 of them off of the offensive glass." His is the life of us. Of how work can sometimes make a person lose notoriety. All work and no play makes Jack like Moses, not dull. Work ethic, resiliency and persistence make Moses unlike anyone else. We carry those traits with us now because Moses showed us the way back then. He called it aggressiveness, positioning and determination. Same thing. Either way, his life has become our 11th Commandment.

(NEXT PAGE) **CIRCA 1980 MOSES POSTER** →

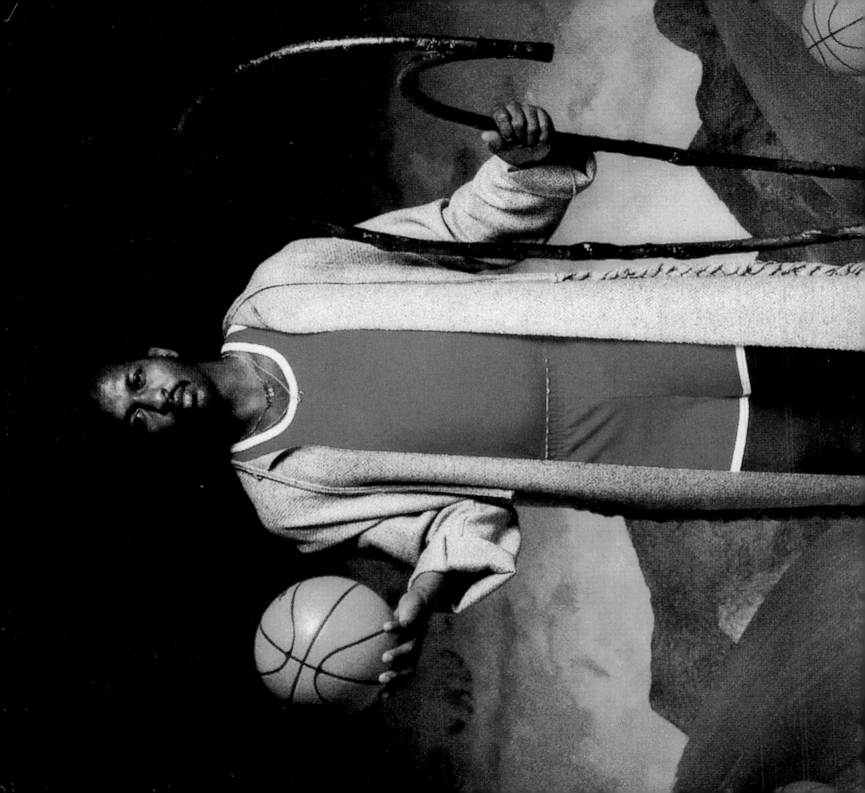

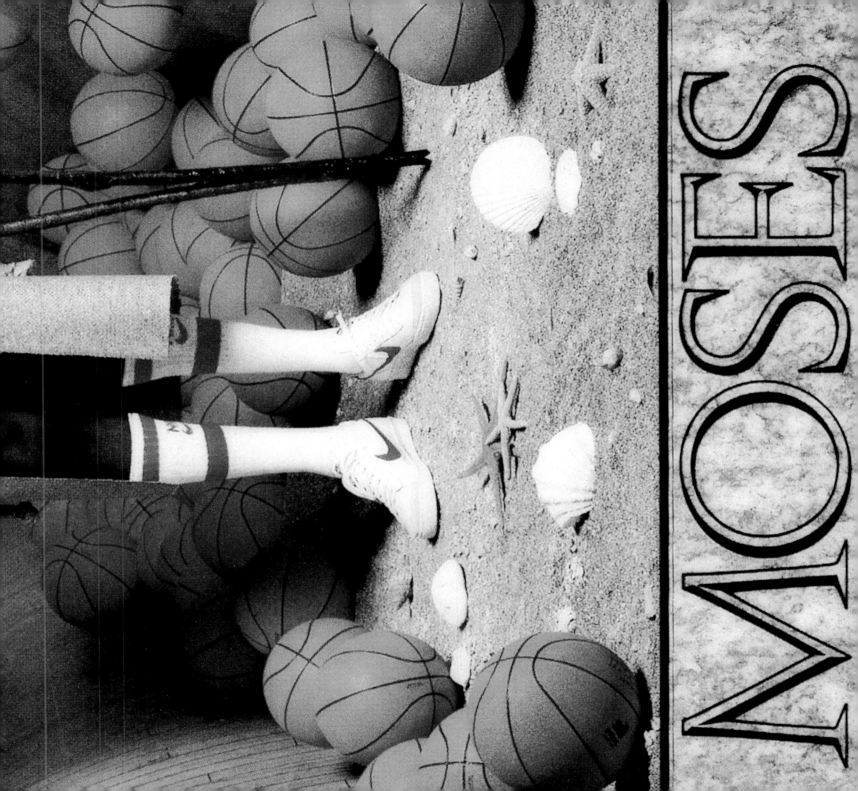

MOSES

The Ladies

The 'X' Chromosome Factor needed athletic accessories, why not start with the most important: the shoes. Basketball was nothing new to them. *"Viva la familia!!!"* they cried. Doing everything the men did, but with increased fundamentals. They were throwbacks to a game lost, yet there was beauty in their movement, in their way of play. Still they had to sell the game, without selling it out. Most of America was not ready for their showcase of skills. "They can't dunk," was the major complaint. Neither did the Celtics during their 11 championships in 13 years run. Still some bitched. But the ladies persevered. Theirs was a floor game, one played below the rim. The kicks they wore were custom made for that: sleek, light, almost sexy. Custom made for keeping all chauvinists silent. Like their anthem, they survived. And they didn't even have to defeat aging male tennis players to do it.

X

CHROMOSOME

La dada di la dada didi dada... **oh, funk me** The bigger the headache the bigger the pill. But you still had to swallow. The velvet black-light posters, Saturday morning kung-fu film fests, when weed was pot, number runners, fire-hosed and honey-dipped women on album covers, bell-bottomed jeans and long-collared shirts, Mudbone. Yeah, baby! The 70's were the decade that represented decadence, freedom of expression, broken barriers. Each week on The White Shadow

NIKE

the importance of the basketball shoe and its future place in society grew. It used to be when it was all so simple then, she sang. The shoes reflected that. The Blazer, the Bruin, The MVP, The Franchise, the All Court. The original starting 5. The original Fab 5. Little did everyone know these 5 simple sneakers would influence the rest of the world. Simplicity, but damn they were funky. And remember when funk used to be a bad word?

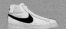 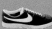

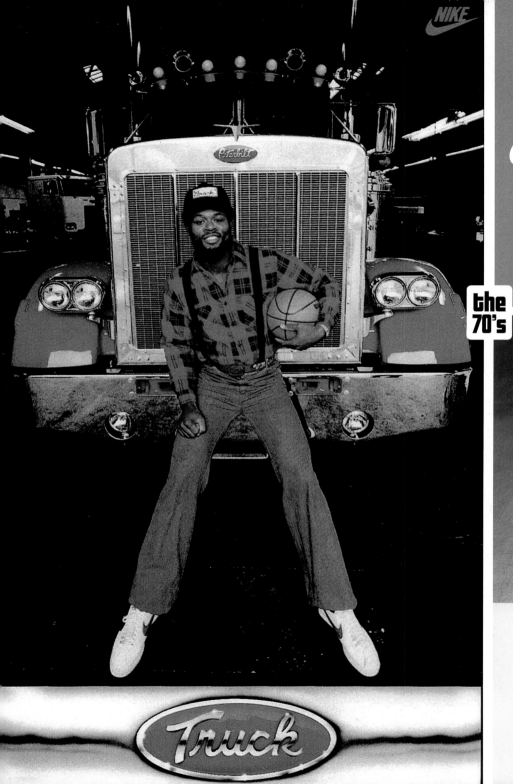

the 70's

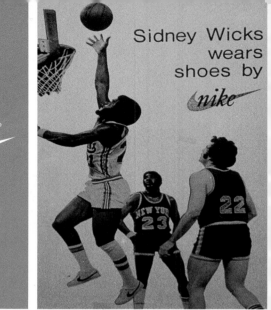

Sidney Wicks wears shoes by *nike*

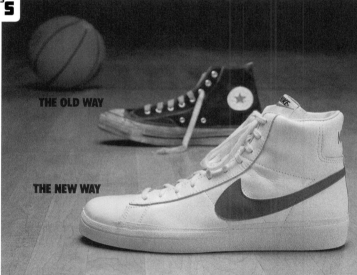

THE OLD WAY

THE NEW WAY

TWO WAYS TO GO TO COURT.

In the last 20 years a lot of things have changed about basketball.

Including shoes.

You don't have to settle for those old black and white canvas hi-tops any more.

Today more and more players are going to court wearing Nikes. Just look at the playgrounds, colleges and the NBA.

Take the Nike Franchise up there in the picture. Uppers of fine grain leather. Soles with a specially designed pattern for quick stops and sharp cuts. Light. Comfortable. And built to give extra support where you need it most.

Try the Franchise.

Or take your pick of our Blazer and Bruin models.

Nike basketball shoes.

They're made to beat the competition.

 Beaverton, Oregon

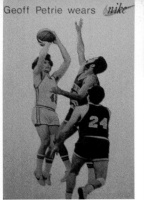
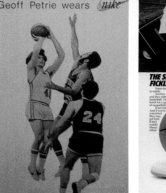

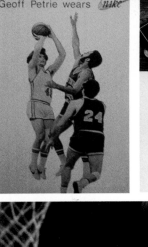

Geoff Petrie wears *nike*

THE SHOE FOR FICKLE FEET.

THE NIKE ALL COURT IS FIVE S
It's a Basketball shoe. A Tennis shoe.
A Handball shoe. And a Racquetball

Billy Ray

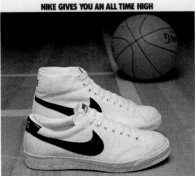

NIKE GIVES YOU AN ALL TIME HIGH

AND LOW IN BASKETBALL SHOES.

**FIVE WA
TO SHO
A LAY
BY PA
WEST**

One: Do it in Nike blue suede low top Bruins.

Two: Put it up wearing our All Court canvas low tops.

Three: Go up in white low top leather Bruins.

Four: Make it in red suede Blazer hi tops.

Five: Wear the Blazer leather hi top like Paul Westphal does every NBA game he plays.

Or take your pick of any other basketball shoe we make.

But no matter which way you go, you can't miss. Because Nike makes basketball shoes built to the exact specifications of NBA stars like Paul Westphal.

Matter of fact, Westphal and our other pro players help us build our shoes better. Year after year after year.

And it's working. For proof, watch an NBA game. Chances are, the guys you see swishing the net will have swooshes on their feet.

Nike swooshes.

World Headquarters:
8285 S.W. Nimbus Ave., Suite 115
Beaverton, Oregon 97005

Also available in Canada through
Pacific Athletic Supplies Ltd., 2451 Beta Avenue,
Burnaby, B.C. Canada V5C 5N1

BREATHE Stop. Breathe in,

Breathe out. BREATHE...

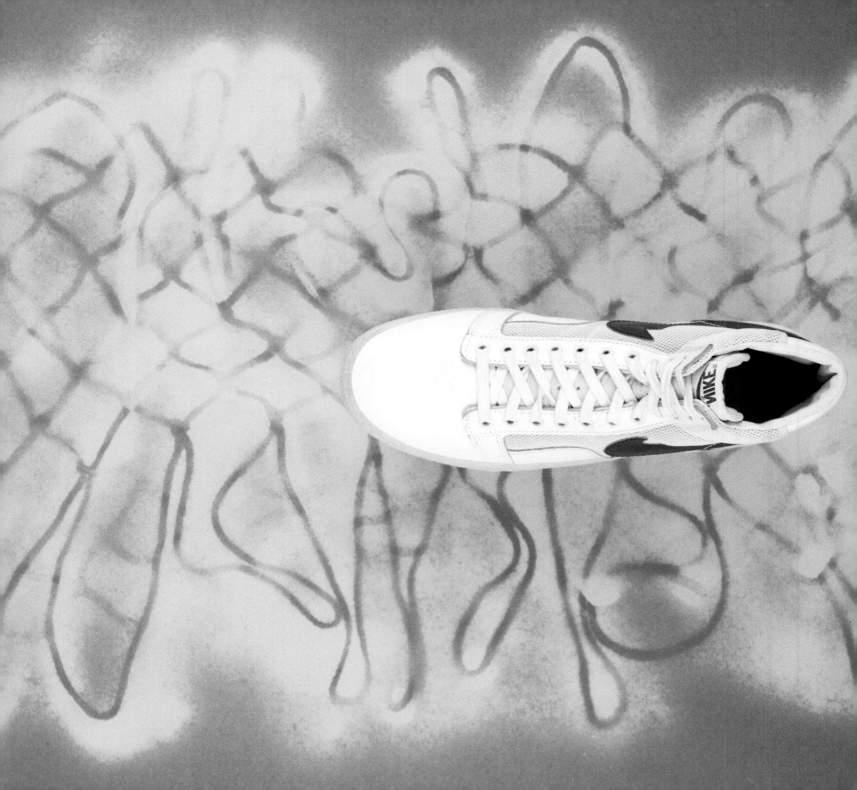

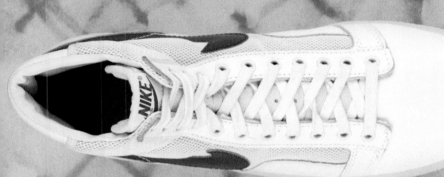

Necessity finally gave birth to the sole child. Brilliance. Masterful. Sic thinking.
"Add Mesh," they said.

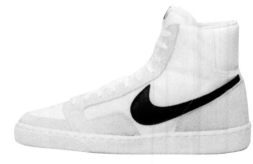

DYNASTY ↑

The Dynasty

Give the player room to breathe, feet get hot you know? Swell up on ya. Especially in 90 degree heat. Hair was shagged, j-curled or big parted. It was the brothas on West 34th Street that got it started. But not just them, the brothas on Venice Beach; the ones at Cole Park; they helped kick start it too. All over America, the outside game was expanding. Growing. It had everyone nationwide hypnotized and big-eyed at what was being displayed on the courts. One-man dynasties birthed under the sun: "Hook" on the West Coast, "Master Rob" down South, "Bags" up East, "AJ" in the Midwest. And others all like them, all over, leaving fans, defenders and street vendors breathless. They made breathing stop. Made the concrete their heaven. And as Rick Telander penned in eulogy years prior, heaven could definitely be found on the playground.

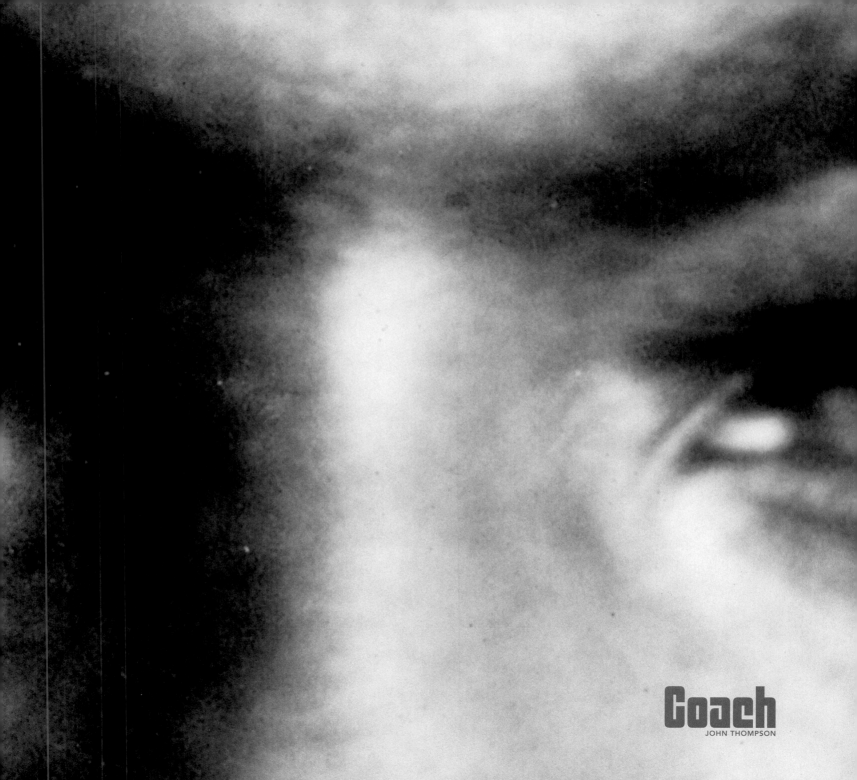

Coach
JOHN THOMPSON

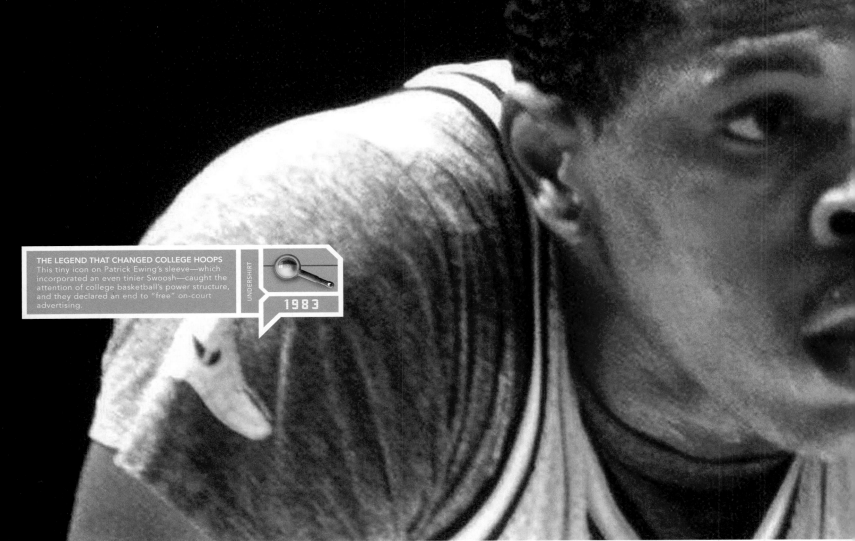

THE LEGEND THAT CHANGED COLLEGE HOOPS
This tiny icon on Patrick Ewing's sleeve—which incorporated an even tinier Swoosh—caught the attention of college basketball's power structure, and they declared an end to "free" on-court advertising.

UNDERSHIRT

1983

PATRICK EWING'S NIKE UNDERSHIRT

A Defiant One.

Washington, D.C. Reaganomics. Go-Go was providing a soundtrack for America that it would never hear. The essence was rare, the funk was trouble, the chants rang loud. Toothbrushes became major accessories, because scuffed up Legends were for suckas. John Thompson knew this and thought the Legend gave his Georgetown teams an identity. A defiant one. They introduced the world to what ballers on concrete were calling, "the best playground shoe ever." But it was in boardrooms where the dignitaries, the NBA luminaries, assembled to pass a new amendment. To a shoe that rearranged the course of the way kicks would be designed: first to have colored soles and colored linings, first to have a perforated toe, first to create a flexpoint on the lacing system at the ankle break of the shoe, first to rock a hook on the back for no reason. If the shoe played baseball it would be numbered 42. Guess they didn't call it (or Thompson) a Legend for nothin'.

NBA PLAYERS HAVE A BIG COMPLAINT.

Actually, when you're 6'11", you like having big feet. They kinda keep you from tipping over.

The real problem is what to put those feet into. Like everything else, most court shoes are made for people who are built much closer to the ground.

Not our new Legend.

This revolutionary basketball shoe was made for the big men of the NBA. As a result, it is one of the most technically advanced models on the market.

For any sized foot.

Take the problem of stability. When a 250 pound athlete suddenly switches direction in the middle of a sprint, something's got to give. Frequently,

it's the shoe's upper—which rolls right over the top of the cup sole.

Not so in the Legend. The vertical stabilizer straps hold the foot firmly in place.

And when the foot won't runneth over, traction improves, mobility increases. And the quick-cut gets even quicker.

The Legend also borrows some advanced thinking from Nike running shoes, with our Variable Width Lacing System™ that adjusts to most any sized foot.

Inside, it's a terrycloth sockliner backed with EVA for extra cushioning as well as absorbency. And thanks to a perforated leather toe, the Legend keeps those interior temperatures to a cool minimum.

Finally, a word about hi-tops. If you've shied away from them because they dig into the ankle, slip into the Legend Hi. See how the hinged eyelet design lets the shoe bend instead of buckle.

We've stuffed a lot of innovations into the Legend. But frankly, when you work as closely as we do with NBA players, you don't have much choice.

Because if you think they've got big feet, you ought to see the size of their flats.

NIKE
Beaverton, Oregon

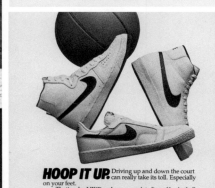

HOOP IT UP.

Driving up and down the court can really take its toll. Especially on your feet.

That's why NIKE makes a complete line of basketball shoes designed for comfort, support and durability. In hi tops and lo. With hard-gripping outsoles. Canvas, mesh or full grain leather uppers. For men, women and children.

NIKE Basketball Shoes: It's hard to imagine a better place to dunk your feet.

NIKE

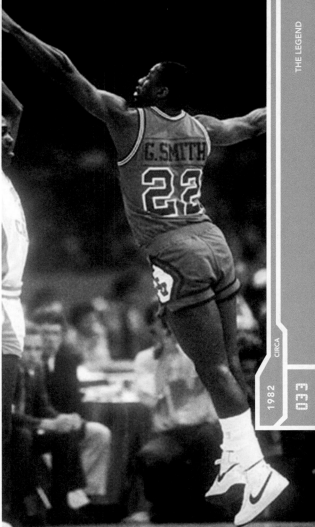

JOHN THOMPSON & PATRICK EWING ⬈ NIKE ADS FOR THE LEGEND ⬈ GENE SMITH ⬈

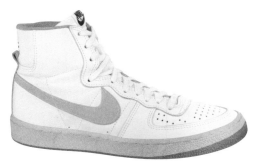

LEGEND ⬈

introducing
air

Nothing but Air

At the time, no one was really thinking forward. No one thinking past making a name for themselves, no one thinking about changing history. Well, maybe someone was. Because someone had this idea. This idea of putting air into shoes. Mr. Nike loved this idea. In 1979, Nike introduced the world to this shoe called the Tailwind. It was a running shoe. A running shoe with the "air idea" inside. Between the foot and the sole of the shoe, there were two pieces of polyurethane film molded together. It was less than a half-inch in thickness, weighed less than half a pound. People ran in it. The shoes sometimes fell apart, but the people kept running. They were in love with the insole (technically called a midsole). They'd never experienced such a feeling. Some would pull the insole out of the shoes, look at them, examine them; some would buy an extra pair of Tailwinds just to destroy the insole of their original pair to see what in the hell was giving them that "bouncy, air bag feeling." They'd find nothing. Nothing

but Air. The people would never know. "The first 5–7 years of dealing with the full-length air midsole was about taming the material and properties of the shoe and make it work together with the technology of the air sole cushioning," one of the original "air men" Bruce Kilgore said. "Then when it came to trying to transfer that concept to basketball the question became, 'How do you take something inherently unstable and put into something that's all about stability?'" It took Nike 4 years to figure that out. They went through hundreds of shoes, hundreds of concepts and prototypes. Then they developed the Tailwind's big brother: the Air Force 1. They knew this air technology was going to set them apart. They knew it was going to make them, not break them. They knew a simple concept of placing a "poured polyurethane midsole" into a sneaker was literally going to change the world we live in. Because Phil Knight, aka Mr. Nike, was thinking forward too.

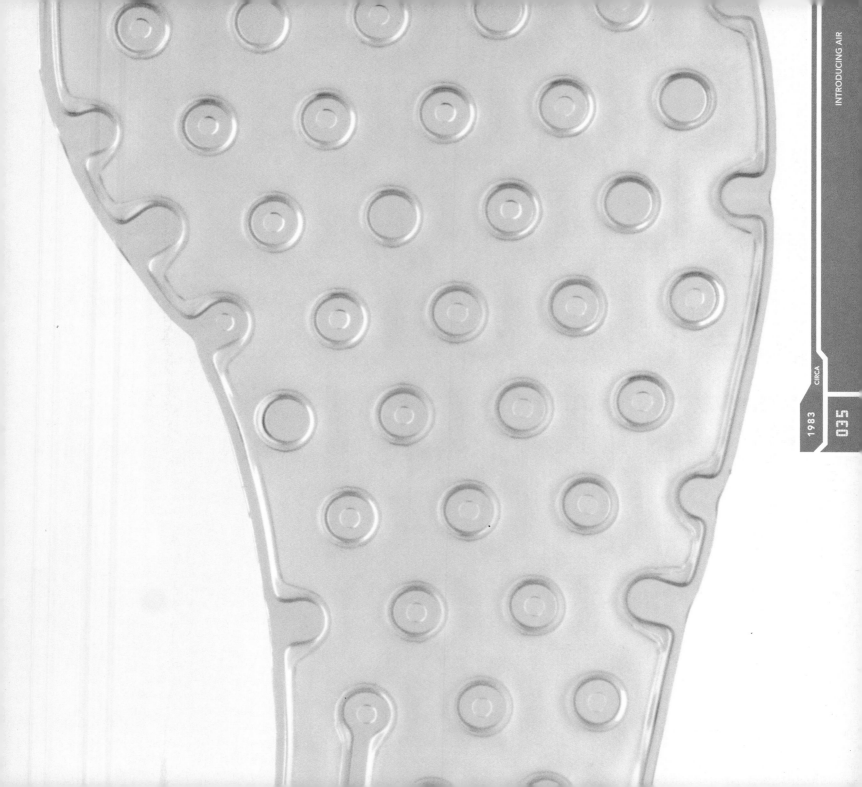

Personal Restraints

They used to call it "the smile." Not a good thing. The smile
was what designers used to say occurred when the sole
and the shoe itself separated. Every shoe made past 1983
was designed to "eliminate the Blowout." "There's a reason
shoes made after 1984 don't get the same (love)," Air Force
co-designer Bruce Kilgore admitted. They went by way
of Italy. Rubber chemistry, change to cup sole construction,
reinforcing upper material (three plate mold), everything
flipped. They had an idea for a shoe that wouldn't smile.
They had the technology to build it. A 1/2 inch thick insole
was developed. This would be the genesis of a new era of
basketball footwear design. But it was the strap that sold
us, made it a thing of beauty. The ultimate fashion aesthetic.
Although designed to create a more secure fit and cut down
on the ever-growing high ankle sprain in players that con-
tinued to occur, the strap became a staple in urban fashion
equivalent to baggy jeans and beepers.

But above everything and more significantly, these in-
genious designers took the world's MVR (most valuable
resource) and found a way to place it into the insole of the
shoe: Air. Simple, but well, forever.

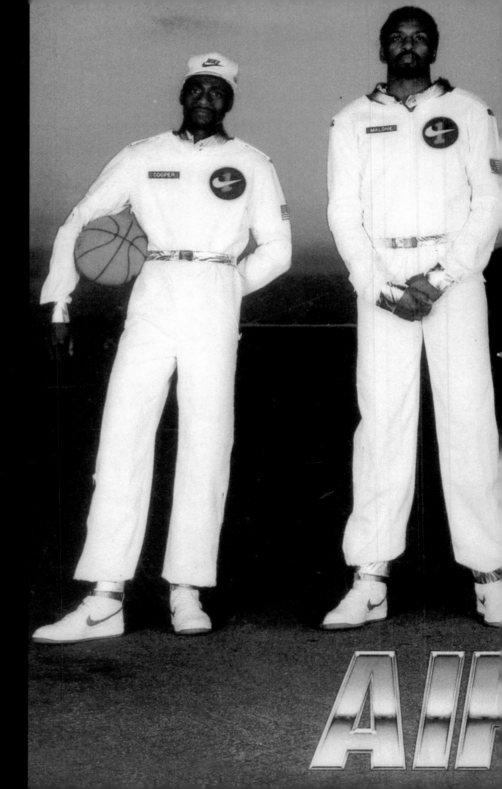

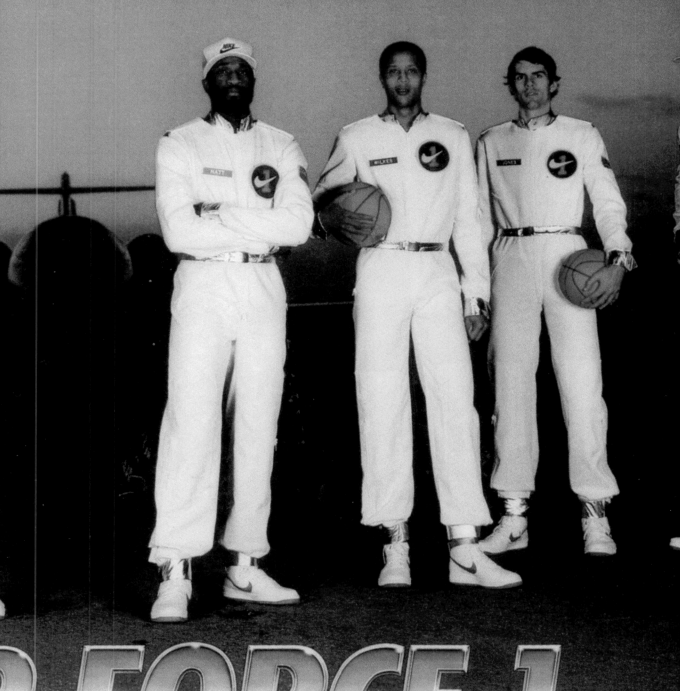

CIRCA

1983

037

R FORCE 1

and on the eighth day...

In 1983, the Man (upstairs) did something different. Looking down he saw some things. Thangs, really. He saw three kids from Hollis advancing a culture, laying down laws from state to state; He saw a new form of escapism replace basketball in black communities; He saw unnecessary killin', black actors and comedians get top billin', young men in Kangols across the land cold chillin'; He saw the earth, the wind, the fire, He saw the ways of the world turn hearts cold. The Man knew life was a jungle sometimes; it made him wonder what kept his people from going under. Through it all the Man still heard a ball bouncing. The beautiful sound of rubber or leather meeting concrete or wood. This was His music. To define His music the Man created a shoe in His image. He added a strap for power. It was to be worn by those who played his music and by those who didn't. A shoe void of lifeline or span, something He could resurrect 20 years later. The Man asked his son Rasheed to wear it, carry the legacy. Yes, this was what the Man (upstairs) did on his eighth day of work after seeing all He saw. And on the ninth day, the Man hooped.

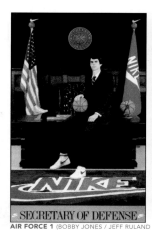

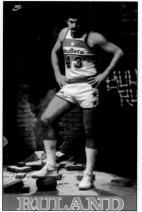

AIR FORCE 1 (BOBBY JONES / JEFF RULAND POSTERS)

NOT ORIGINAL SHOE COLORWAY

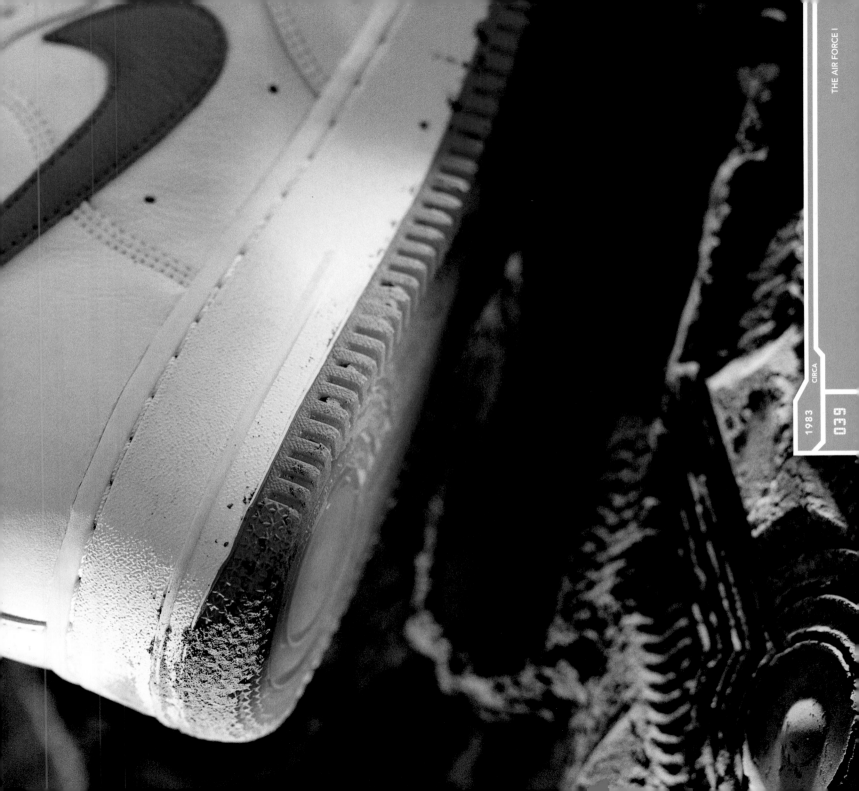

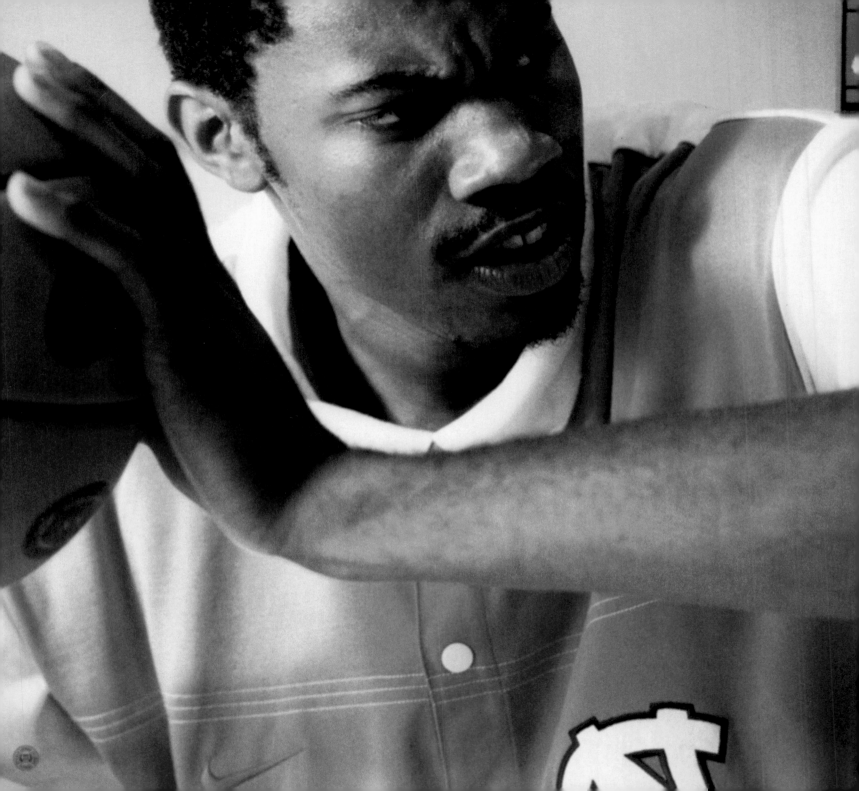

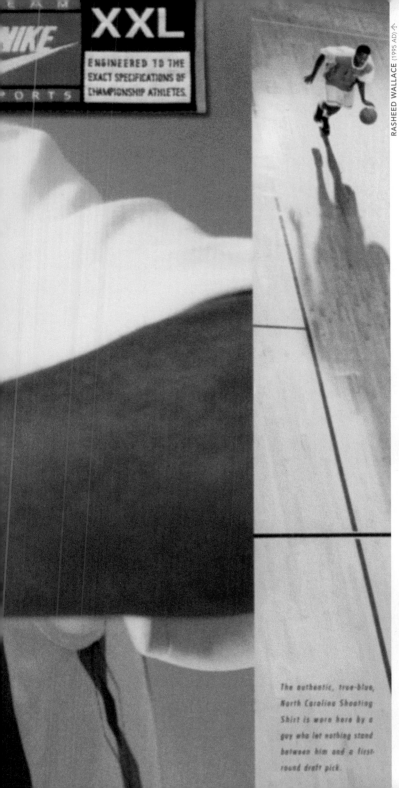

Air Force I. Hell Yeah.

Someone had to do it, perform this resurrection, why not him. Someone, somebody, something had to give Tim some competition. Even before this retro thing started to be a retro thang, Rasheed Wallace was rocking the vintage. Dirty, clean; old, original or patent leathered. He, to this day, pays it no mind, instead he pays tribute. As long as it's AF1's on his 17's, he'll ball 'til you fall. It's his way of recognizing the true school, the rested souls of the game that made it possible for him to be here. While others may on occasion wear specially made jerseys in All-Star games and on podiums at championship rallies, 'Sheed displays his love every game without fail. And unlike many other NBA stars who only—yet always—rock their 1's off-court, Ra looks at the images on the 1985 poster and sees himself being there. Among the Michael Coopers, Calvin Natts, Jamaal Wilkes, Moses Malones, Mychal Thompsons, and Bobby Jones, 'Sheed knows he belongs. But today, he stands alone. Solo. Going for delf. In giving the "most important hoop shoe ever made" a second and forever existing life, Mr. Wallace (cause that's what we call him) has no equal. Actually, no one else is really worthy; no one holds significance in this like he; no one else could have performed such a resurrection...and he knows it. Even the refs around the Association have to respect him for that.

AIR FORCE 1

The authentic, true-blue, North Carolina Shooting Shirt is worn here by a guy who let nothing stand between him and a first-round draft pick.

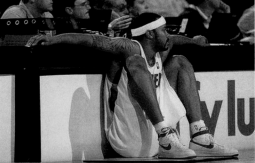

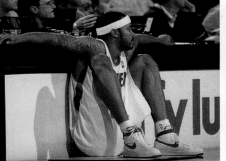

AIR FORCE 1 (RASHEED WALLACE GOES OLD SCHOOL)

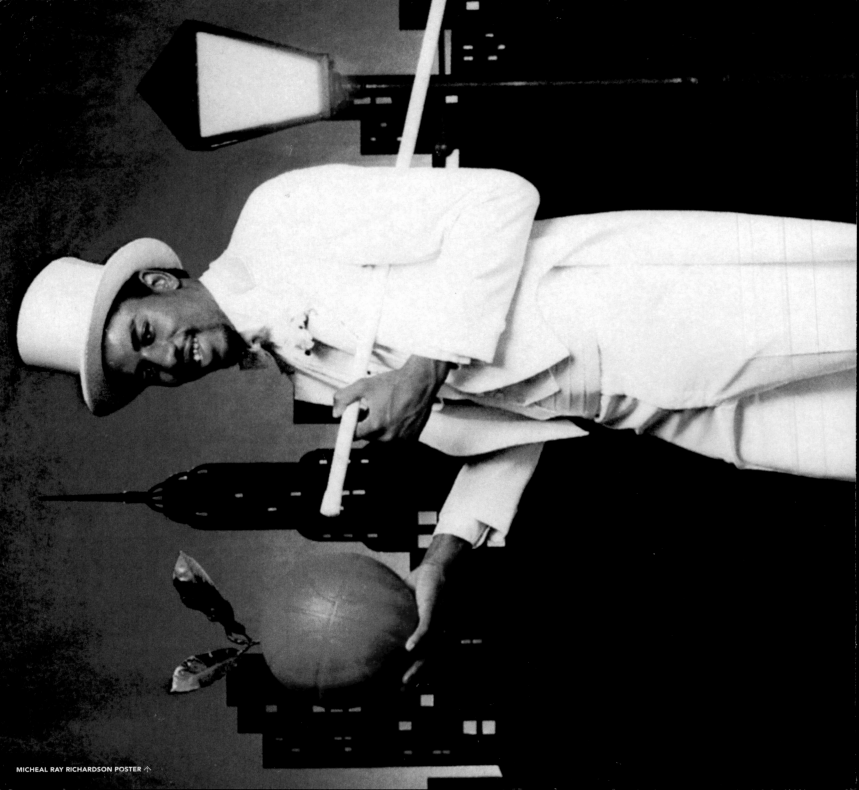

MICHEAL RAY RICHARDSON POSTER ⇑

SRS-One

Style reigned supreme over nearly e'rything. The shoes signified that. But one player personified the beginning of the decade. His name: Sugar. A young black kid from Denver who went to college in Montana who unfortunately got drafted to play ball in New York and proceeded to get caught up in his own money makin' Manhattan night life. The fame, the fortune, the fans, the All-Star games, the playoffs, the minks, the links, the gold teeth, the triple doubles, the steals, the good, the bad, the never ugly misunderstanding of his entire life. That was then. Almost every shoe created during this period could have been an alternative nickname for him: the Legend, the Franchise, the Hoop It Up, the Dynasty, the Air Force, the Game Breaker, the Penetrator. All seemed to fit Micheal Ray Richardson, the darkside version of a cat called Clyde. He was the early 80's consolidated into one sweetback bad ass basketball playing human being. Too bad the shoes that came out during this time lasted longer than he did.

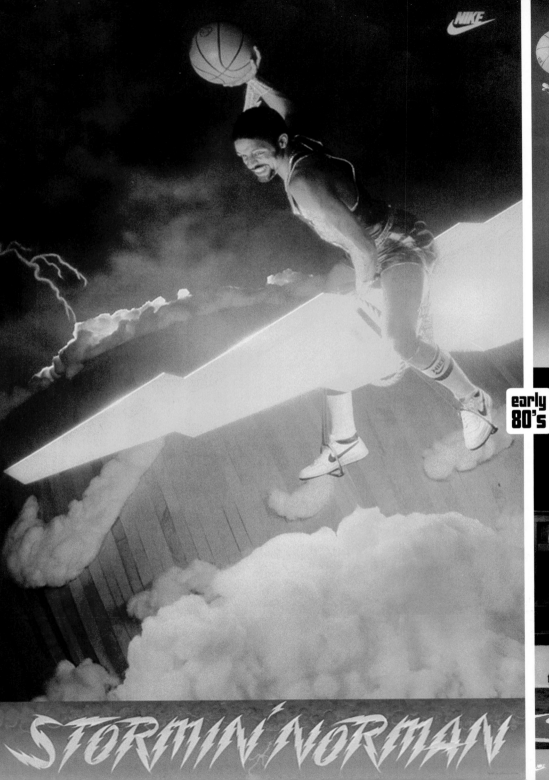

STORMIN' NORMAN

SIR SID

NIKE

SECRETARY OF DEFENSE

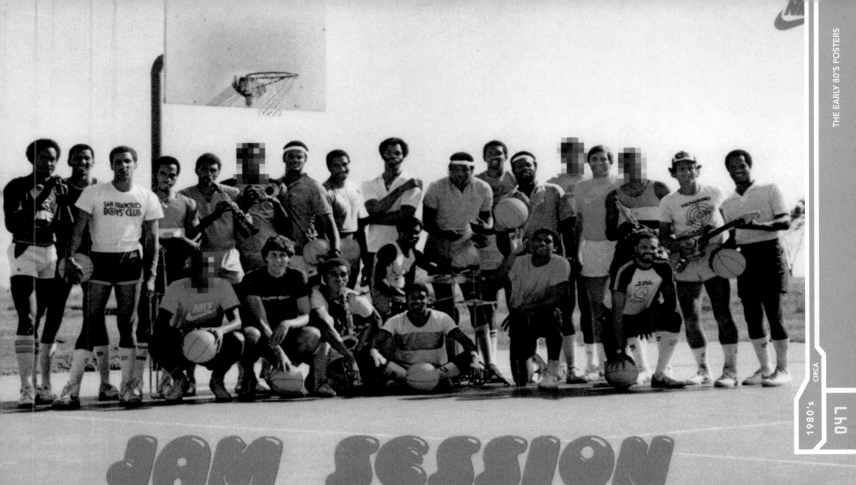

JAM SESSION

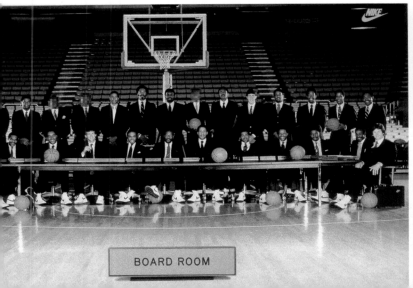

BOARD ROOM

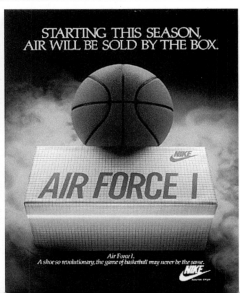

STARTING THIS SEASON,
AIR WILL BE SOLD BY THE BOX.

NIKE

AIR FORCE 1

Air Force 1.
A shoe so revolutionary, the game of basketball may never be the same.
NIKE

RULAND

Is this the first sign of change?

And if so, is this the icing on the cake?

Blackballed from the get, that's the most important thing to remember. He came into the league wanting to, needing to

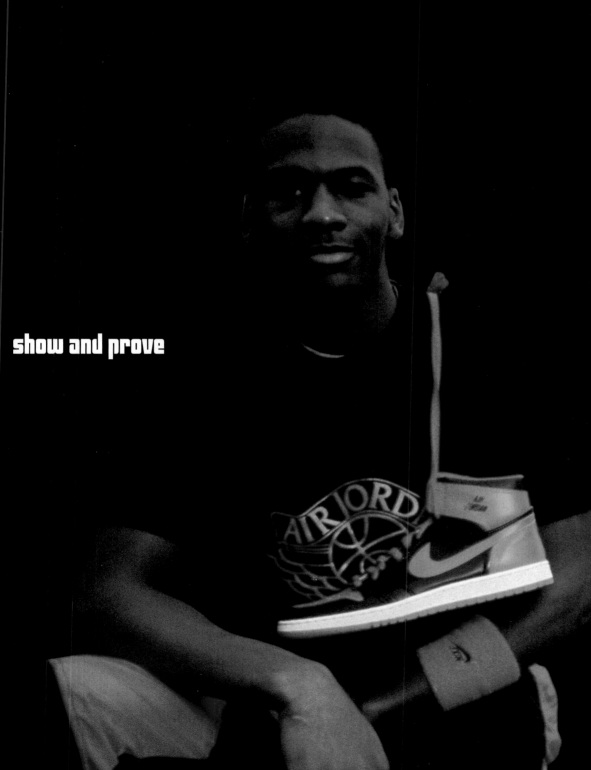

show and prove

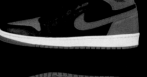

AIR JORDAN 1 ↑

...something beyond basketball.

Air Jordan 1

He possessed a gift. More than the high-flyin', death-defyin', 360 degree (Brooklyn) slam dunk, he had the ability to turn a shoe company into a marketing company. He had a vision, not to be bigger than the shoe, but create a linear coexistence. "Is it the shoes?" that made him so spectacular, that got him rookie of the year, that got him victories in dunk contests, that got him 63 against the Celtics? That was the question he had every-one asking. The Association tried to stop the bum rush, they banned his signature sneaks because, in his words, "they didn't have any white in them." Fined him every time he laced them up. He made it worth it. Once called "The dopest shoe on the planet" by Slam magazine, (even making a 42-point swan song

CIRCA

1986

053

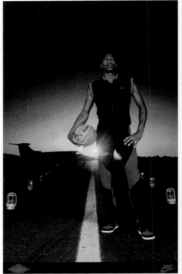
1986 MICHAEL JORDAN POSTER ⚓

MICHAEL JORDAN (JUMPMAN POSTER) STREET—AD) ☃

comeback in Madison Square Garden in 1998), the red and black power movement became an institution of change. From two colors to three (they added the white), from three to a variety, and with the basketballed winged logo on the side and the basketballed winged game to match, the man wearing #23 on his chest reinvented a sport and how we appreciate it by making us concentrate on what he had on his feet. His moniker: Air; his name: Jordan. Connect game forever. *And the madness was just beginning.*

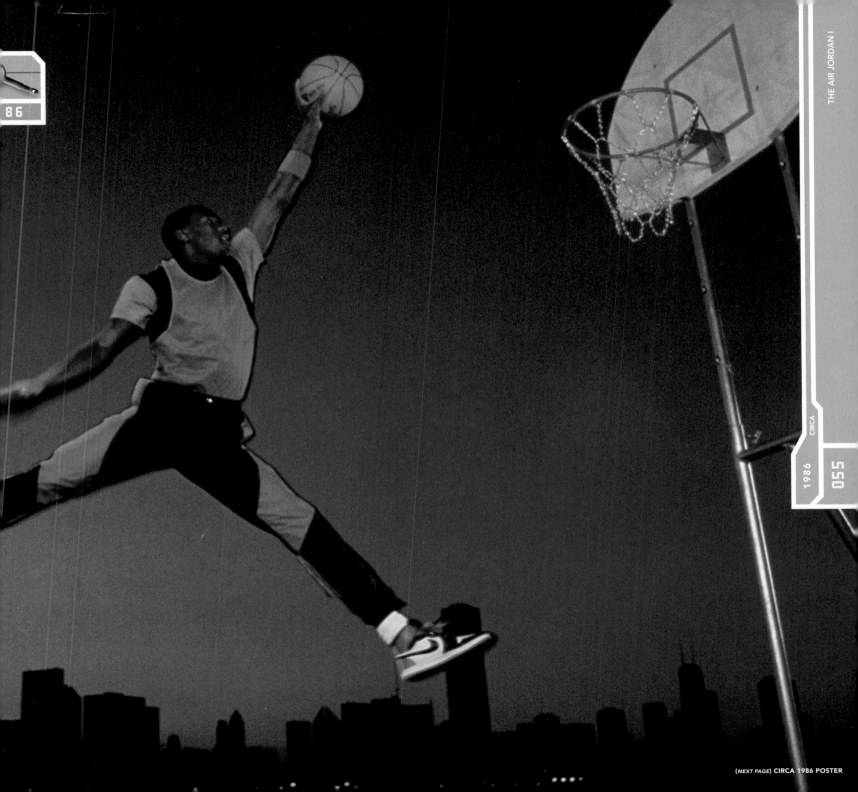

86

CIRCA

1986

055

(*NEXT PAGE*) **CIRCA 1986 POSTER**

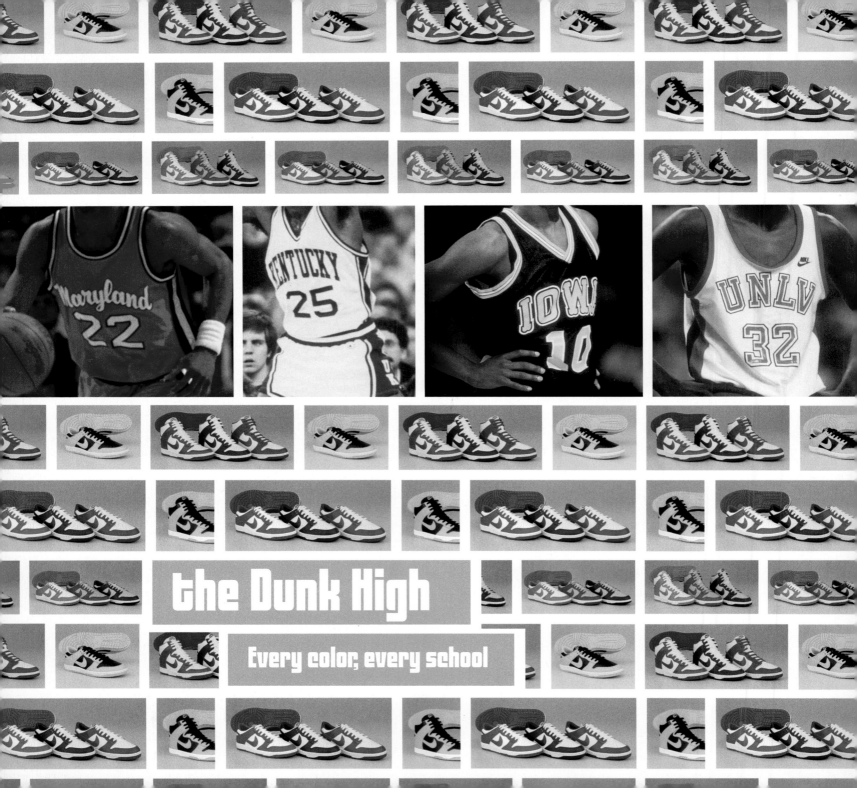

the Dunk High

Every color, every school

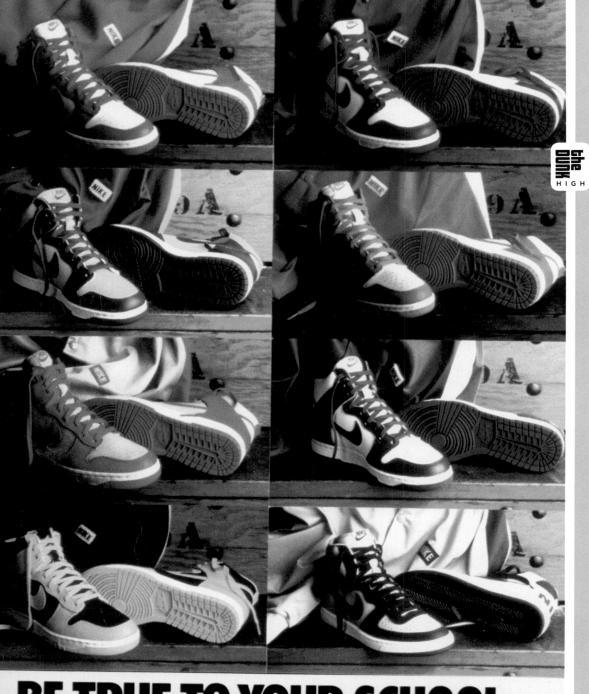

BE TRUE TO YOUR SCHOOL.

Basketball team colors by Nike. **NIKE**

Membership has its privileges.

The story goes that the Hoyas, being the trendsetters that they were, refused to exit the Legend, the shoe that defined them...until the Terminator was born. But Georgetown couldn't be alone. Others had to get special treatment. Remember, membership has its privileges. The Dunk became the Terminator's fraternal twin. Every color for every school. Dunk High, Dunk Low. Didn't matter because coordination was prime. So prime time it went. Appearances in NCAA tournaments, on national television. From University of Kentucky to University of Michigan to Syracuse University to University of Maryland to University of Iowa to Georgetown to University of Arizona, and UNLV. Al McGuire's voice a constant companion; several shining moments, not one; crazy Nielsen ratings. The year was '86, the year of the death of a college superstar, the year of the birth of the compact disc, the year of AMG kits, and *Miami Vice*. It was the dawn of crack, hard times for sucker MC's. But there remained brightness, often found wrapped below the ankles of common folk who began replacing their faded denim jeans with color-coordinated baggy sweats. Some rolled the right leg up to show off their matching kicks. The Dunk, although strictly made for D1 schools, transcended the world of academia. Because the world knew a shoe was a terrible thing to waste.

Big Nike

A'yo, bust it/Kids bum rush it/Came here to discuss it/Discuss me/Separating myself from thee/Like a low I.Q. and a college degree/I started the revolution/ Of big men needing a solution/To their foot problem/Big Nike's my name, I came to solve 'em/1986/Mr. Magic on the mix/Cold rocked the game 'cause it needed a fix/Straight outta Portland/Other sneakers called me rude/Dude/I'm SWA: sneaka wit' an attitude/Just tryin' to let suckas know/I came here tonite to run the show/Take other gym shoes out of the game/Cease their fame/ Because to me they all lame/Thinkin' they can chill/They know the drill/Big Nike, I'm beastie, got a license to ill/When they first clocked, forwards and centers lost their breath/Came in the game like I was avenging my brother's death/No symphony, no flash, simple design, no flair/Catch wreck like Hillary from Bel Air/New school look, old school sole/First player I made famous was Manute Bol/Stunts call me Big Nike/Here to invade your psyche/You Gotta Have Me, like your name is Spike Lee/N 'cause I'm nice/I 'cause I'm intense/K for the game I kick/E for the evidence/I leave/When suckas believe/That they can hang/I leave 'em empty like sleeves/Hollow like the canyon/Other sneaks tried to stand in/But they realized that was stupid, dumb, absurd/It's like the egg trying to fertilize the seed, them other sneakers is backwards/Got my name printed on my back, it's so wicked/Sole so curvy it couldn't be straight if you hot picked it/Other shoes say they got beef/Try to claim they the best/They ain't/Because with these words/I manifest/And put they soles to rest

THE BIG NIKE ↑

3ft. BIG NIKE

2ft.

1ft.

CIRCA

AVERAGE FAMILY

AVERAGE MALE 5'7"

MANUTE BOL 7'7"

The Delta Force AC ¾
The Remembrance.

There was once a team called the Nike Pro club. It originated in 1975. If you ask some b-ball lexicons they'll tell you that they were the original All-World Team. The members included Spencer Haywood, Alvin Adams, Phil Chenier, Charlie Scott, Austin Carr, John Drew, Rudy Tomjanovich and Paul Silas. Rumor has it that they rolled around the country in the off-season on a tour bus challenging anyone from existing NBA teams to ABA All-Stars to AAU squads. Myth has it that they never lost. At one point, it was said every basketball team alive was scared to play them. Unfortunately, all of those rumors are false. In reality, the Pro Club rolled more like the Brat Pack in Vegas. They took trips together in Honolulu, balled with Phil Knight, played golf, cocktailed. They had special rings made for members only. They were a professional basketball syndicate. For years the Pro Club

tested different shoes for this brash company called Nike. They'd try out different designs and models of different kicks and report back on what changes needed to be made and what shouldn't be touched. Some called them a Mob; the company called them "a focus group." Years after they disbanded, after the small shoe company became large, a designer (who will remain nameless), realized that the Pro Club had no recognized legacy. The shoe you see before you is the remembrance. A lifetime achievement award. A "thank you" to the original team of dreams.

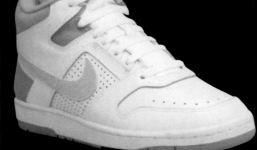

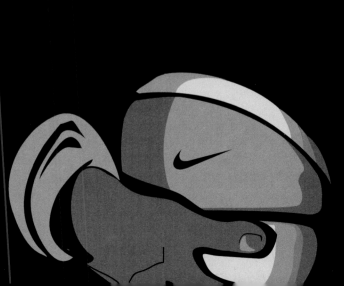

THE PRO CLUB

George "Iceman" Gervin

Rudy Tomjanovich

Spencer Haywood

Phil Chenier

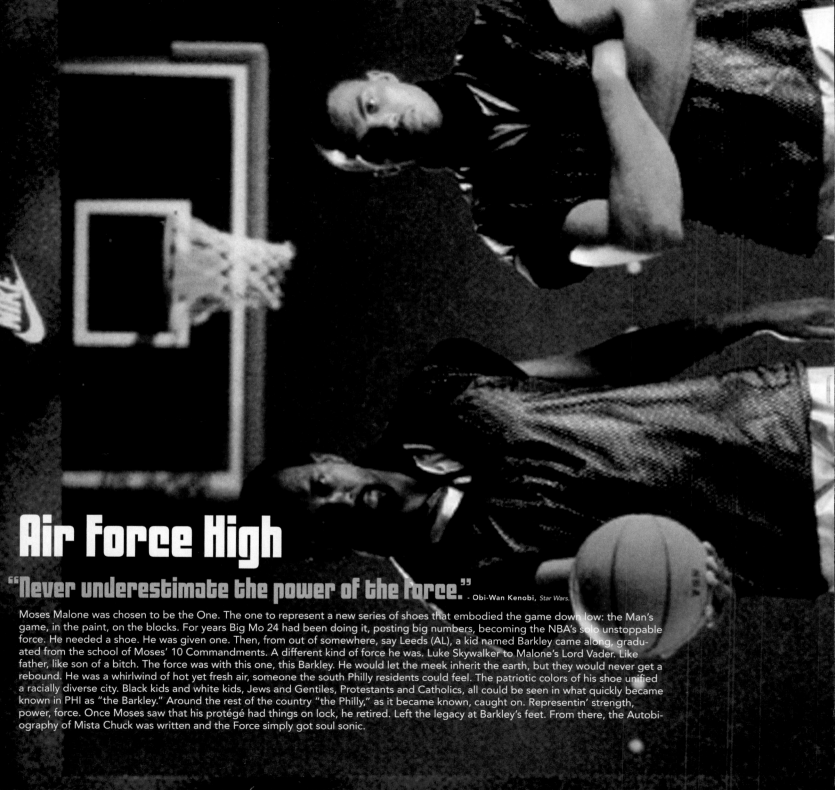

Air Force High

"Never underestimate the power of the force." - Obi-Wan Kenobi, *Star Wars*.

Moses Malone was chosen to be the One. The one to represent a new series of shoes that embodied the game down low: the Man's game, in the paint, on the blocks. For years Big Mo 24 had been doing it, posting big numbers, becoming the NBA's solo unstoppable force. He needed a shoe. He was given one. Then, from out of somewhere, say Leeds (AL), a kid named Barkley came along, graduated from the school of Moses' 10 Commandments. A different kind of force he was. Luke Skywalker to Malone's Lord Vader. Like father, like son of a bitch. The force was with this one, this Barkley. He would let the meek inherit the earth, but they would never get a rebound. He was a whirlwind of hot yet fresh air, someone the south Philly residents could feel. The patriotic colors of his shoe unified a racially diverse city. Black kids and white kids, Jews and Gentiles, Protestants and Catholics, all could be seen in what quickly became known in PHI as "the Barkley." Around the rest of the country "the Philly," as it became known, caught on. Representin' strength, power, force. Once Moses saw that his protégé had things on lock, he retired. Left the legacy at Barkley's feet. From there, the Autobiography of Mista Chuck was written and the Force simply got soul sonic.

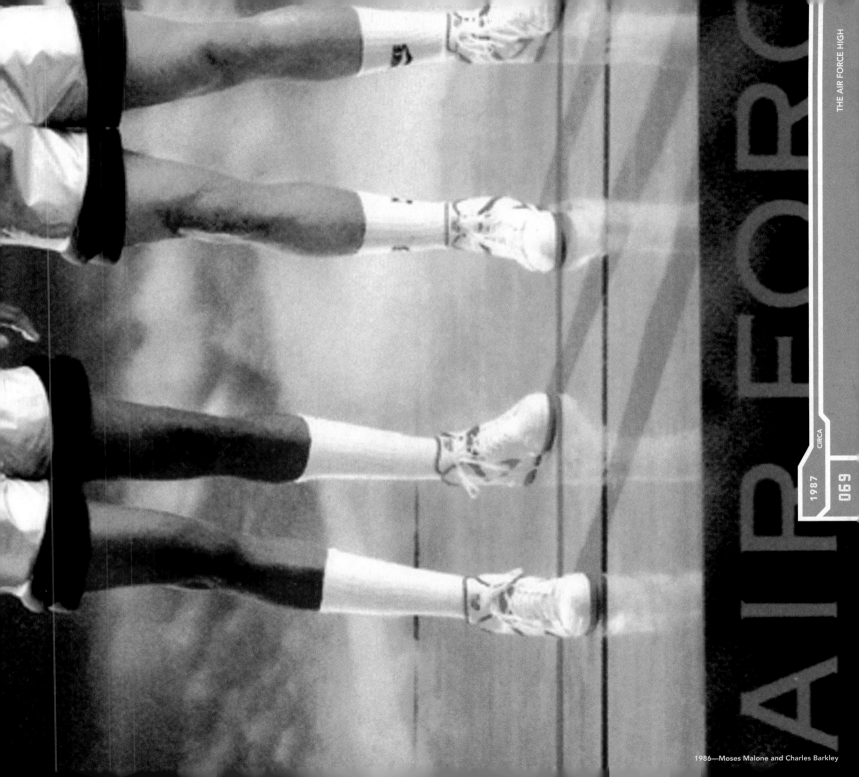

CIRCA

1987

069

1986—Moses Malone and Charles Barkley

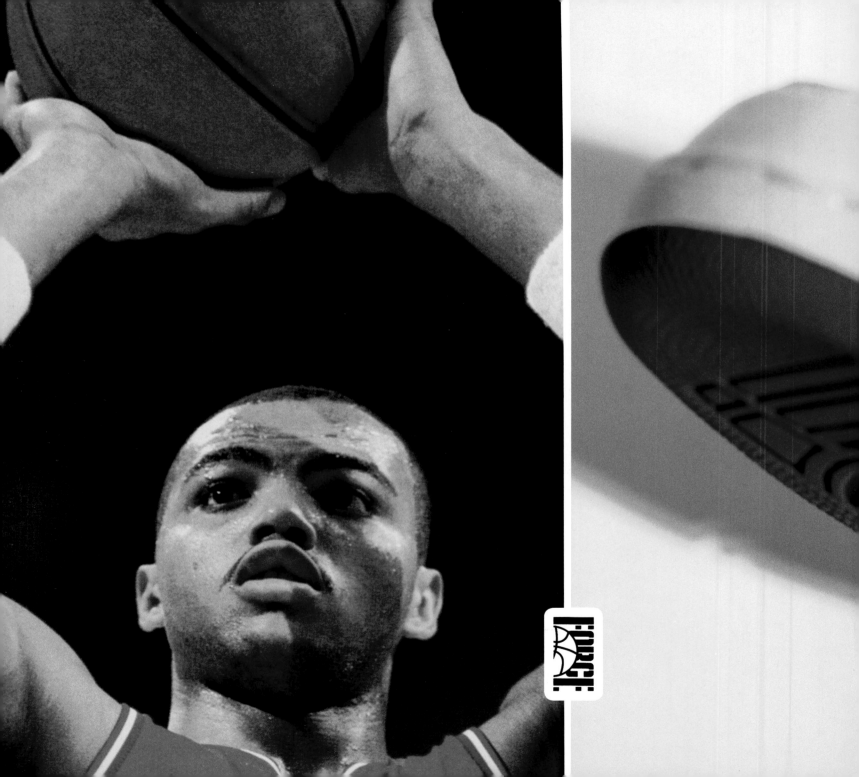

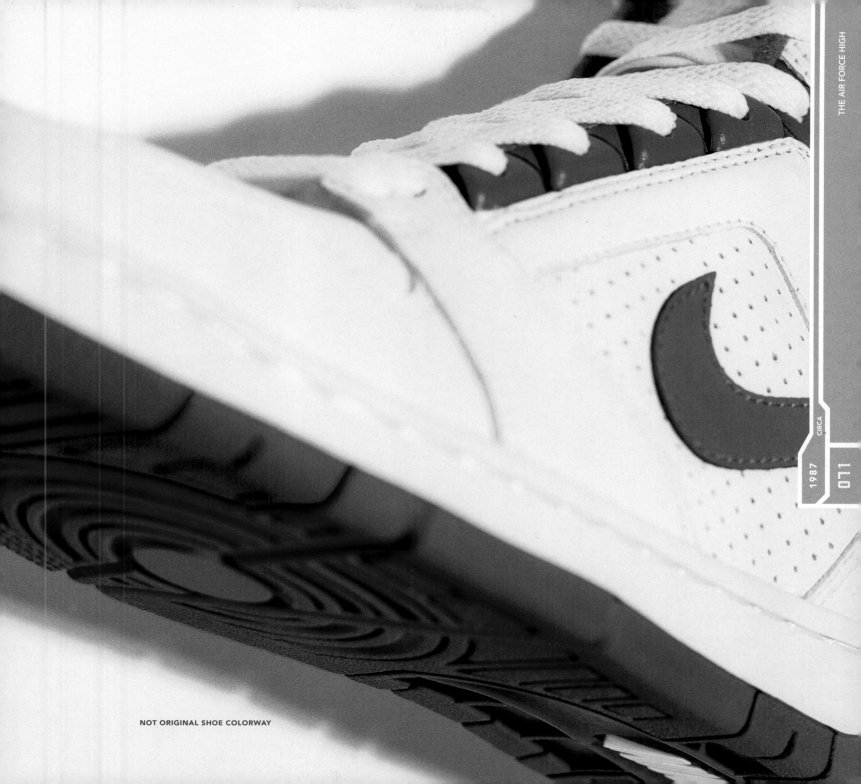

NOT ORIGINAL SHOE COLORWAY

THE AIR FORCE HIGH

CIRCA

1987

011

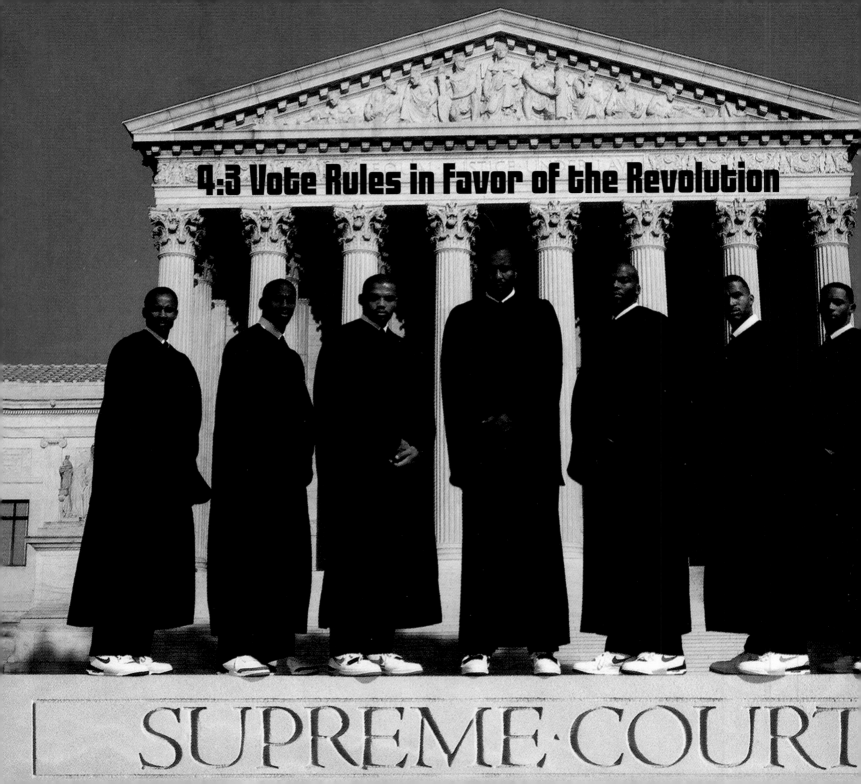

NIKE

'88 THE SUPREME COURT—L TO R: SIDNEY MONCRIEF, MICHAEL JORDAN, CHARLES BARKLEY, MOSES MALONE, CHUCK PERSON, RON HARPER, ALVIN ROBERTSON

CIRCA

1987

073

SUPREME COU

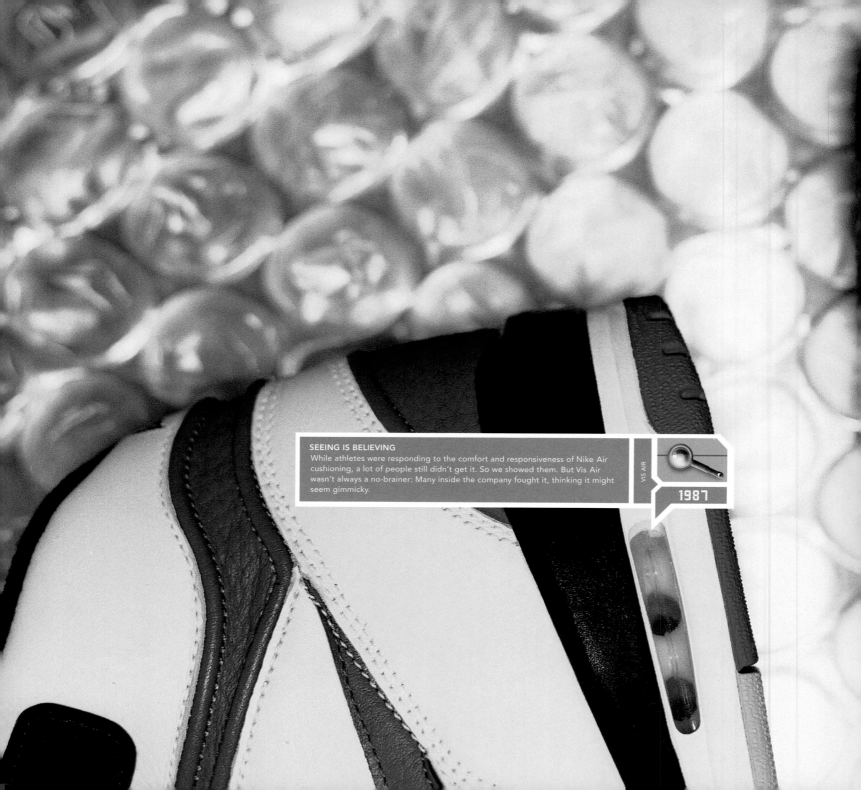

SEEING IS BELIEVING

While athletes were responding to the comfort and responsiveness of Nike Air cushioning, a lot of people still didn't get it. So we showed them. But Vis Air wasn't always a no-brainer: Many inside the company fought it, thinking it might seem gimmicky.

VIS AIR

1987

Air Revolution

Air just got visible

That's what the campaign promised. It was '88, time to set 'em straight, there was no half steppin'... it was time for a revolution. It was what many considered the greatest year in the history of hip hop, the epicenter of the generation. Every mic staker spit the dopest rhymes ever as the future of America was about to be introduced to the post-Frest Fest movement of everything MTV refused to show. Basketball, on the lower level, was taking the same path. Because breeding in those futuristic shoes, the ones with the "see-through air window in the sole that looked like moon boots" were children's stories untold. Unknown grammar school and high school kids out for fame in Oakland (Jason Kidd), in Philly (Eddie Jones), in Ohio (Jimmy Jackson), and in Virginia (Joe Smith) who would come together years later and do a commercial that not only defied gravity but spoke about a revolution. B-ball b-boys to the fullest, catchin' wreck, composing the ultramagnetic symphony. And no dis(respect) to the founding fathers of the terminology but, the Revolution was 'bout to be televised.

AIR REVOLUTION ⚁

GRAVITY WILL NEVER BE THE SAME.

The Air Revolution from Nike. It comes with Nike-Air® cushioning, great stability and a warning: If you're afraid of heights, buy another basketball shoe.

AIR REVOLUTION (AD) ⚁

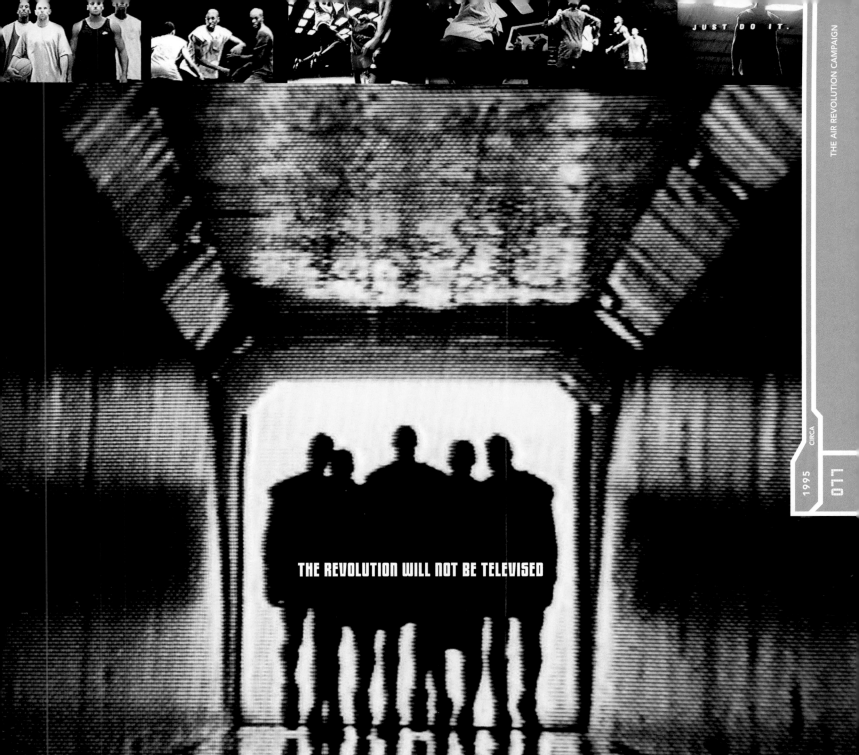

JUST DO IT.

THE REVOLUTION WILL NOT BE TELEVISED

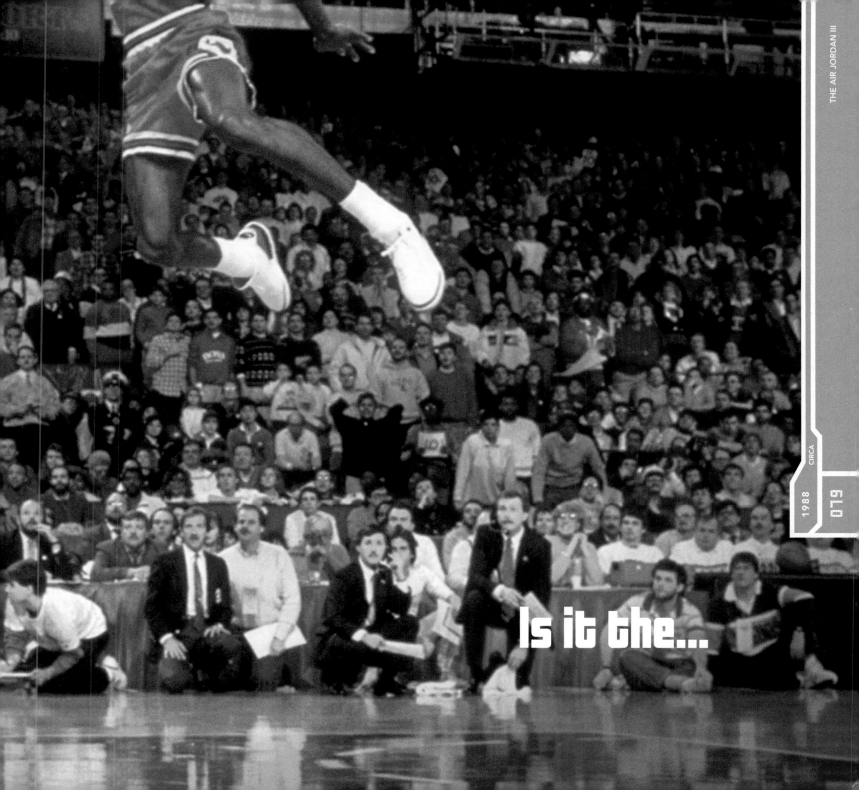

CIRCA

1988

079

Is it the...

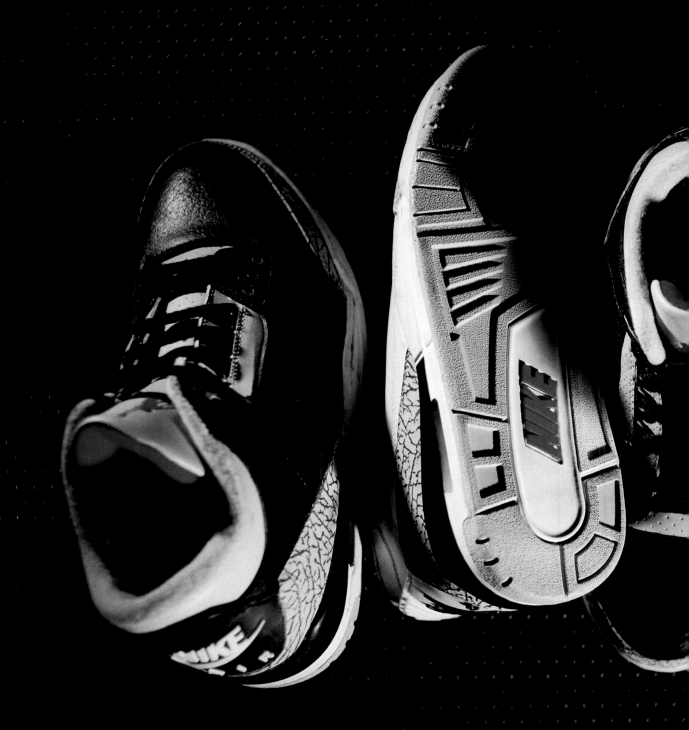

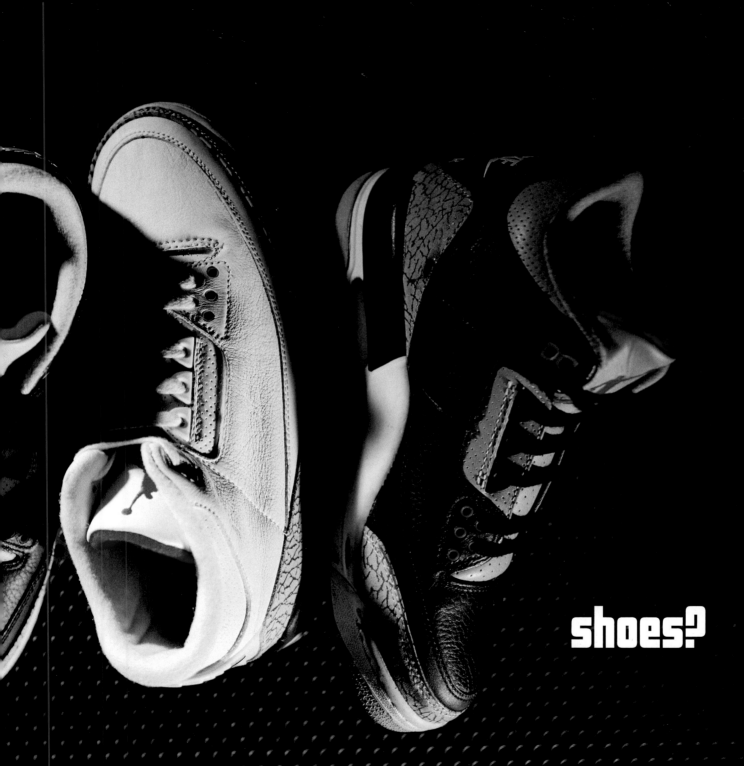

shoes?

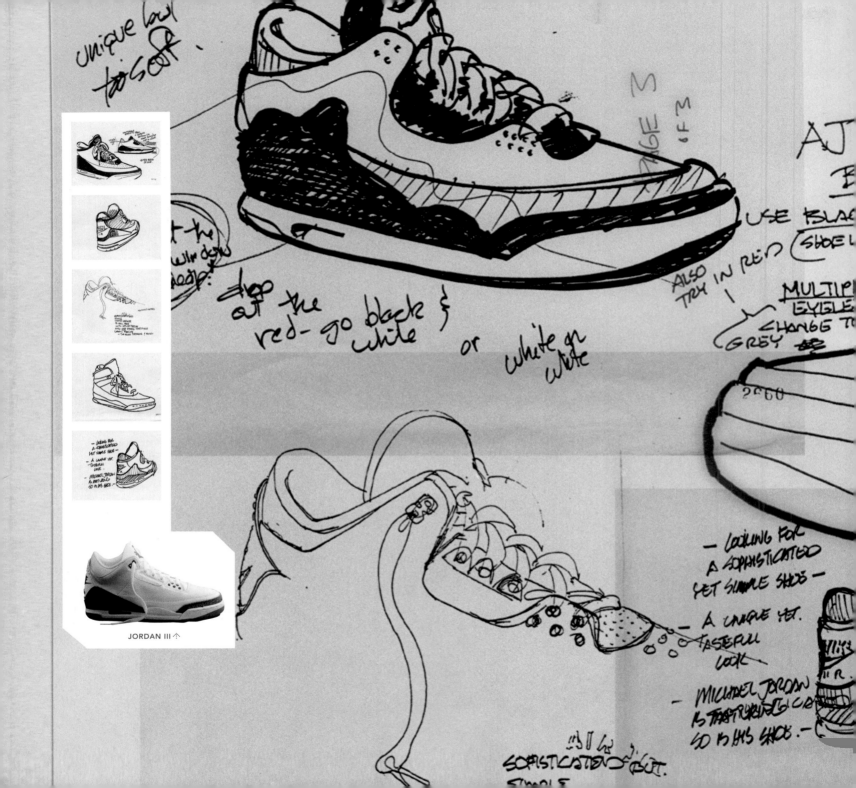

JORDAN III ↑

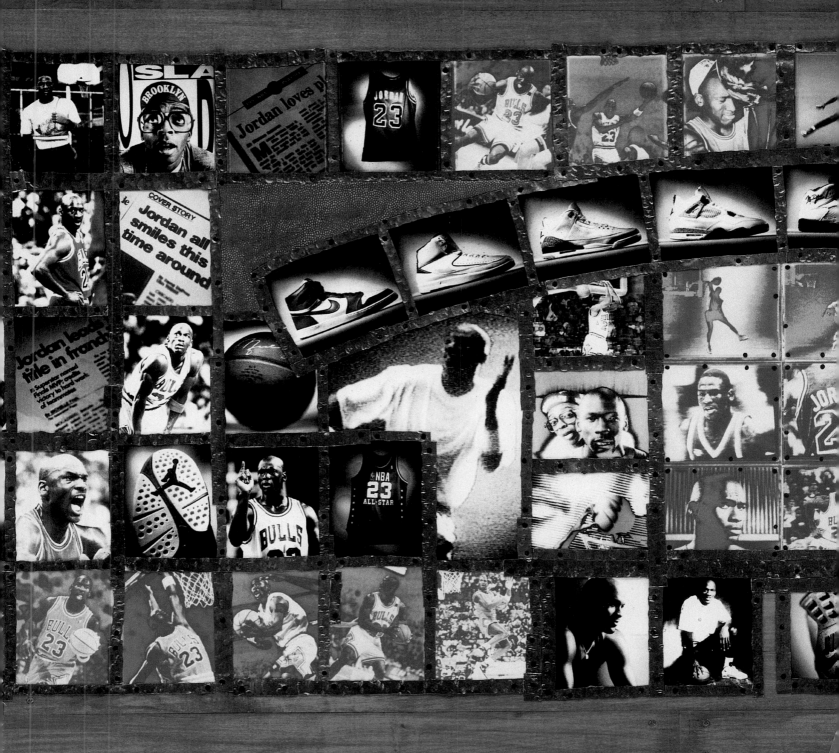

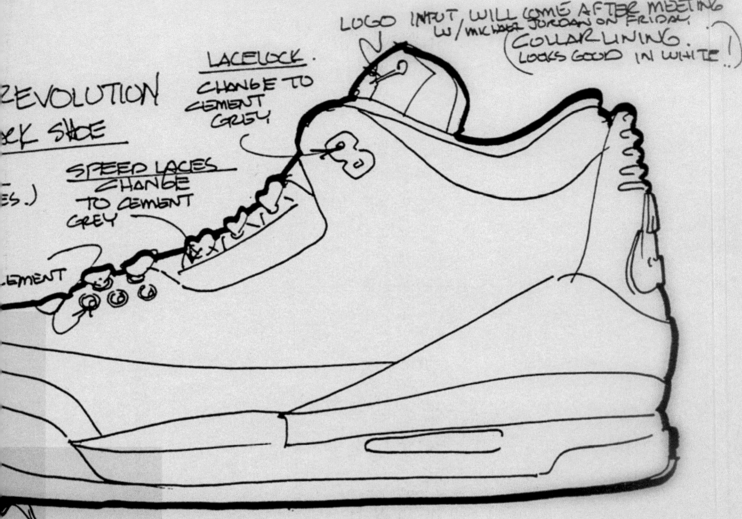

LOGO INPUT WILL COME AFTER MEETING
W/ MICHAEL JORDAN ON FRIDAY.
COLLAR LINING.
(LOOKS GOOD IN WHITE..!)

LACELOCK.
CHANGE TO
CEMENT GREY

REVOLUTION

CK SHOE

SPEED LACES
CHANGE
TO CEMENT
GREY

ES.)

EMENT

Air Jordan III

Shoe design is a funny thing. Designers never know what the public is fiending for, but at the same time, they have to create popularity. Designers, they are funny, too. They are shoe doctors, sneaker pimps. They break down every aspect of every nuance of every shoe that they've ever created and make everything sound like med school. Every shoe has a story. The story behind MJ's third shoe is this: The original designers of the first two kicks were no longer with the company and apparently were trying to woo Jumpman to jump ship. He was with it, but he was obligated to at least look at what the new designer had come up with before he bolted. For four hours the designer, his crew, Mom and Dad Jordan, and Phil Knight sat in a room waiting for $ to show. Once he did, he already had in his mind that this was going to be quick; he wasn't trying to hear anything. Then he saw the shoe: The first mid-cut, the elephant skinned wrinkled leather, the first appearance of his logo on a shoe. And just like you and I did when we first saw it, $ freaked. It was love at first, second and third sight. He went on to have what many purists say was his best, most complete season ever in the shoe, while the shoe itself, well, it went on to live a life of its own, changing the landscape of shoe design and performance. And oh, the shoe designer? Thing is, $ sorta liked him. His name was Tinker Hatfield; he went on to design the next 12 Air Jordans. He sorta became an icon. In the gym shoe design industry they simply call him Employee #23. Kinda funny, huh?

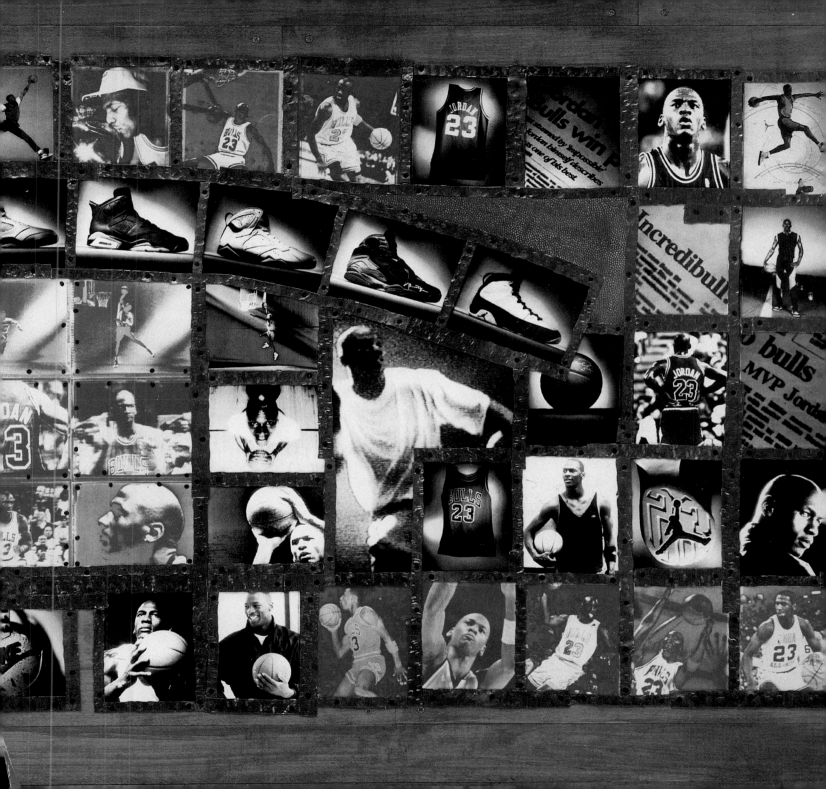

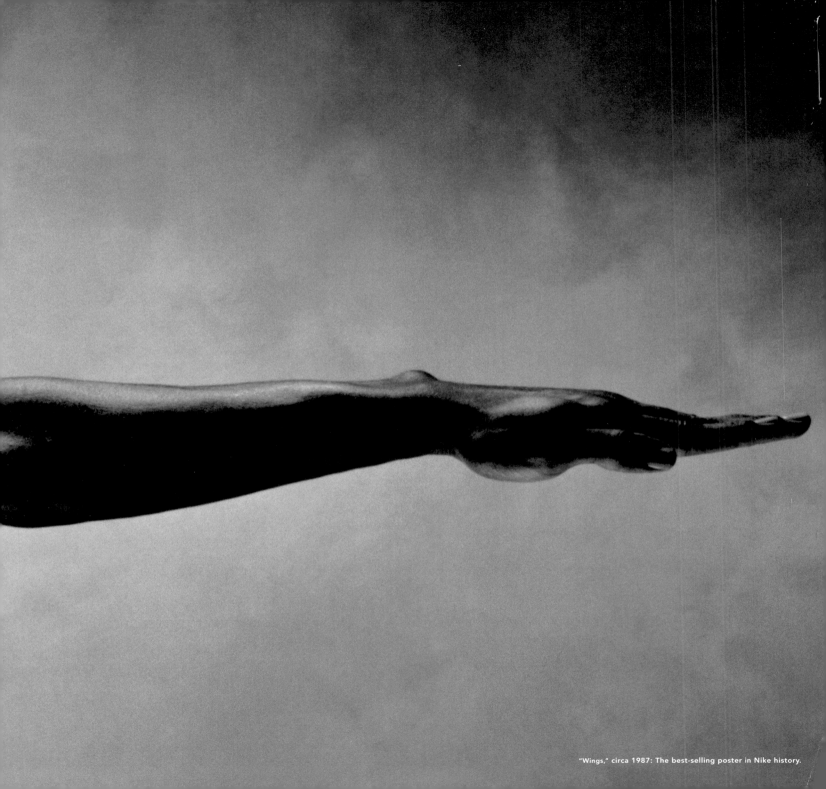

"Wings," circa 1987: The best-selling poster in Nike history.

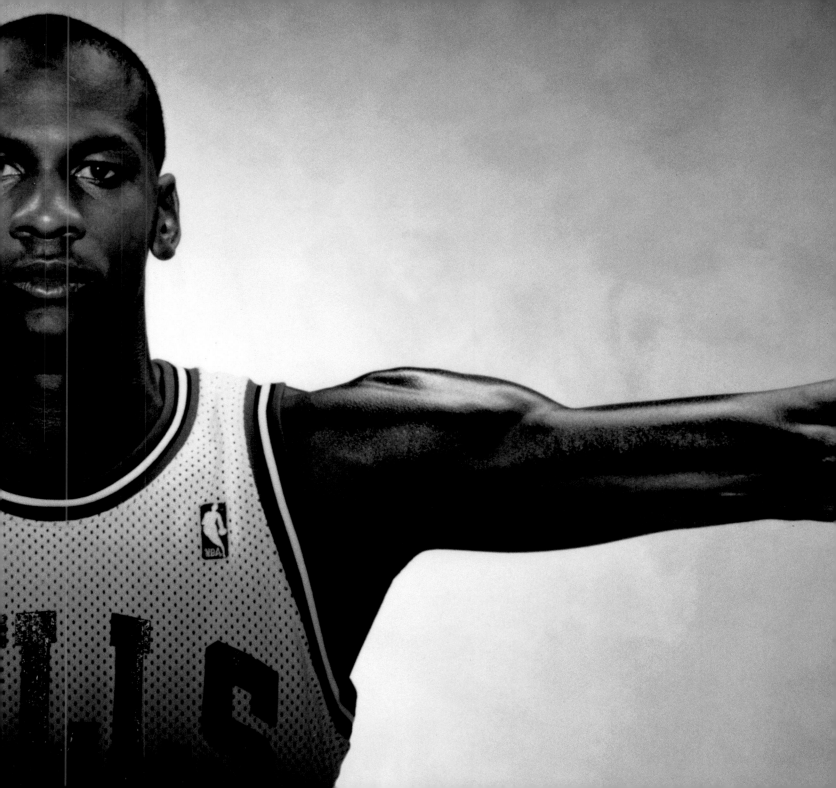

ALPHA

The Game was getting too pretty. All Stars, bringing the game a sense of b Ugh. Then came along this cat called

FORCE

these finesse players, pop star All-
auty dipped in political correctness.
Round. Last Name: Moundofrebound.

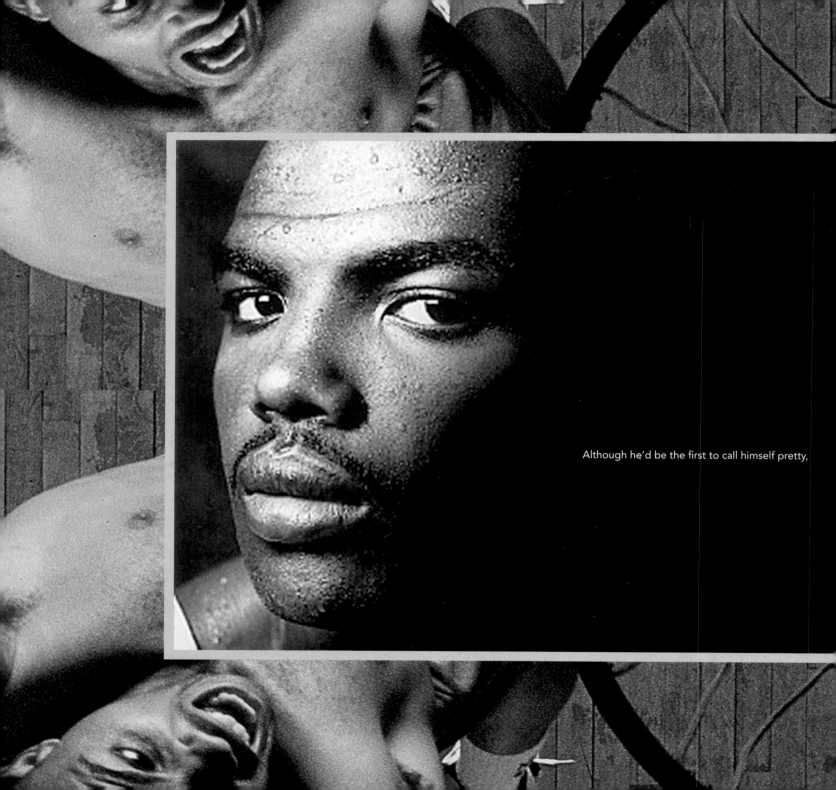

Although he'd be the first to call himself pretty,

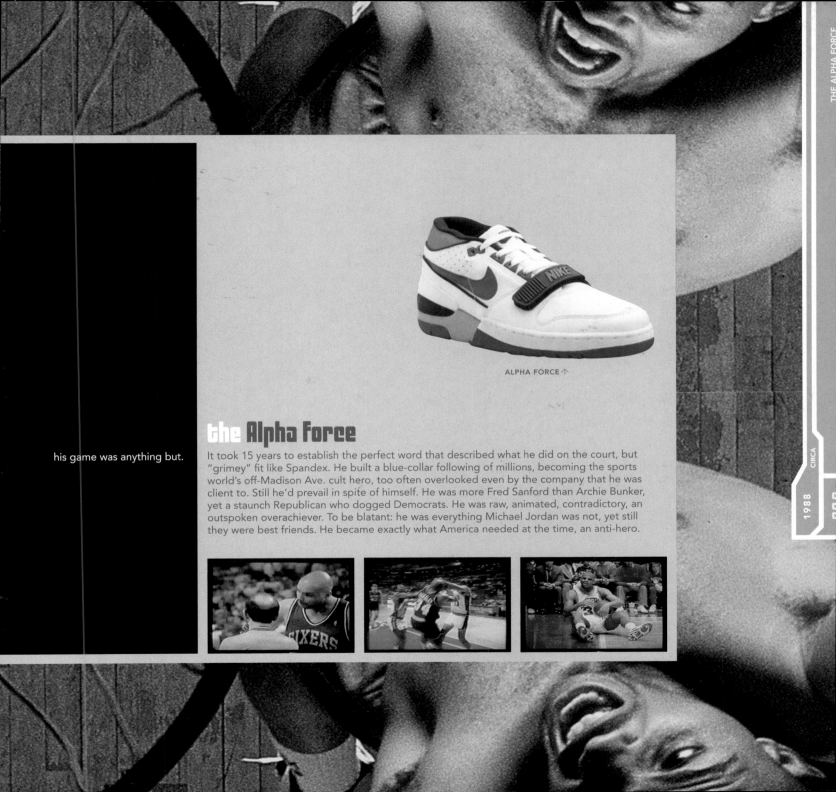

ALPHA FORCE ↑

his game was anything but.

the Alpha Force

It took 15 years to establish the perfect word that described what he did on the court, but "grimey" fit like Spandex. He built a blue-collar following of millions, becoming the sports world's off-Madison Ave. cult hero, too often overlooked even by the company that he was client to. Still he'd prevail in spite of himself. He was more Fred Sanford than Archie Bunker, yet a staunch Republican who dogged Democrats. He was raw, animated, contradictory, an outspoken overachiever. To be blatant: he was everything Michael Jordan was not, yet still they were best friends. He became exactly what America needed at the time, an anti-hero.

FORCE vs. FLIGHT

You can get with this... or you can get with that. Encapsulated Polyurethane or Ventilated Hytrel. Those were the choices given because for so many years there were no choices. Bottom-line: Big men play the game differently than not-so-big men. But for years all had to ball in the same shoes. The Force series since its inception in 1987 had become like tires designed for SUVs in a game slowly being dominated by sports cars. Then in 1989 the luxury whips (ball players) finally got their own set of wheels and a competition was born. It was the lightweights versus the heavyweights. Speed against strength. But no one was looking for a winner. Only choices made. The solid rubber outsole with the "built-in flex grooves" made the Flights perfect for a player named Jordan who they were going to model the design and campaign around. The Center of Pressure outsole with the "anatomical flex grooves" made

CIRCA 1989

Forces perfect for a player named Barkley who they were going to continue (Moses Malone was the original Force guy) to model the design and campaign around. Then everyone weighed in: 250 lbs and up, you Force'n it; 250 lbs and under, Flight time. From David Robinson and Alonzo Mourning to Scottie Pippen and Anfernee Hardaway with A.C. Green and Reggie Miller in between, the battle lines were drawn. But no one saw the total picture because each series put such a stranglehold on each market in every corner it was hard to distinguish who over the years was having the deepest, most vital impact. One shoe would never outdo the other. Becoming one of the greatest rivalries in sports. Force versus Flight... the choice is yours.

Which camp are you in?

Force

Charles Barkley
Moses Malone
Artis Gilmore
David Robinson
Rasheed Wallace
Alonzo Morning
AC Green
Buck Williams
Jeff Ruland
Truck Robinson
Juwan Howard
DL (Down Low)
Manute Bol
Bobby Jones
Patrick Ewing
Natalie Williams
Elton Brand
Paul Silas
Maurice Lucas
Tim Duncan
Jermaine O'Neal

Flight

HALL of FAME

Michael Jordan
Jason Kidd
Ron Harper
Penny Hardaway
Scottie Pippen
Gary Payton
Michael Cooper
Sidney Moncrief
Baron Davis
Reggie Miller
Norm Nixon
Byron Scott
Kiki Vandeweghe
Paul Pierce
Tim Hardaway
Mitch Richmond
AC (Area Code)
Alvin Roberston
Cynthia Cooper
Maurice Cheeks
DaJuan Wagner

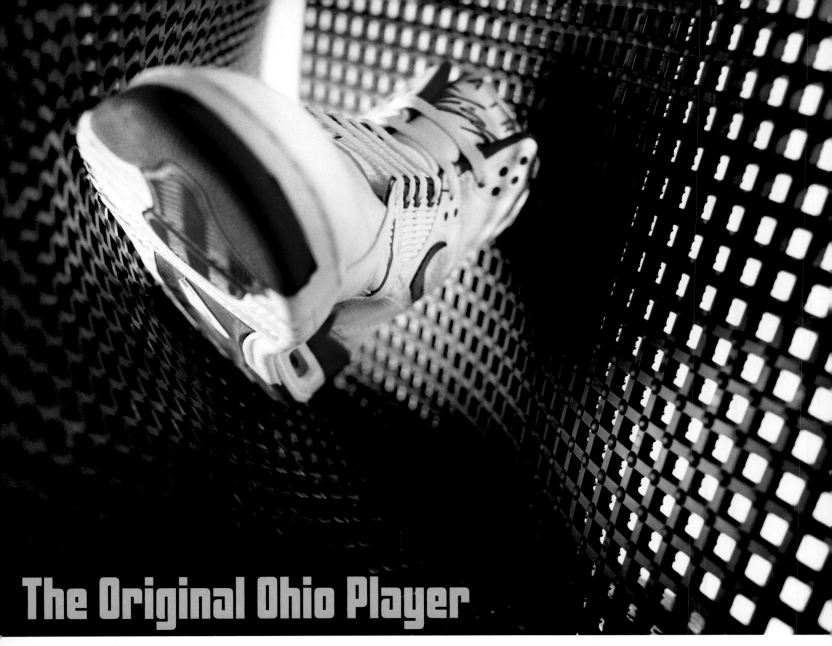

The Original Ohio Player

Imagine how large he would have become had there never been a Michael Jordan? Think about how different this unknown's life would have been. He was the NBA's Plan B. A starving ball player whose hunger was never totally appreciated at the time because the light around #23 shined so bright. This dude made all of the other wannabes in the league look not just stupid, but stuck on stupid. Jump shot, got 'em; ability to get to the basket and score at will, got 'em twice; lock opponents best players up on defense (including MJ), got 'em one more again. Was there nothing he could not do? Yes. Ron

Harper couldn't get famous. So he remained nameless. Until someone in marketing (or at the ad firm Wieden & Kennedy) had an idea: Isolate Jordan and let there be Flight. The next day there was Flight and Harper's name atop of the list to lead it. The fact that he didn't dunk in dunk contests but tomahawked on people instead impressed the list makers. The 23 ppg he was putting up didn't hurt either. They called him "The Ohio Player," "The poor man's Jordan," "The Not-From-Tuskegee Airman." He represented everything the Flight basketball shoe line was 'bout to be about. He was

OHIO FLYER

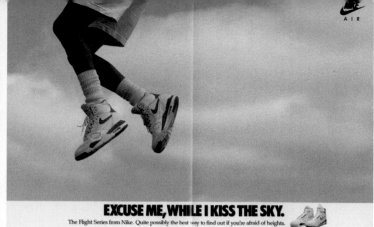

EXCUSE ME, WHILE I KISS THE SKY.

The Flight Series from Nike. Quite possibly the best way to find out if you're afraid of heights.

Air Flight Air Solo Flight

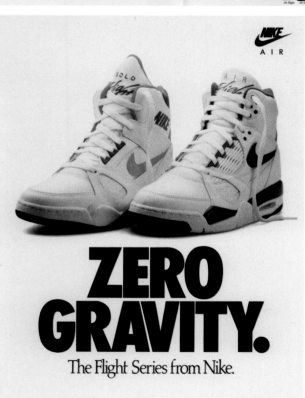

ZERO GRAVITY.

The Flight Series from Nike.

simply "the other" future. Then his knee went out on him. Then he got traded to the Clippers. For a few years they said he would never be the same. "Come back, Harp" his Flight fans would cry. "Please fly again for us." But those days would never return. The dramatic end to Ron Harper's Flight saga came in 1995 when he was traded to the Chicago Bulls, signed a 5-year, $19 million contract, and became best friends with the new Flight list-leader Scottie Pippen. Soon after that Michael Jordan would come out of retirement to play with Harper in the backcourt. They'd get three championship rings together. Then Ron would return to LA and get two more rings by orchestrating the Lakers offense and anchoring their defense. Never to fly again. Now he just chills, retired, finished with the game, never becoming a household name. And for the trauma of never reaching superstardom all Ron Harper has is those 5 damn rings to show for it.

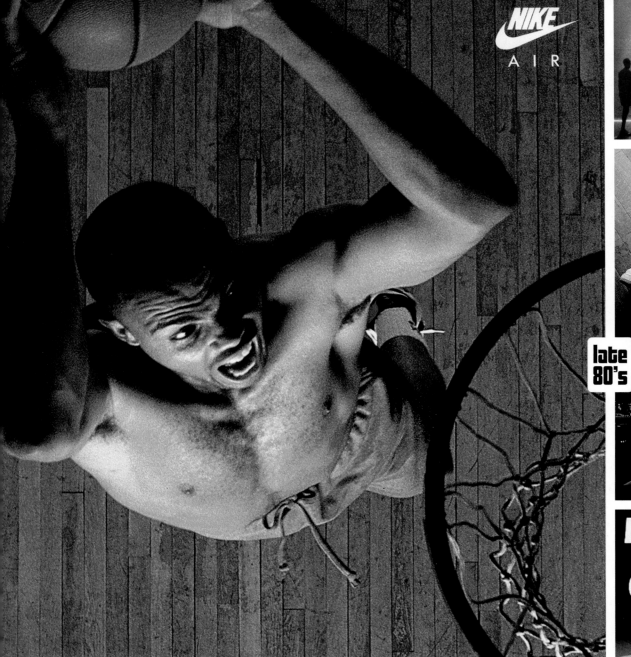

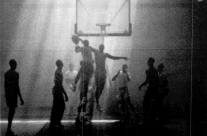

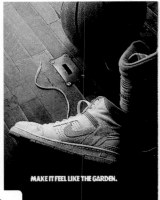

MAKE IT FEEL LIKE THE GARDEN.

late 80's

AIR FREIGHT.

The Force Series from Nike. When it absolutely,
positively has to be in someone's face.

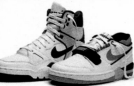

Air Force III Air Alpha Force

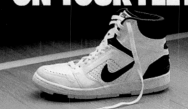

MELTS IN YOUR HANDS, NOT ON YOUR FEET.

Leather so soft, so supple, it feels as if you've worn it forever. From the first day you put it on.

We're not talking about garment leather. Garment leather would be fine if you didn't plan on anything more strenuous than a cocktail party.

But the Nike Air Force is headed to the pass. Where a shoe that stretches, a shoe that blows out, is a shoe that is benched. Permanently.

That's why we developed Performance Leather. From select Western hides. With fibers chemically and mechanically treated to both strengthen and soften. It's an exclusive with Nike.

And once you put it on, it'll be an exclusive with you.

PERFORMANCE LEATHER

290840 CHARLES BARKLEY 290839 DAVID ROBINSON 290841 CHRIS MULLIN

18" × 18"

290842 GERALD WILKINS 290843 MARK JACKSON 290844 RON HA

18" × 18"

FORCE

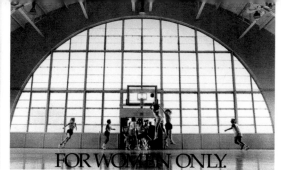

FOR WOMEN ONLY.

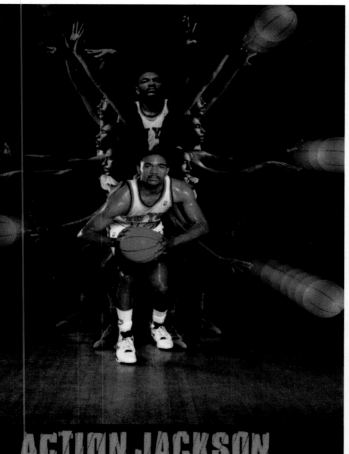

ACTION JACKSON

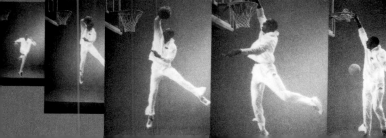

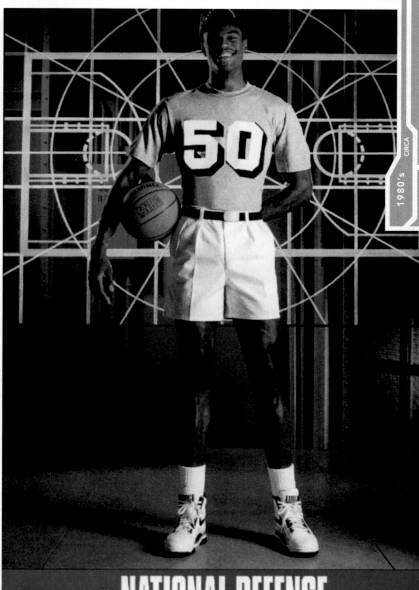

★ NATIONAL DEFENSE ★

Every business hits a stride. That's the nature of un-failing. Economics 101. But what do you do when you hit that stride? Ride or die? In 1990 Nike musta knew [in the words of Bernie Mac] it had something goings on. Simply because of what they did at the turn of the decade. These eight years, from '90-'98, are what have become known as the Golden Years. The years where they could do no wrong, where they coulda da [and sometimes did] jump back and kiss themselves. A time period where not just every shoe was hittin', but every player signed was ballin', every commercial aired was considered "classic," and every marketing scheme was so ahead of its time pop culture adjusted with every breath the brand took. Jordan was apex, Barkley was murder, Duke was unstoppable and all other players and teams in between were hitting on all cylinders. Players like Reggie Miller and Tim Hardaway who rep'd the company to the death were always "third team all-pro"

and still got no love, but without them the Golden Years wouldn't have had the same impact in the suburbs and on the streets. The Air Force Max and the Air Zoom Flight were born, more importantly the Air Max Uptempo, born in 1995, became the standard which all other basket-ball shoes could not match. David Robinson gave the illest twist to Mr. Robinson's Neighborhood since a kid from White Plains did the redux on SNL in the 80's. Little Penny and Mars Blackmon and Lil' Richard as the Genie In The Lamp all came through during this time. As did a collection of spots highlighting some of the true underground playground legends that set the table for all future shoe companies to eat. Yes, these years were special, if not unforgettable. In the 30 years of the company's involvement in basketball they have never hit a stride like this. One where nothing not only could go wrong, it didn't. The question for the future of the brand now is can they "just do it" again?

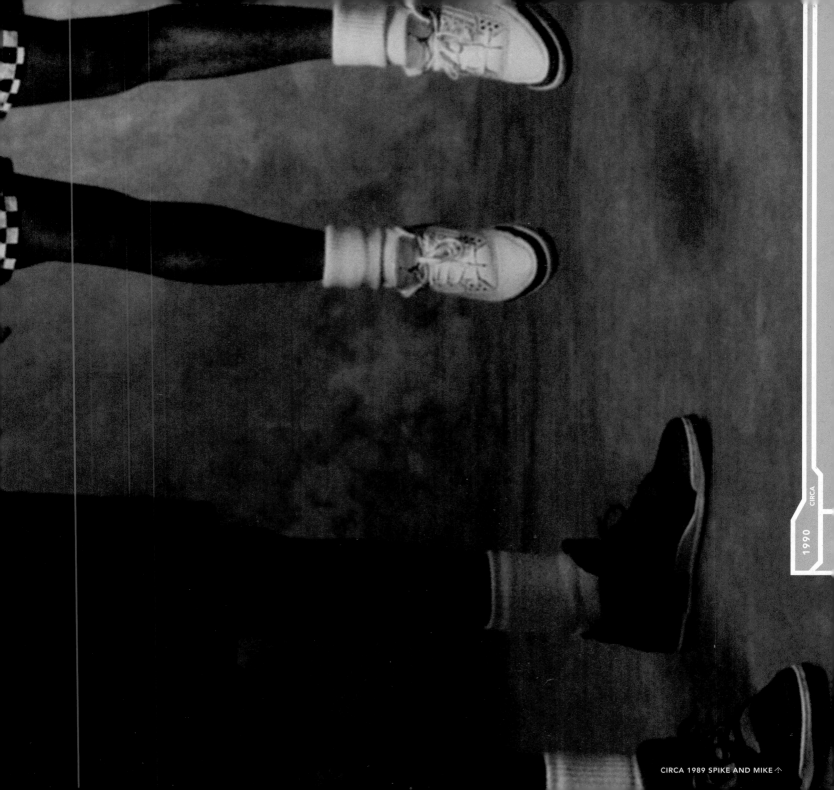

CIRCA 1989 SPIKE AND MIKE ↑

CIRCA 1990

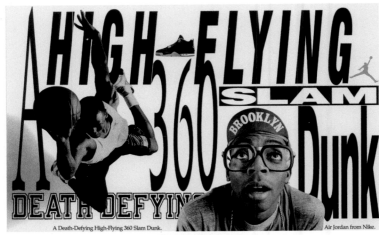

A Death-Defying High-Flying 360 Slam Dunk. Air Jordan from Nike.

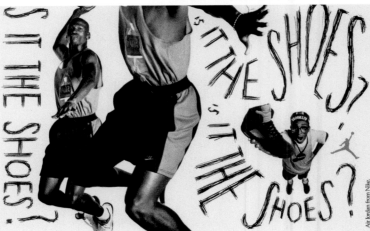

Air Jordan from Nike.

Yo $, Yo $, Yo $, Yo...

Have you ever noticed that in the early commercials MJ never said anything? No lines. He just flew in the air, doing mind-boggling dunk after mind-blowing dunk through the lens of an upstart film director named Sheldon Jackson Lee. The spots were all shot in black and white and $ was performing dunks no-no-nobody had ever seen. Being a fan and having vast knowledge of the history of silent movies, young Lee believed a collection of "short films" featuring America's most beloved athlete would be endearing to the public and at the same time 1) introduce Nike to the Mars Blackmon ghetto fan base, 2) turn Jordan into an international icon, 3) and get himself courtside seats at the Knick games. His plan backfired. True, he got what he wanted out of the deal, but little did Spike Lee (or the people at Wieden & Kennedy that created the campaign) know that his little "trick to get some money on the side while he was in-between films" would turn out to be just as significant to his career as

Hollywood wasn't. And the longer they did the commercials, the larger Mars Blackmon became. All of a sudden, by default, Michael Jordan went from person to personality; white kids started saying "please baby, please baby, baby, baby, please!!"; posters would be hung on bedroom walls and bus stops everywhere; and (most importantly) millions upon millions of sneakers would be sold. All because of some little Nike wearin', bicycle cap sportin', no woman gettin', repeat talkin' hood nerd alter ego from Brooklyn who wouldn't shut up and give Michael Jordan a chance to speak side-kicked his way into America's heart by getting on our last freakin' nerve. Genius, it was. To date the campaign is still considered the nascence of the basketball shoe's 60-second revolution with television. Simply put, they were the best commercials on Earth and the best commercials on Mars. Did you know that? Did you know, did you know, did you know?

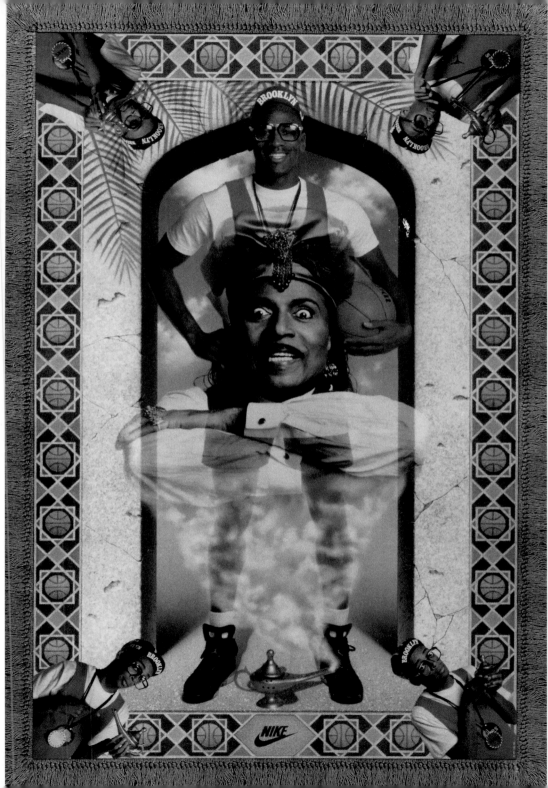

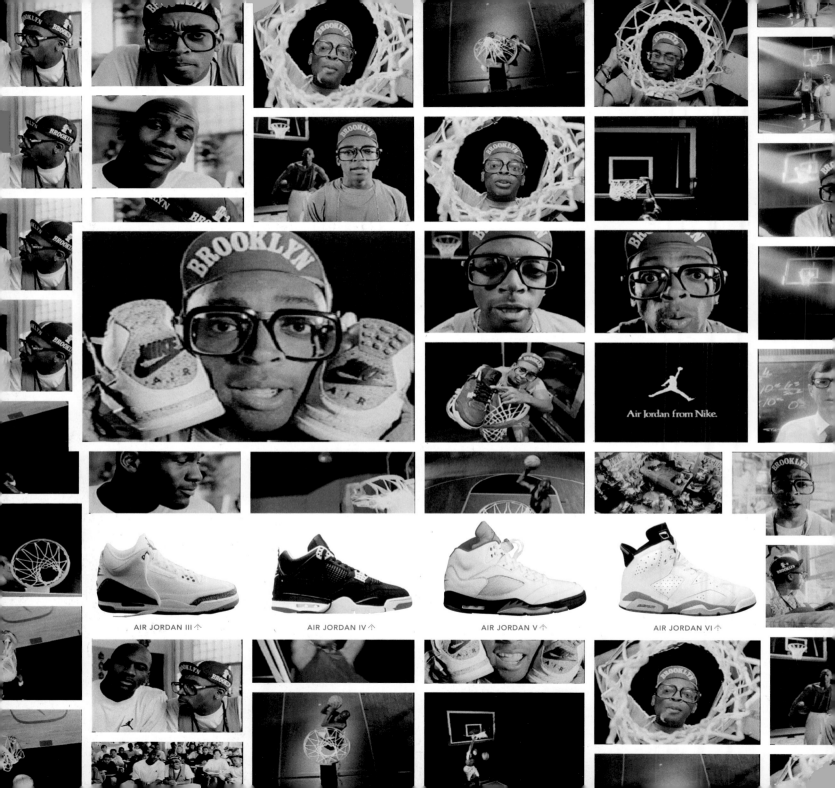

AIR JORDAN III ↑ AIR JORDAN IV ↑ AIR JORDAN V ↑ AIR JORDAN VI ↑

Air Jordan from Nike.

BROOKLYN
NIKE

Air Jordan from Nike.

mister robinson's neighborhood

mister robinson's neighborhood

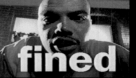

fined

rebound

practice

NIKE

Somebody Call Five-0

You can't teach size. And boy did he have it. With his size, all 85" of him, David Robinson commanded respect on the court. Arms too strong to box with God, legs too powerful to get boxed out. The former Navy recruit turned All-World ball player had become the game's new golden child. But the hardrock ball players, the ones who spend hours on the courts of NY, DC, Philly and Detroit leaving scars on concrete, were not feelin' anything David Robinson had to offer. To them he was soft, vanilla and overrated. Forget the fact that he was unquestionably the most complete and arguably the best center in basketball, the hood was not taking Mr. Robinson in or under. How, as a business, was a dude stuck in a football-driven state going to be the frontman to sell to a company's most influential target audience (the basketball audience) in a post-LA riot culture? Tight shoes with a tighter ad campaign was the answer. Starting with the entire Force collection and culminating with Air Command Force, Mr. Robinson's Neighborhood took DR past the commercial marketplace and into the cribs and pjs of the same folks that weren't giving him love and made them fall in love. Instantly the scrutiny got lighter, slowly the game came easier, quietly all the world began to

hold a place in its heart for ol' 50. His life was all good. He had money, fame, fortune, shoes, a loving family, support, more shoes, endorsements, pianos, a tattooed, blonde-haired rebounding maniac, shoes. All he needed was a championship ring, maybe one MVP and someone to help him get his team over the hump. Damn, don't you just love it when a plan comes together?

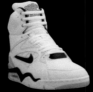

AIR COMMAND FORCE

FORCE.

the official shoe of

mister

Can you say
"mr. robinson"?

neighborhood

can you say
"nike-air® cushioning"?

can you say
"customized fit"?

can you say
"big socks
not included"?

can you say
"air command force"?

rob
in
son's

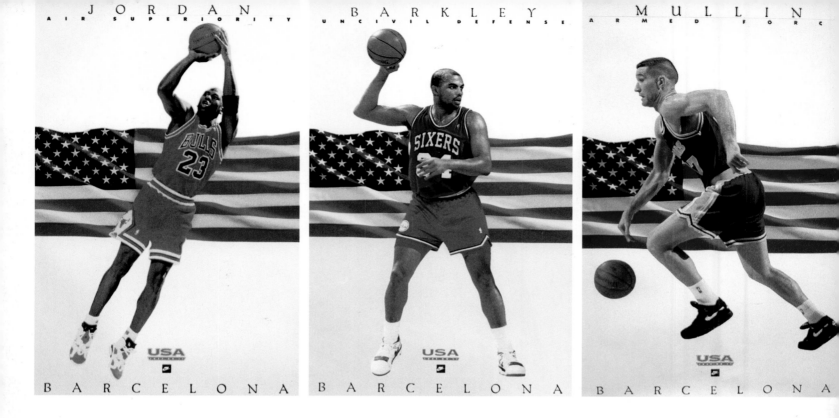

JORDAN
AIR SUPERIORITY

BARKLEY
UNCIVIL DEFENSE

MULLIN
ARMED FORC

Patriot Games II
The Ringers

The best squad ever assembled, right? Well, truth be told, on the first day during their first practice in their first scrimmage, they got beat. Score untold, unimportant. Just the fact that the greatest team in the world got upset by a bunch of college All-Americans spoke volumes, but nobody really knows this. That would be the last time anyone would come close to defeating the team dreams were made of. When Charles Barkley went to the bench in the second scrimmage and said (unofficially and off the record) that he would "personally kick everyone and anyone's ass" that didn't shut their man down, everything changed. By the time they had arrived in Spain, the word was out. The world knew, but wasn't prepared. Not for the onslaught. And among the "greatest team ever assembled"—the team that went 8-0 with a margin of victory somewhere around 30, the team that played two weeks without calling a single timeout—there was something else unknown. There was this un-hyped, drastically under-marketed fact that every player on the '92 squad had a signature shoe designed specifically for the Barcelona games that would never be released to the public. If we only knew. True, the animated commercial of Jordan, Pippen, Barkley, Stockton, Mullin and Robinson was ill, but they were

highlighting the player, not shoes. Hidden from the consumer was the fact that David Robinson had a superhightop, old-school Air Force shoe with the pump made only for him, or that Jordan wore the AJVII's in the patriotic colors that never came out, or that Pippen and Mullin had the same concept applied to their Air Flight Lites, or that John Stockton was actually playing in 007-like designed cross trainers. But the question is: was it important to know? Did the public have a right? Millions and millions of dollars are spent by us (fiends) on shoes that make us feel "exclusive." The first on the block concept is old, today's sneaker pimps want to be the first in every city and will drop major bank to be that. Had we ballers known (or paid closer attention) that there were sneaks out there unattainable, the pursuit to attain a pair of Jordan, Pippen, Barkley, Stockton, Mullin or Five-O exclusives would have overshadowed everything, even them winning the gold medal and changing international basketball forever. So the answer is, "yes." Yes, it was important and the public did at that time did have the right to know. Why? Because now we have Ebay.

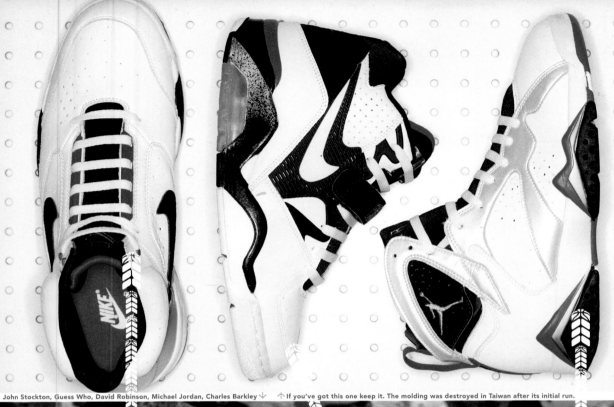
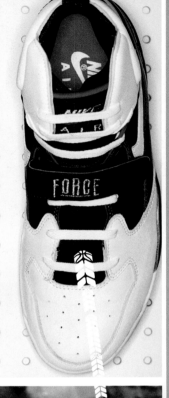

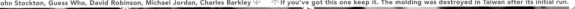

John Stockton, Guess Who, David Robinson, Michael Jordan, Charles Barkley ✦ ✦ If you've got this one keep it. The molding was destroyed in Taiwan after its initial run.

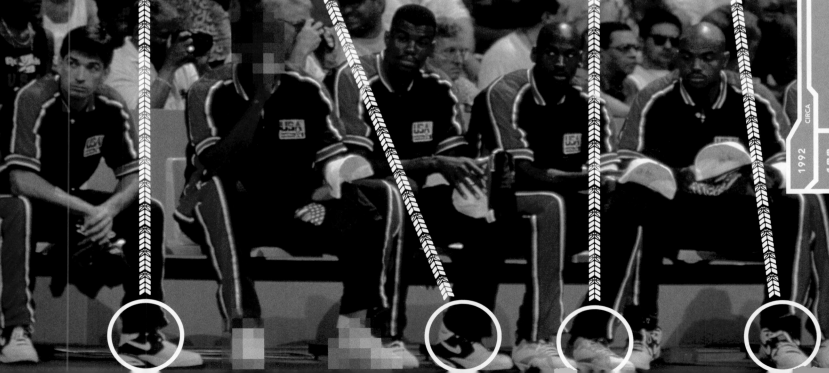

CIRCA 1992

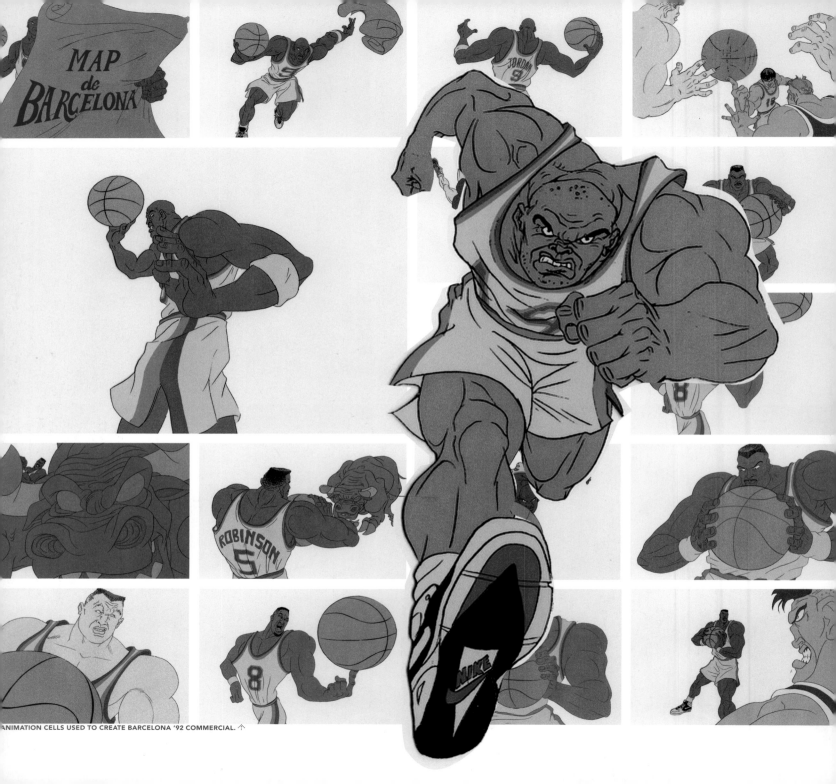

MAP de BARCELONA

ANIMATION CELLS USED TO CREATE BARCELONA '92 COMMERCIAL.

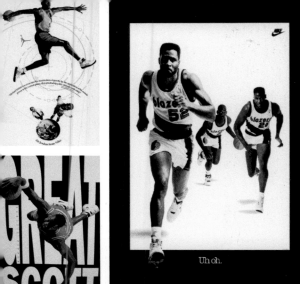

Uh oh.

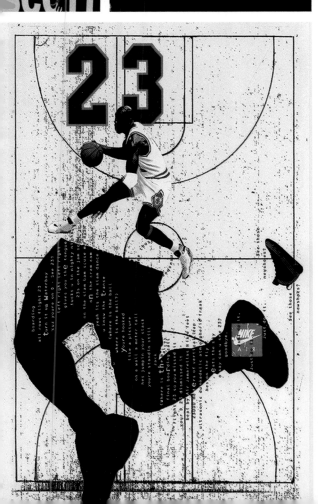

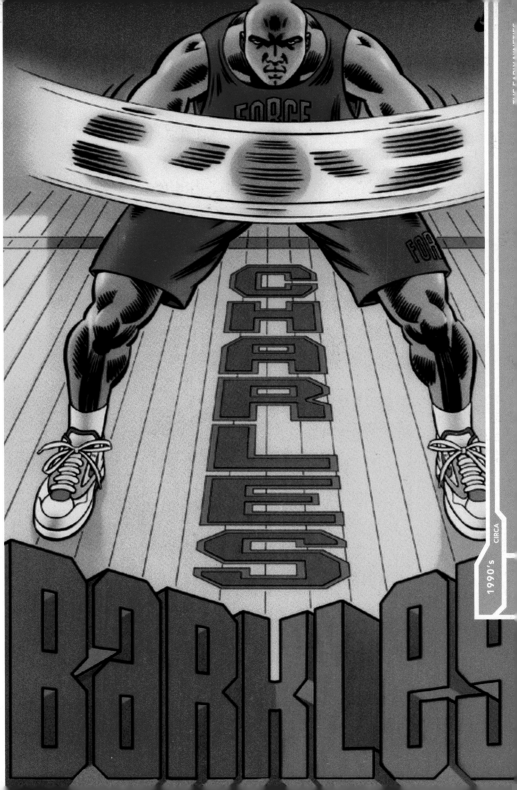

No short stoppin', takin' no shorts.

KNEE TO SHORTS
12 INCHES

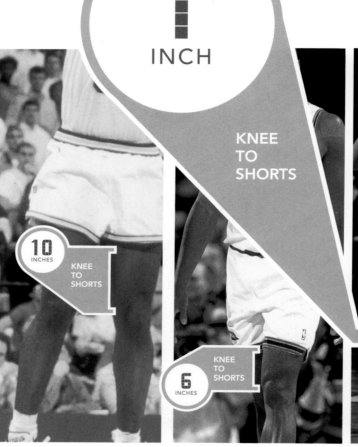

10 INCHES
KNEE TO SHORTS

1 INCH

KNEE TO SHORTS

6 INCHES
KNEE TO SHORTS

TEAM NIKE SPORTS **XL**

ENGINEERED TO THE EXACT SPECIFICATIONS OF CHAMPIONSHIP ATHLETES.

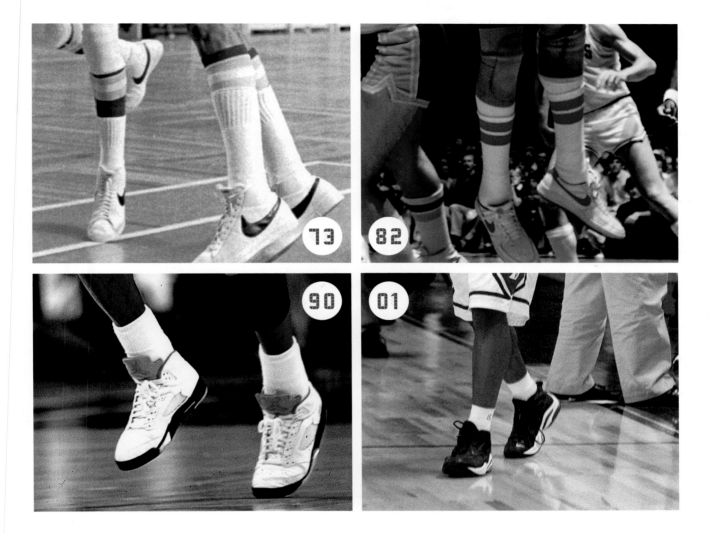

Bacndadaze when the cats wore short shorts and sported wavy waves. Back when Barkley and Jordan had hairlines. Back before there was limited edition sneakers, throwback jerseys and retro anythings. Back then, the way gear was rocked meant as much as the gear worn. Socks were (damn near) thigh high, shorts were called "nut crackers," knee pads and wrist bands covered wrists and knees respectively. Everything was so pure back then, so simple, so satin. Shiny were the suits that they gave them. Material, limited. But that's how folks was livin' back then. That was style. Today, after many transformations, alterations and innovations, fashion has come half-circle: wristbands came back in style but were worn on the forearm instead of the wrist (only to later be worn back on the wrists), headbands resurfaced, and socks

pulled up to the knees returned, but this time no stripes or colors. Shorts were the other 180, though. Comfort ruled everything 'round the way as long, baggy shorts along with loose, oversized tops and breathable mesh material replaced the ballerina look. 2X for the 5'8"ers. Hidden knees. Until the hierarchy put a stop to the madness, mandating industry rule 4081: all shorts 1" above the knee. Corporate heads just don't understand. You know, understand that the ball player look didn't go urban, ethnic, ghetto or thug, it just went casual. Shorts and socks: from short to long, from high to low. A natural transition. It's just the majority doesn't see it quite like that. And they probably never will.

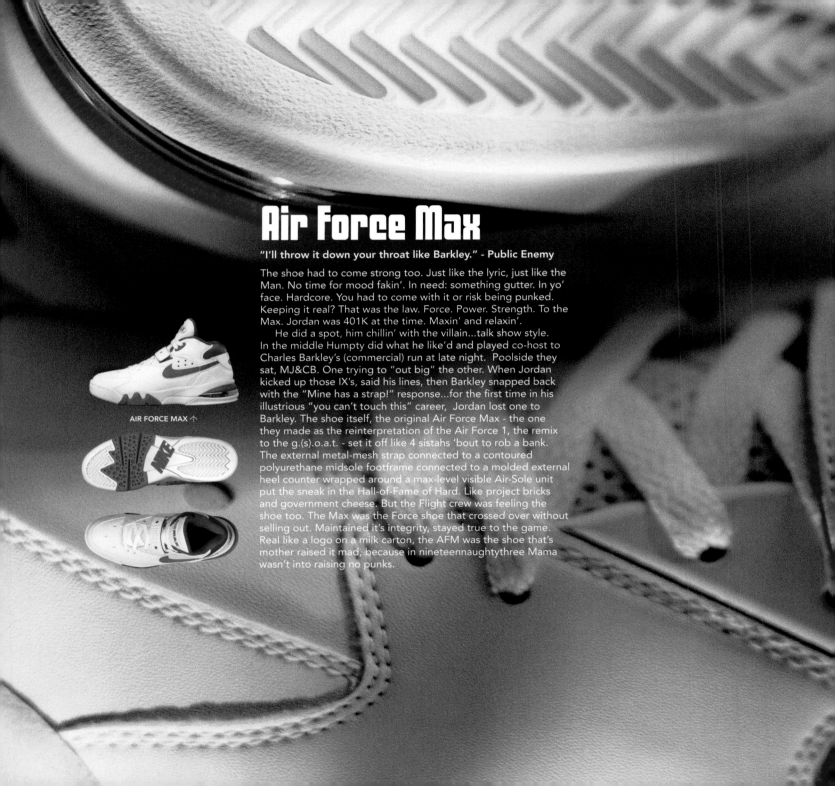

Air Force Max

"I'll throw it down your throat like Barkley." - Public Enemy

The shoe had to come strong too. Just like the lyric, just like the Man. No time for mood fakin'. In need: something gutter. In yo' face. Hardcore. You had to come with it or risk being punked. Keeping it real? That was the law. Force. Power. Strength. To the Max. Jordan was 401K at the time. Maxin' and relaxin'.

 He did a spot, him chillin' with the villain...talk show style. In the middle Humpty did what he like'd and played co-host to Charles Barkley's (commercial) run at late night. Poolside they sat, MJ&CB. One trying to "out big" the other. When Jordan kicked up those IX's, said his lines, then Barkley snapped back with the "Mine has a strap!" response...for the first time in his illustrious "you can't touch this" career, Jordan lost one to Barkley. The shoe itself, the original Air Force Max - the one they made as the reinterpretation of the Air Force 1, the remix to the g.(s).o.a.t. - set it off like 4 sistahs 'bout to rob a bank. The external metal-mesh strap connected to a contoured polyurethane midsole footframe connected to a molded external heel counter wrapped around a max-level visible Air-Sole unit put the sneak in the Hall-of-Fame of Hard. Like project bricks and government cheese. But the Flight crew was feeling the shoe too. The Max was the Force shoe that crossed over without selling out. Maintained it's integrity, stayed true to the game. Real like a logo on a milk carton, the AFM was the shoe that's mother raised it mad, because in nineteennaughtythree Mama wasn't into raising no punks.

AIR FORCE MAX ☖

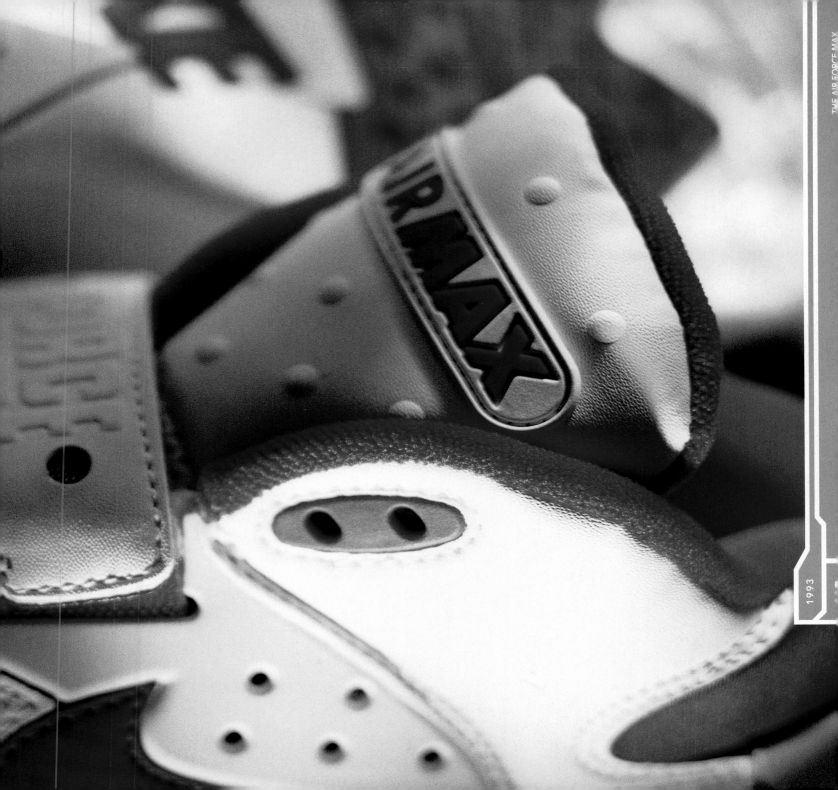

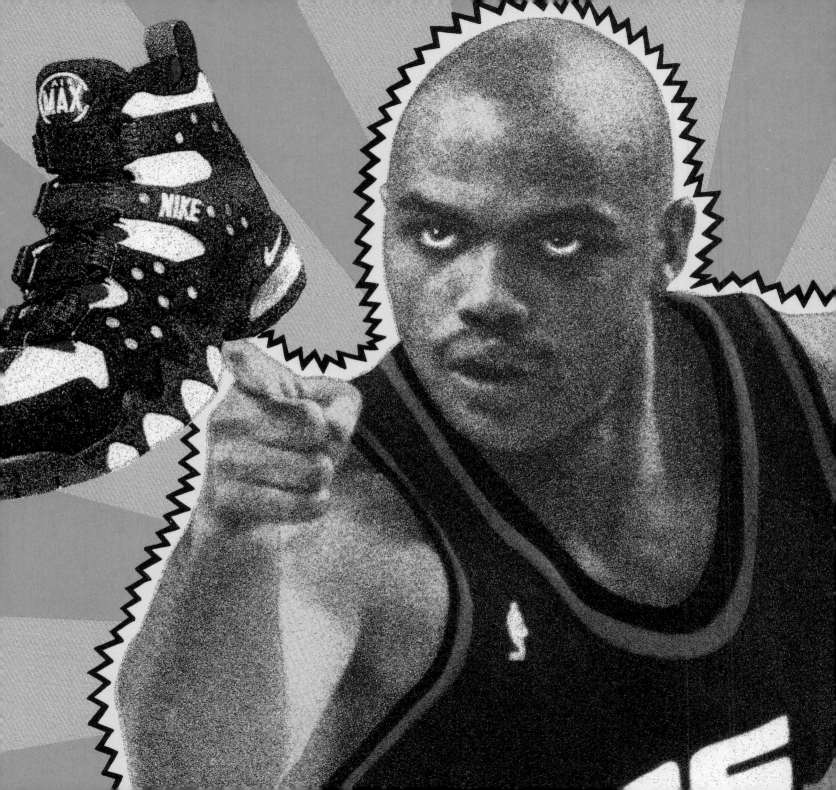

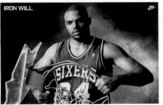

CHARLES BARKLEY POSTERS ⬆

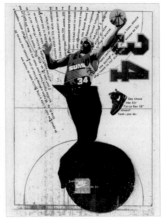

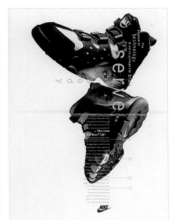

How do you market a madman ?
the Saga Continues . . .

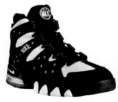

AIR MAX CB² ⬆

Even years later. Say "hi" (and goodbye) to the bad guy. The need for Barkley on Madison Ave. (aka: worldwide) was so subconsciously great it almost ended before it truly began. How do you market a madman? Sell insanity? It had taken years to figure out. Once Barkley moved from PHI to PHX, his true value would be pimped, in a good way. Almost immediately he exited the Force, going on his own midnight run. He battled an enormous, Tokyo-protecting, fire-breathing, goggle-wearin', post-up game-possessing lizard, he was given a talk show, he went to the NBA Finals, he won the MVP. The Air Max CB² was his first true solo joint. Drastic panel alignments equaling his personality, literally the shoe was strapped with a lace-locking system and a metal mesh-backed strapping support system giving it that psychiatric ward look, which also (according to some) fit his aura. It was also one of the first basketball shoes to exhibit the visible Air-Sole in the heel that would damn near become standard in all other b-ball kicks in the future. Sir Charles had changed the game with this one. Finally, he could leave his statement on the basketball world. And his statement was this: "I am not a role model." He told the truth, the truth got sold. And he was right. Because Charles Barkley was never a role model, instead he was an inspiration.

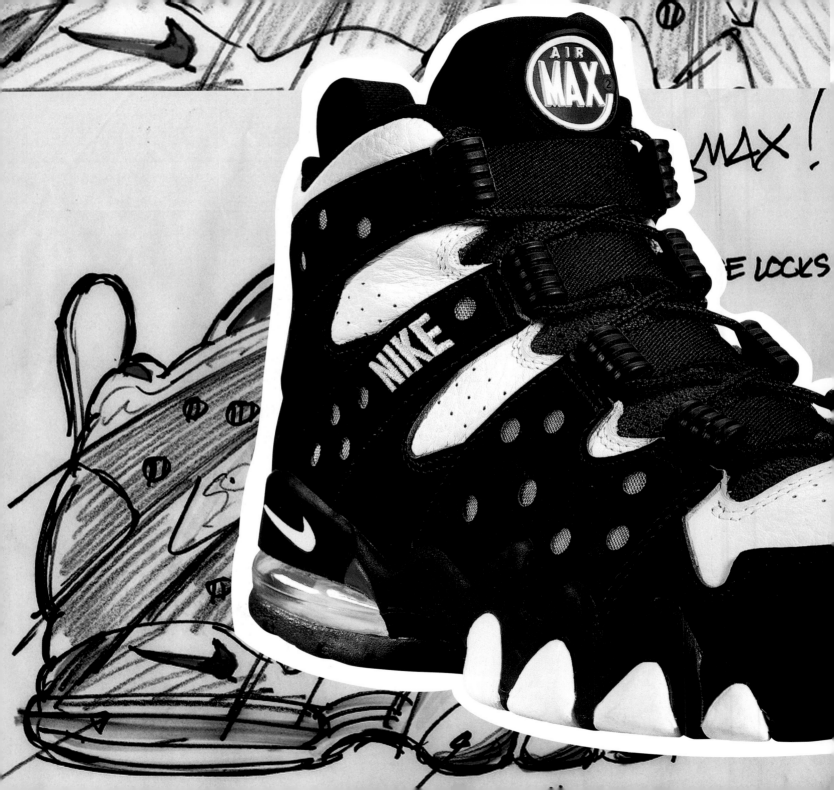

Air Barkley Max
Tech Package
Strobel / FT/PD
Steve Roth 5/28/93

✳ Patterns check ok however will have to change to Strobel.

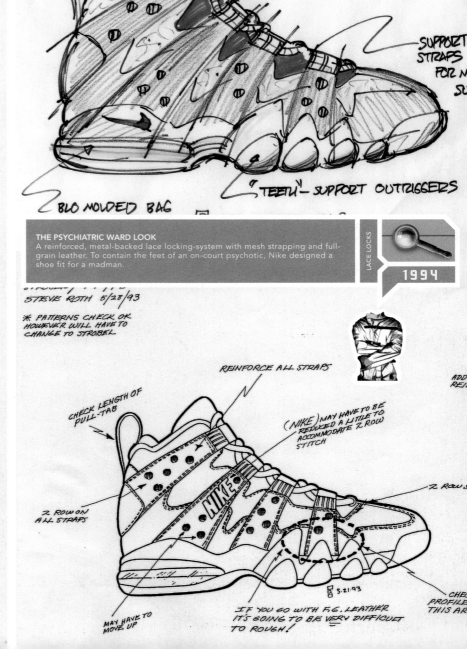

Ⓡ AIR BARKLEY MAX!

INDIVIDUAL LACE LOCKS

SUPPORT STRAPS FOR MID SUPP

"TEETH" - SUPPORT OUTRIGGERS

BLO MOLDED BAG

THE PSYCHIATRIC WARD LOOK
A reinforced, metal-backed lace locking-system with mesh strapping and full-grain leather. To contain the feet of an on-court psychotic, Nike designed a shoe fit for a madman.

LACE LOCKS

1994

STEVE ROTH 5/28/93

✳ PATTERNS CHECK OK HOWEVER WILL HAVE TO CHANGE TO STROBEL

REINFORCE ALL STRAPS

ADD THE REINFO.

CHECK LENGTH OF PULL-TAB

(NIKE) MAY HAVE TO BE REDUCED A LITTLE TO ACCOMMODATE 2 ROW STITCH

2 ROW S

Z ROW ON ALL STRAPS

MAY HAVE TO MOVE UP

IF YOU GO WITH F.G. LEATHER IT'S GOING TO BE VERY DIFFICULT TO ROUGH!

CHECK ALL MID PROFILE ESPECIA THIS AREA

5.21.93

CIRCA 1994

the Role Model

"I am not a role model"

00:00:01

SIR CHARLES:
"I AM NOT A ROLE MODEL, I'M NOT PAID TO BE A ROLE MODEL, I AM PAID TO WREAK HAVOC ON THE BASKETBALL COURT, PARENTS SHOULD BE ROLE MODELS, JUST BECAUSE I DUNK A BASKETBALL DOESN'T MEAN I SHOULD RAISE YOUR KIDS."

00:05:10

00:06:02

00:07:20

00:08:00

00:08:37

00:10:15

BARKLEY
00:11:13

00:12:45

00:17:05

00:22:10

00:25:45

JUST DO IT.

00:30:00

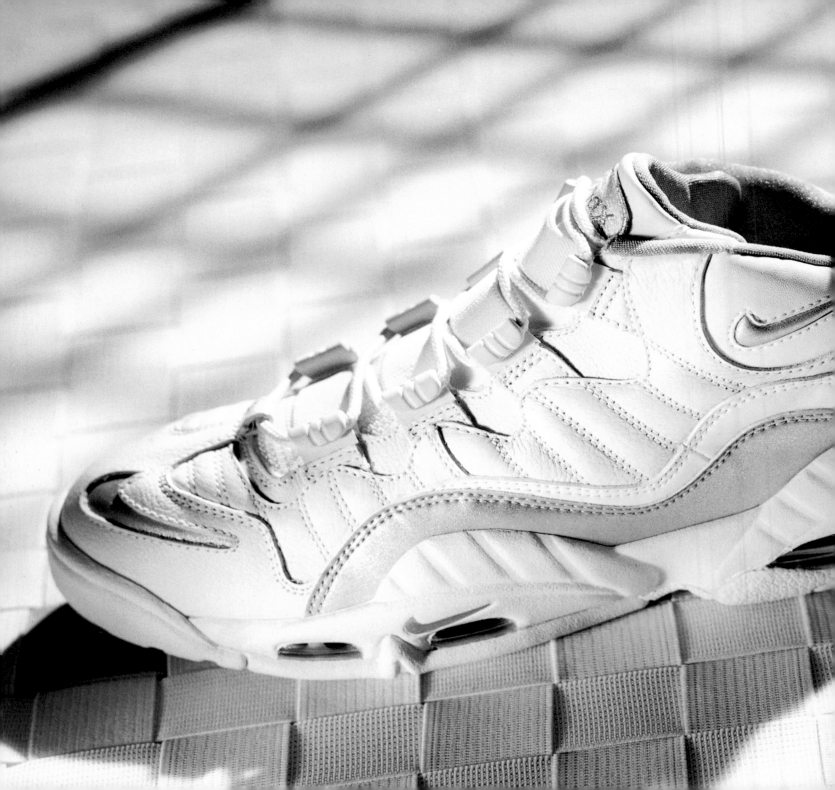

Discreet.
Quiet.
On the DL.

No one was expecting these. They, unlike any other basketball shoes of this time, came from out of nowhere. Discreet. Quiet. On the low end of the DL. The year they dropped, the experts thought there was too much competition. Not only was it the year of the Air Jordan X, but also the re-issue of the AJIs and IIs, along with the Air Max CB34, the Air Penny, the original Air Max Tempo (later named Uptempo), and the Air Flight One. All dropped that year, all were banging ball shoes, all were crazy popular. But when the smoke cleared and it came time to recognize, this shoe, the Air Max Sensation (originally dubbed the Air Max CW) did more than hold its own in the over-saturated market of supreme clientele, it shattered dreams of the others kicks that felt they were superior. They weren't. And although the shoe was never given a chance to live the life it deserves (legal reasons with the player it was originally signatured to and designed for) a limited edition reincarnation is what it has ultimately earned.

AIR MAX SENSATION ⚘

CIRCA

1995

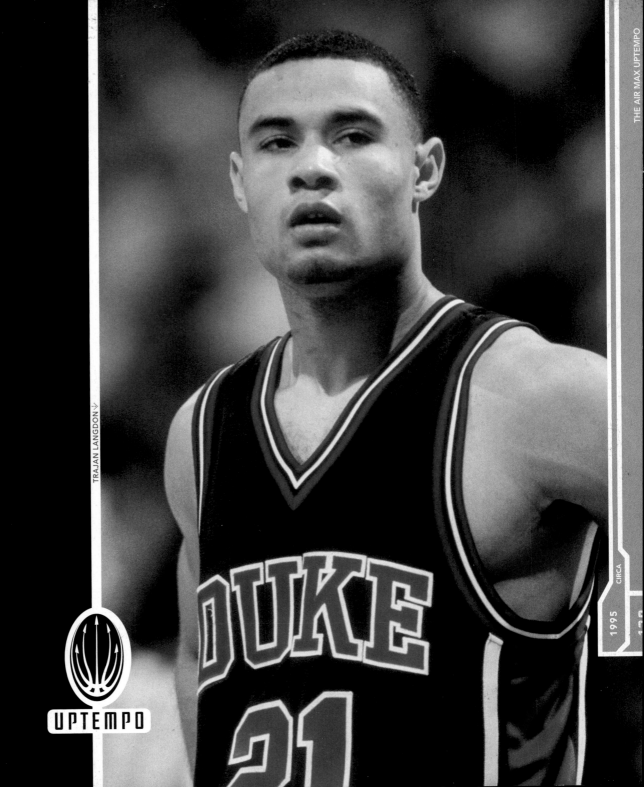

TRAJAN LANGDON

UPTEMPO

THE AIR MAX UPTEMPO

CIRCA 1995

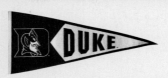

Air Max Uptempo

The devil made him do it.

Looking back, it's hard to believe that Duke was not a Nike school. It almost seems like they were part of the fam from the get...but that ain't so. In 1991 the school's b-ball program was on the verge of becoming not just a college basketball dynasty, but possibly this generation's version of the 60's Boston Celtics. They had a whip, every year. But urban university folklore is told that during the 1990 loss to UNLV for the crown Mike Krzyzewski was looking for a change. And while everyone was thinking something else, Krzyzewski was thinking something *extra*. A few years went by and the course inevitability ran through North Carolina like blue DNA. The Air Max Uptempo was birthed and like seeing his first grandchild (or Elton Brand in high school), Coach K fell in love. So he did what the slogan suggested: He just did it. Winning not only a couple of more championships, but becoming more powerful than their rivals across the way. Now conventional wisdom and conspiracy theorists believe that there's something more to this story, that a shoe alone could not have made Coach K flip shoe contracts for his entire program. Those same people who "believe" different are the same ones who've never tried on (or played ball in) a pair of the only pre-2000 un-retro basketball shoe the pros swear by. They don't know the power the Uptempo got or the power Duke gained. They just don't know.

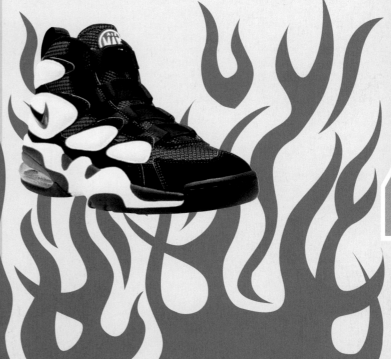

Mike Krzyzewski

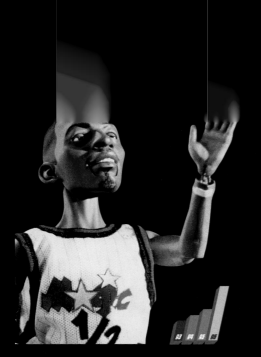

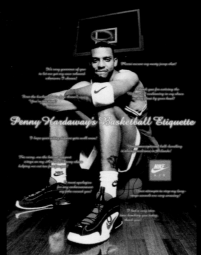

Penny Hardaway's Basketball Etiquette

The future is here

Net Prophet

The next Jordan he was crowned. Early. He had game so much that by himself he was a starting 5. He was good, very good. He was handsome, very handsome. Smoove, soft-spoken, nice smile, well-dressed and manicured. Humble. Grandma had raised him right. Perfect. But accolades have no consciousness. With bullet in foot, he traveled. Traveled into the upper echelon of hoopdom instantly. All-NBA first team, two years in a row. The next Jor..., dare say. Anyway, with the introduction of Anfernee Hardaway's signature shoe the alternative—but not opposite—of the Jordan shoe line's stage was set: Contrasting duel rubber-over-leather panel schemes (similar to the Air Way Up) with an un-linear, semi-circular line structure and see-through heel with the 1Cent logo on the back. It was a combination of controlled madness, organized confusion, and self-contained creativity. According to Kris Aman, Nike Basketball Product Guru, the shoe is beyond dope, it's "legendary." Everything Penny was on the court was displayed in that shoe. It was all so not-Jordan. It was to be the start of another legacy.

NET PROFIT

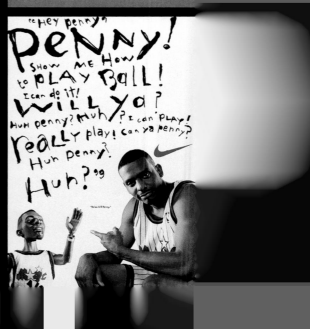

"Hey penny"
PENNY!
SHOW ME HOW
to PLAY BALL!
I can do it!
WILL ya?
Huh penny? Huh? I can PLAY!
reALLY play! can ya penny?
Huh penny?
Huh?"

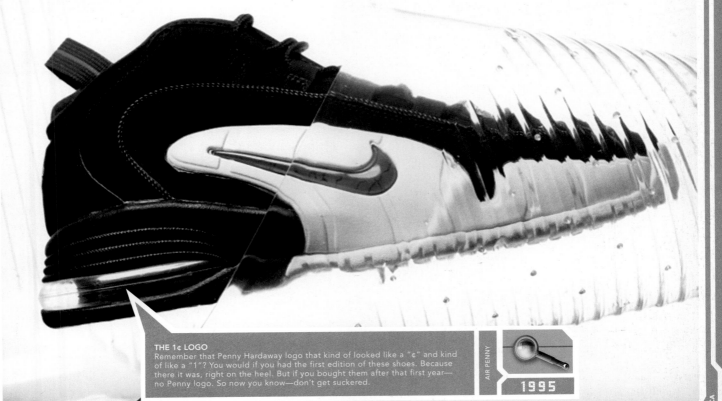

THE 1¢ LOGO
Remember that Penny Hardaway logo that kind of looked like a "¢" and kind of like a "1"? You would if you had the first edition of these shoes. Because there it was, right on the heel. But if you bought them after that first year—no Penny logo. So now you know—don't get suckered.

AIR PENNY

1995

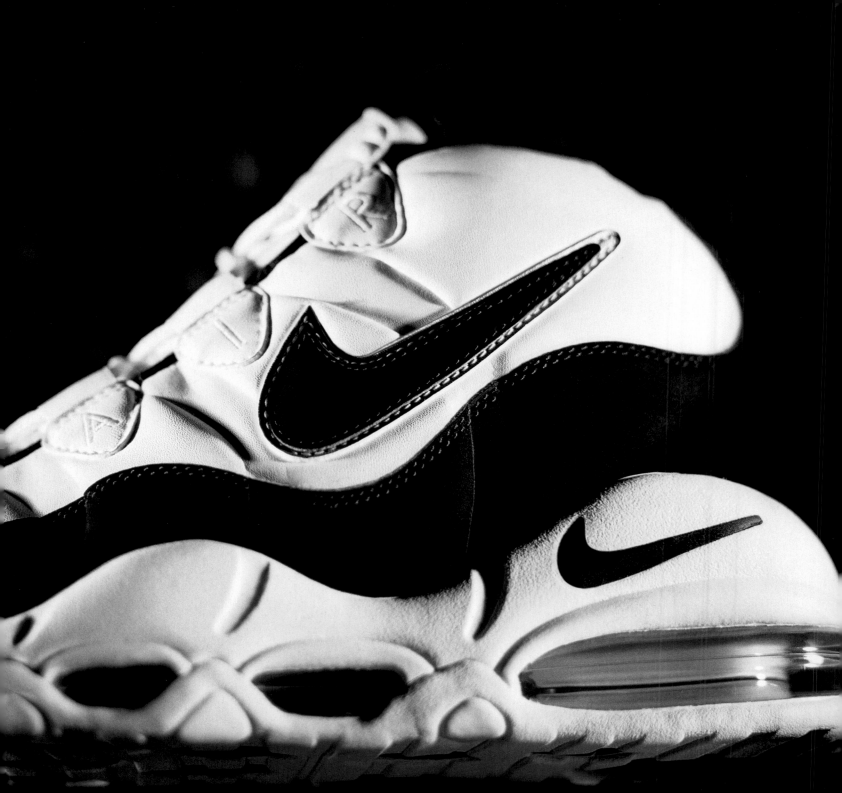

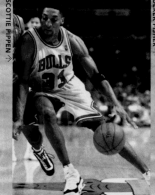

SCOTTIE PIPPEN

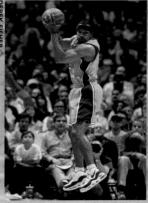

DEREK FISHER

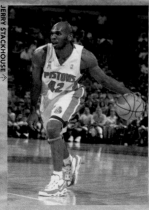

JERRY STACKHOUSE

AIR MAX UPTEMPO ⬆

Save the Earth

One Court at a Time.

Ever heard of a man's man? A comic's comedian? A player's player? Well, this, the Air Max Uptempo, is a basketball shoe's shoe. Ask around the L, ask anyone. Ask at the parks, at AAU games, in the alleys where basketball is played on coat hangers; ask in the rec leagues, the biddy leagues, the 6'-under leagues, the 40 & over leagues; ask at the Big Man camps, the rookie orientations, the hoop summits and free agent workouts; ask Scottie Pippen, Derek Fisher, Jerry Stackhouse. Just ask. Their words will all match: Lace-for-lace, sole-for-sole, air cushion-for-air cushion this might be the greatest on-court shoe ever made to play basketball in. As the ad said when the shoe came out, "(It) will save the earth... one court at a time." It's nice to know that the people at Nike weren't lying.

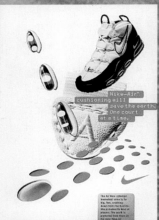

PRINT AD ⬆

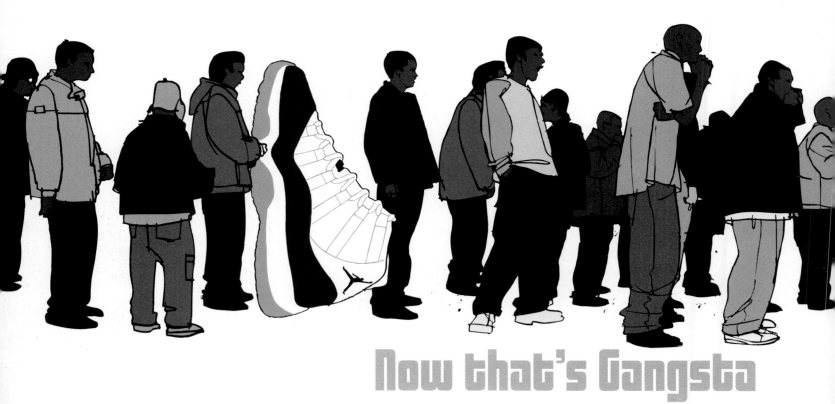

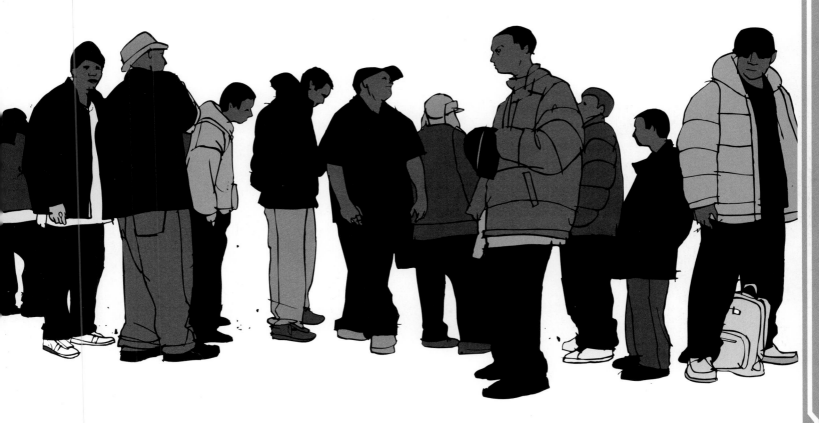

THE AIR JORDAN

XI

So you wanna be gangsta? Funny how this shoe's design was inspired; drafted by the spats worn in Hollywood. Bumpy, Bugsy, Lucky. Tommy guns and running boards. Grapefruits in the face. See. Happy Saint Valentine's Day. For 10 years the phenomenon of Michael Jordan's shoes and their release dates were one of the unexplainable forces in American psychology. Millions would leave the shelves only weeks after they dropped into stores. Retail managers would turn over paychecks (sometimes 3 times the cost of the shoe) in order to be able to wear the shoe two days before anyone else; big city ballers would take the "being first with the new Jordans" to new illegal levels that will not appear in this book; pro ball players as kids (Vin Baker) would sacrifice trips to Hawaii to play in games for a pair of the most recents; even Jay-Z needed his fix: (circa: 1998) (He) repeatedly asks his product manager, "Why aren't the Jordans in my hotel?" He wants these kicks.

Moments later, a cell phone appears, a Nike rep on the other end. "Why don't I have the new Jordans?" Jigga quizzes. A pause, then, "You know, there are a lot of words that rhyme with Reebok." Everyone addicted. But the hysteria had gotten out of hand by the time the XI hit. Unnecessary real-life drama. Young'ns sticking each other up. All over every state, county, city or town; all over the shoes. Priorities got severely twisted and soon the supply couldn't meet the demand. Thousands stand in line on release dates only to see days later those same shoes dangling from the city streetlights. It was sad. Too bad that life sometimes comes too close to imitating art.

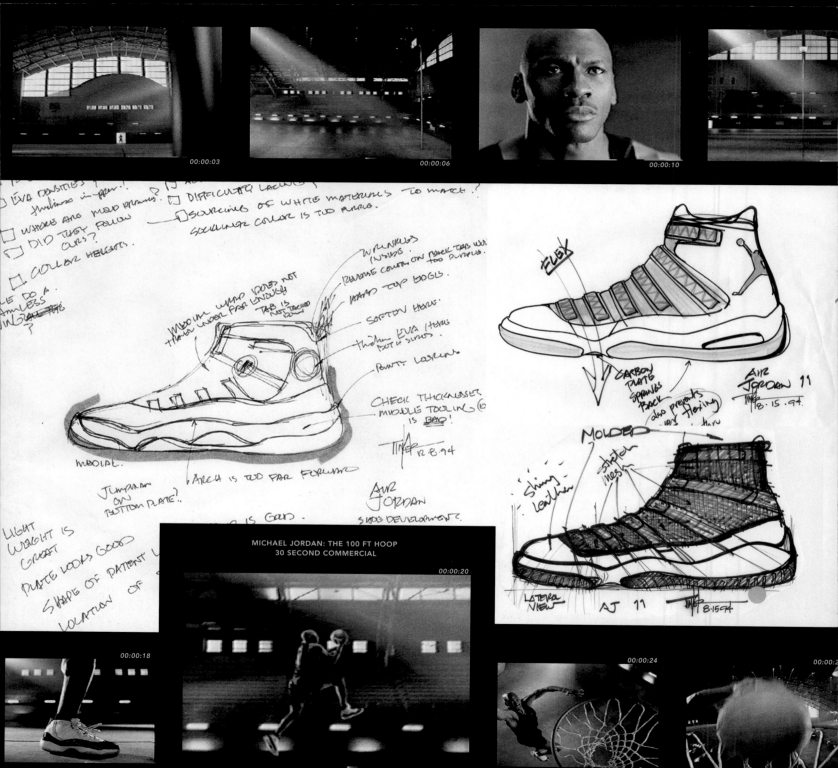

00:00:13

00:00:15

00:00:16

THE AIR JORDAN SOCK

The initial design inspiration for the Air Jordan XI was...a sock. This completely lace less design was meant to provide a custom fit with maximum comfort. Custom, high-tech fasteners were created to provide stability and lock in the foot. This all changed when MJ provided the input to use patent leather. He thought it would be cool to introduce a sophisticated hoop shoe that could be worn with a tux.

SPATS

1996

MIDSOLE.
SCULPT
LINE
IS WAY OFF.

00:00:30

CIRCA

1996 1|11

00:00:26

JUST DO IT.

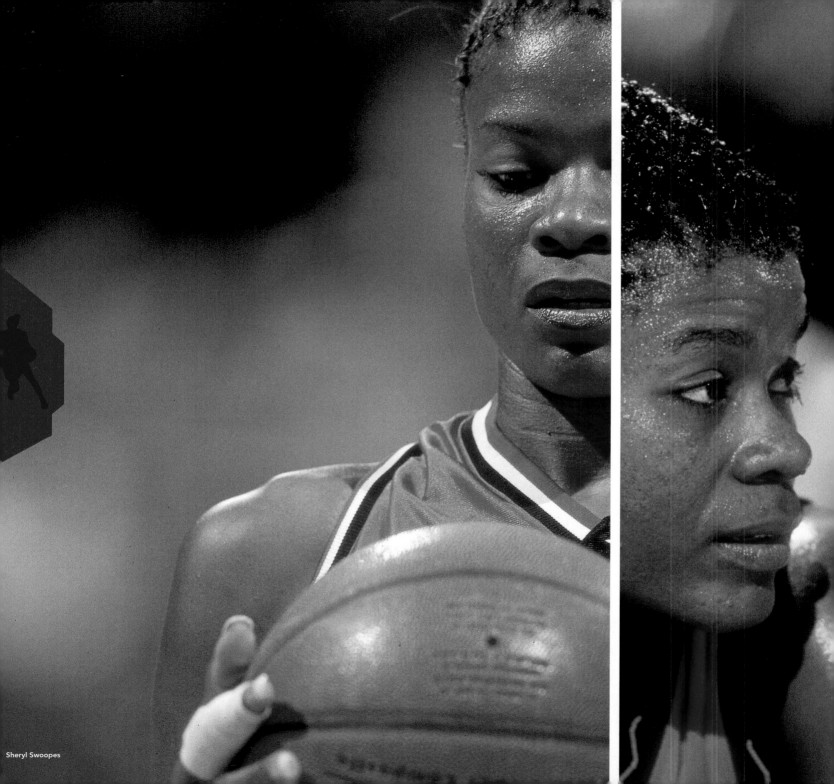

Sheryl Swoopes

Chivalry is dead.

It was bound to happen. Whenever someone—man or woman, male or female, baller or ballette—drops 47 in a championship game (Sheryl Swoopes NCAA champion-ship 1993) and that team wins that game by only 2 points, as a shoe company you got to put the pitch together instantly. Get her before the others peep her game. Around April of 1993 that was the situation. But Sheryl Swoopes, the one they were calling "Michelle Jordan," was out of the game. She straight was not hoopin' because she had nowhere to hoop. So she became the best b-ballin' bank teller in Texas basketball history. Then in 1996, on the heels (get it?) of the success of the Woman's National Team's 60-0 record and their performance in the ATL games, the WNBA was formed and that 3-year old pitch from said shoe company was Randy Johnson'd. The result—the original Air Swoopes, the first basketball shoe named after a female. Other female players had been overlooked; others may have been better, but like any great cultural pioneer, the timing was just as accurate as the in-dividual. Plus, the skills were unarguable. For four years she played Scottie Pippen to Cynthia Cooper's MJ in Houston, never not winning a championship. Every year had a new Air Swoopes. Young girls had their shero. And for the haters over those years who tried to deny her impact and importance, Swoopes never directed anyone to her shoes; instead she offered them a chance to read the charm hanging from her necklace. It read: Try God. She did, and that's why she's in this book.

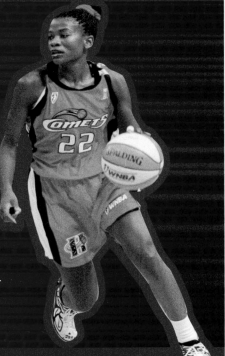

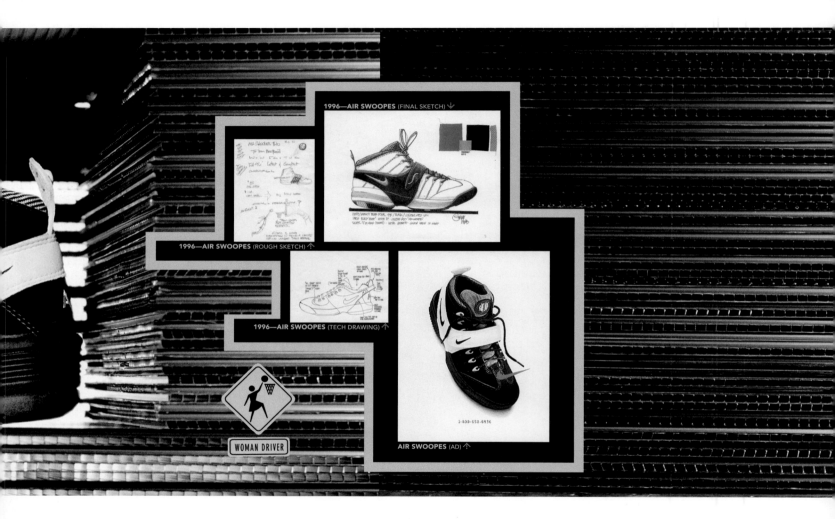

1996—AIR SWOOPES (FINAL SKETCH)

1996—AIR SWOOPES (ROUGH SKETCH)

1996—AIR SWOOPES (TECH DRAWING)

WOMAN DRIVER

AIR SWOOPES (AD)

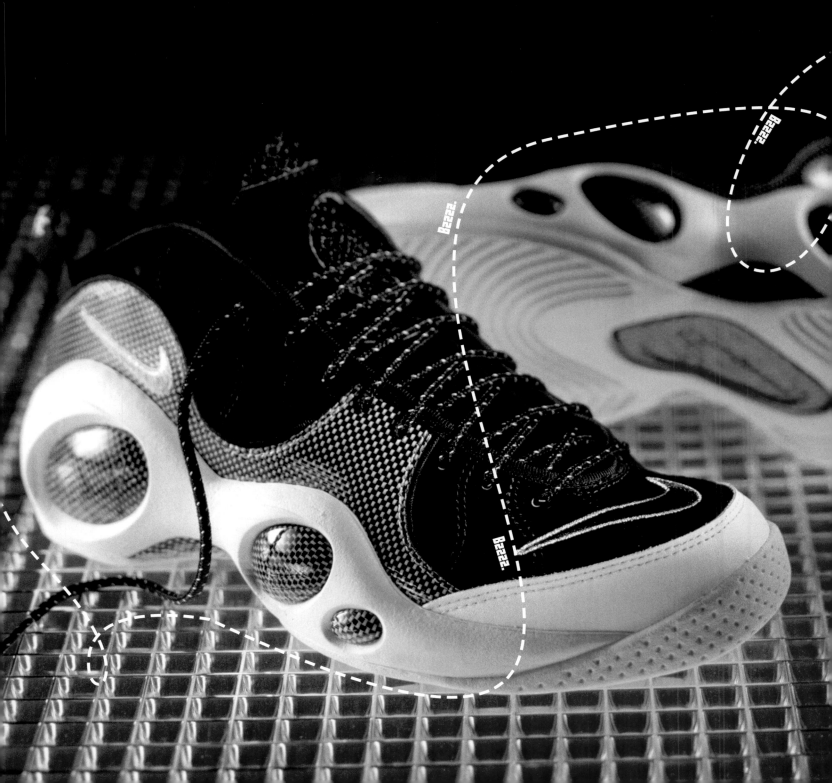

Air Zoom Flight
Bzzzz! Zoom! Bam!

Bzzzz. Like a fly. Seth Brundle. Eyes bulging out. **Bzzzz.** At first glance, they bugged you out. Get it? Aliens. ATLiens. Southernplayalisticcaddylacshoes. Pods. Eyes in the back of your heels. Here's looking at you, son. An eye for an I. **Bzzzz.** Hold up, maybe it's deeper than that. Maybe there was a purpose to the design, something more than just aesthetics. Was there a superior function in comfort and movement, an advance in technology? Designers were asked, Beltway answers given. **Bzzzz.** They, the "scientists," heard that a basketball player straight outta Oakland (Alameda to be exact) was about to fly past all of the league's existing point guards into future MVP status. Not really ready to give him his own "signature" shoe because he'd only been in the pro game two years, there needed to be something attached to this kid without making him an "elite" athlete. Ideas started **buzzing** around the lab. These "scientists" discovered through research that kid was a sneaker fiend, he'd wear anything. Eliminating the hypothesis of him wearing the shoe. They put them on his feet. Soon, you'd see them on the streets, in high school hallways and neighborhood malls. Looking at you every step of their way. Rollin' down strips on vogues. No one called this creature by its name: "Them bugged out" kicks is all the public knew. "Can I get those new bugged out joints, yo? You know, them ugly ones that look like insects. Them ones Jason Kidd be sportin." **Bzzzz.** The next thing you know, a year after the invasion, one of the most prestigious car manufacturers in the world starts changing the look of its new series of rides. Bubble eyed. **Bzzzz**-Class. Coincidence? Um. The insect look was in, beyond fad. Six years later two significant things would happen: 1) a basketball team from Roswell, New Mexico would out-of-nowhere appear on television screens with an insect as its mascot. They'd shox the world. 2) Hollywood would release a blockbuster movie about a guy who when bitten by a spider became a superhero. Now ain't that fly? **Bzzzz.**

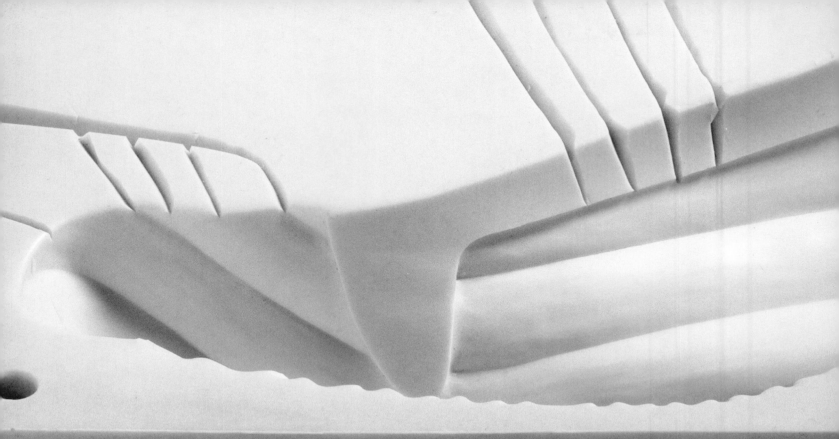

Liquid Sole

Everyone said that it couldn't be done. The people at Nike, the people in the research lab, the people at the factory, to a man (and woman) they all said it was impossible. This idea of having the upper, the mid and the outsole of a shoe all integrated by pouring a synthetic liquid into a mold was insane. "Some went so far to say that it would kill the footwear industry," Jeff Johnson said. First was the cost. Mad expensive (average cost: $750,000 per mold). Second was getting the right strength and stretch of material. Third was the construction. While old school shoes were made by cobblers with hammers and nails, and recent shoes are either cooked (auto clave) or stitched (cup sole) off of lasts, in order to implement the Foamposite formula the mold to the midsole had to be five-times as high as the regular mold of a basketball shoe. Plus, in Asia where most of the shoes were made, there was no company that had the fabric to three-dimensionalize the idea. In other words, the concept had issues. But then Daewoo (yeah, the same one that manufactures cars and stereo systems) came through. They were the only vendor in the world able to create the unique blend of synthetic liquid and textile that was strong enough and could expand enough to sustain the wherewithal of the damage a 6'5"

220lb ball player can cause in 48 minutes, 82 times a year. And once done, heads spun. No one had ever seen or played in anything like it. And although the Foamposite process is different than the advanced Flightposite process ("less sloppy in molding and fit"), it is so far advanced that even people that have worked on the project for years at Nike are still amazed. "The Foamposite process is always the biggest draw when people visit the factory," Johnson says of the idea he claimed to fame. "Usually when shoes get made you see a lot of stitching, but not with the Foamposite, (the process of) attaching the outsole of a shoe to liquid is something that's never been done before. And we're secure that no one will ever figure out how to make this shoe." Which is why he is saying no more about it. Reach your own conclusions, they'll all be wrong. Because developing an aerodynamically efficient shoe, a linear sneaker, and one that takes maybe the closest form to the actual foot than any basketball shoe ever made, is impossible. Remember? A shoe made out of liquid. On the three-quarter-million-dollar mold. A process that they said could never be done. Be glad, for those smart enough to own some 'Posites, that never didn't mean forever.

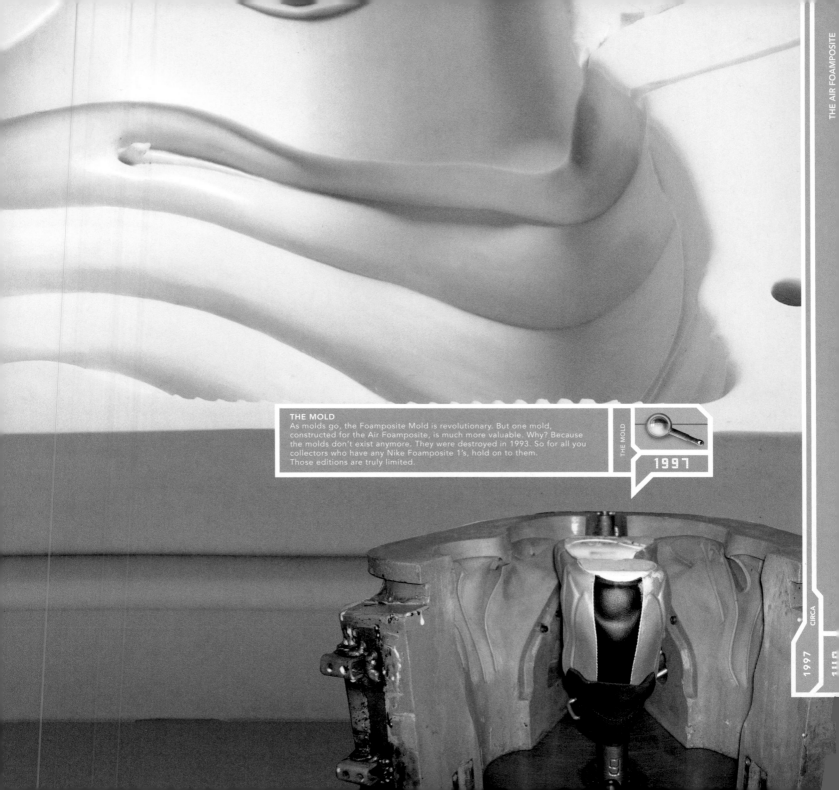

THE MOLD
As molds go, the Foamposite Mold is revolutionary. But one mold, constructed for the Air Foamposite, is much more valuable. Why? Because the molds don't exist anymore. They were destroyed in 1993. So for all you collectors who have any Nike Foamposite 1's, hold on to them. Those editions are truly limited.

THE MOLD

1997

CIRCA

1997

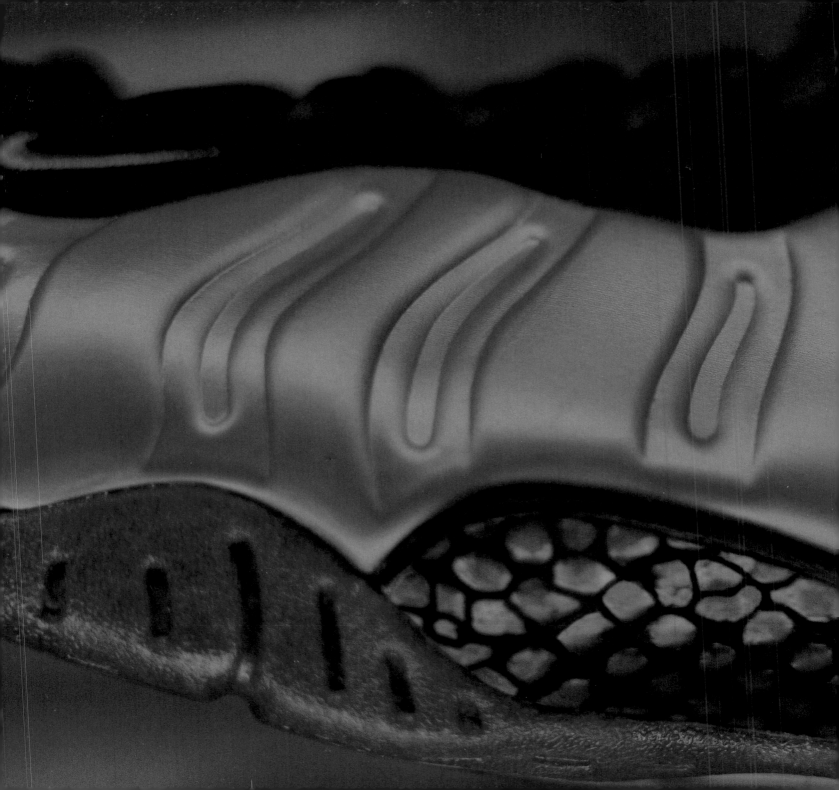

What's in the bag #!✱?, laughing at you?

THERE IT'S NOT. THERE IT IS
You probably remember the first time you saw it. Most do. And it didn't look like this, did it? That's right: No Swoosh. Just a blue shoe, unlike any blue shoe you'd seen before. But after that first season, we added something to make it look a little more familiar—and now you know.

1997

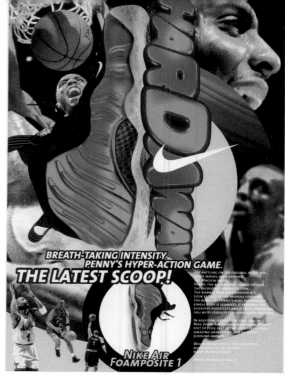

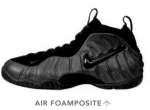

AIR FOAMPOSITE ⚞

The Air Foamposite

That bag. The one mentioned earlier. See on that day, at his house, Penny Hardaway was being shown different designs for different shoes Eric Avar had done for him to personalize. Several different versions of Air Penny: The Sequel. All placed on a table for Penny to explore. His approval, mandatory. But there was this bag just lying off to the side, and inside of this bag was an idea the designers had no idea what to do with. They were into pushing different designs and crazy elements of style, but what was inside of the bag was too far out there. Inside of the bag was the X-files of gym shoes. "So what's in there?" Penny asked. "Oh, nothing," they replied. So Penny looked. Reached. And pulled out something Mulder and Scully would investigate. Penny's eyes got big. "This is what I want!" he said out loud. And that would be what he would have. For he was the first to bless the public with this "hideous" new look. Some would say the shoes looked like the morphing of a roach and a beetle. But soon the insect association would stop after, not just Penny began dropping 40-point games on the regular, but when the University of Arizona led by freshman Mike Bibby won the national championship in those strategically placed "Agent J & Agent K kicks." Like the man who interrupted his own "next Jordan" shoe line to put these "bugged-out blue shoes" on his feet, the Foamposite was ahead of its time. The world just wasn't ready. Who knew an ugly blue shoe would be so, so...beautiful.

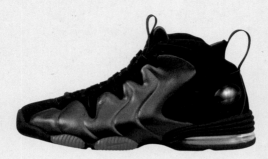

AIR PENNY III ⬆

Can you do that for a brotha?

When the Air Penny III came out, Lil' Penny was H.P.I.C. He was throwing parties whenever Big Penny went on road games, chillin' with supermodel Tyra Banks, and on his off days he was making the john blaze commercials that had the world doubled over like shrimp. Retired now, still maxin' and relaxin' in his retro limited edition AP IIIs, we caught up with LP to reflect on a life that once was.

Q. L, when did you know Penny was going to be a star?

A. Probably once we got to 9th grade. I always knew Penny could play, but in the 9th grade, recruiters started sending letters, reporters started coming to games, you know the story. But I always thought Penny would be a famous lawyer, because when we were kids, you could not beat Penny at a game of Clue. Colonel Mustard did not have a chance against Penny. Maybe after he retires, he'll pursue a career in the law.

TYRA BANKS/LIL' PENNY "BUSY SIGNAL" (00:30/COMMERCIAL) ⬆

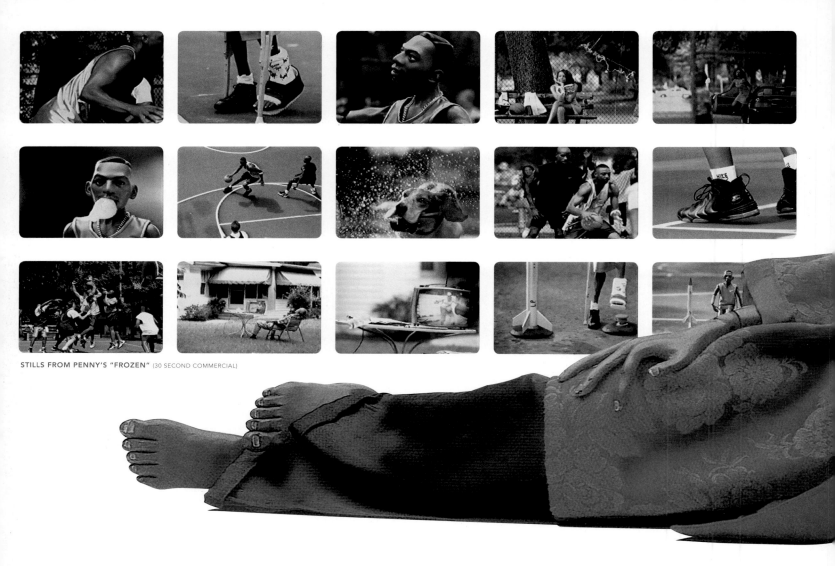

STILLS FROM PENNY'S "FROZEN" (30 SECOND COMMERCIAL)

Q. Did you ever think he'd have his own shoe?

A. We used to talk about it. But then again, we used to talk about all kinds of dreams. I always wanted Penny to have his own line of socks. A lot of players get shoes named after them, but how many get socks? Penny's agents shot the idea down, but I still think my socks idea had merit.

Q. Do you think his shoes will be bigger than Jordan's?

A. (Looking down at his size 5 replica APIIIs) Bigger than Money's? Come on,

Penny's shoes, like the ones I got on, are good, but the Air Jordan is a classic for all time. The last time I was in Japan, I saw some vintage Jordans at a store near the hotel. First year, still in the box. Pristine condition. They were nice. Cat wanted 3,000 dollars for them.

Q: $3G's?

A: 3,000 dollars! 3,000 dollars! People in Japan are crazy.

Q. I read that Mars Blackmon said he would smash you in a one-on-one.

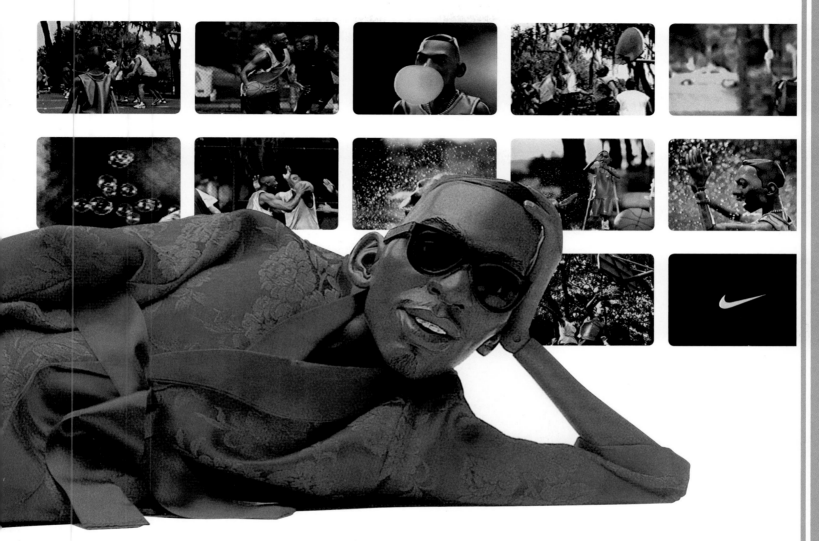

A. Yeah, Mars likes to talk. We had it all lined up in '96, to go one-on-one at halftime of a Magic-Knicks game in the Garden, but Mars never showed up, claimed he had food poisoning. If you're reading this book Blackmon, I'm still ready, and this time, stay away from the pork dumplings.

Q. Whatever happened with you and Tyra Banks?

A. Well Tyra and I don't really talk much these days. I mainly talk with her lawyers. We were at the point in our relationship when we needed to either get married or never see each other again, so I took her out to dinner in LA,

and after dessert I held her hand and I said, 'Tyra, this celebrity life is just too hectic. I've been asked to run a Foot Locker back in Memphis, and I want you to move there with me and be my wife.' Tyra excused herself to go the ladies' room, and I haven't seen her since.

Q. So when is Nike going to come out with a pair of wooden Air Lil' Penny's?

A. That's really funny. Really funny. You should have a comedy show. The last time I wore wooden shoes, Penny and I were doing a promotional tour in Holland, and I got calluses on my arches the size of bottle caps.

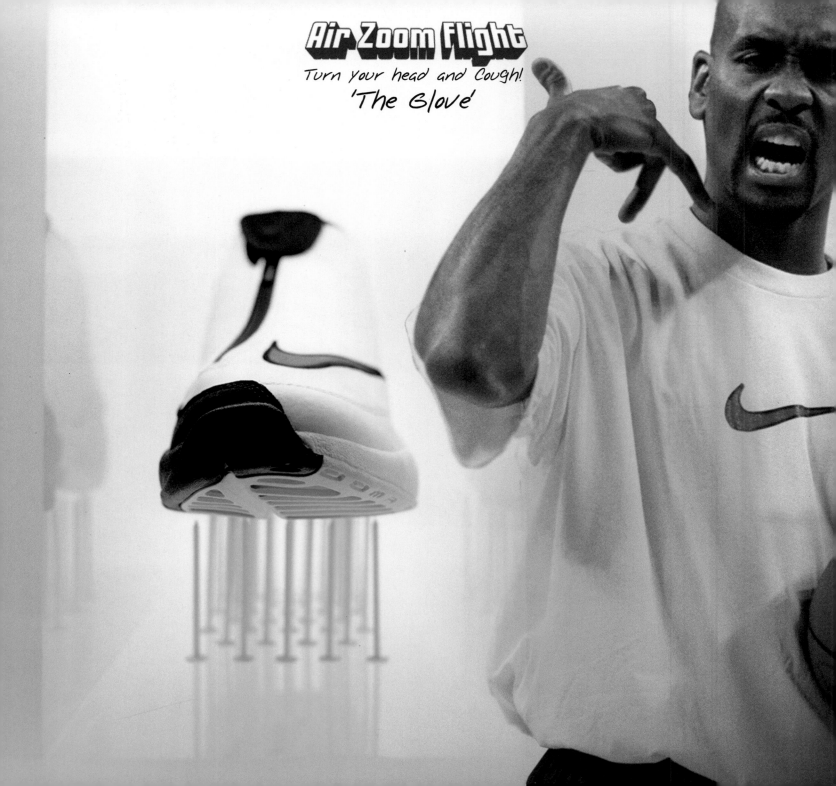

G.P.

Behold what many consider sacred, your shoes.
A treasure providing pleasure for all that have passion in their sole
The way you take the ball to the hole
watch defenders unfold, something to behold
Ignorant ones say 'n you old
best pg in the game let the truth be told
never have you sold- out
took Seattle out of a drought
replaced rain with reign
instant fame.
Came
when you opened your mouth
and let those non-Oakland cowards know what you was talkin' about
who else got that clout?
If you were an album, Reasonable Doubt

nobody owns ya
one of the most beautifullest things in the world is to watch you ball
in the fall, winter and the spring
game a single bling
no floss, no need to hear the word twice. still you remain
ice. Diamond in a League filled with cubic zirconia
If you had an album, the title: Gloveonia
blew past Steve Nash, he caught pneumonia
Welcome to Soo's Property. GP, shortenized.
Not enough recognize
Basketball controls your soul. Revolutionize.

Return grown men to childhood on hardwood
it's all good
Jordan got the rings but he ain't rep the hood. not like you.
Too true. Too real. Too ethnic.
Shoulda been in Freestyle, gotta few tricks
mouth runnin' round the matrix
25 & 366
No MVP trophy? The whole game's fixed.
Can't understand your style of play
not used to ballers from the Yey
JR. JK. Hook mitch.
no one's bitch.
no one's God, no one's savior
media hates your behavior
too black for politically correct eyes. despise.
remember what Mr. Mean taught: You, son, will rise.

the greatest thing since sliced cornbread
unstoppable with ideas inside your head.
antics colorful like Nike fleece
jumper. strange release.
result. points increase
ex-cop of the Fun Police
still having fun
2 years in the same uni, seems like you just begun
like every urban hero, unsung
too smoove to dunk, too ghetto to stay quiet
one man riot, can't deny it
but that's what separates you from the rest
while other guards flunk, you ace the test
set of the curve
haters hate. the nerve.
Pound-for-pound, the Roy Jones, Jr. of the NBA.
as long as you in the L, it's gonna be that way
e'ryday. and e'ry night
the game you hold. Zoom Flight tight.

marquee for the company of swoosh
pull out victories like Bush
court savvy. always aware.
high ball IQ. the truth and the dare.
wiser. more focused. more hungry to prove
that you're in a class with one student
all by yourself. with nothing else
to learn
still the Baron Davis' yearn
the to be like you
No. 20.
the best-
in the West-
since Buck left.
brought the heat of the concrete to the fans in the seats
the chain nets. the iron rims. unique.
wifey Monique
every now and then at Mosswood you wanna "run it back"
Repeat.
predict and still score 30
never made a promise you couldn't keep.
zippers on shoes. beyond sweet.
the League's baby Barkley. Don't agree? Check his feet.

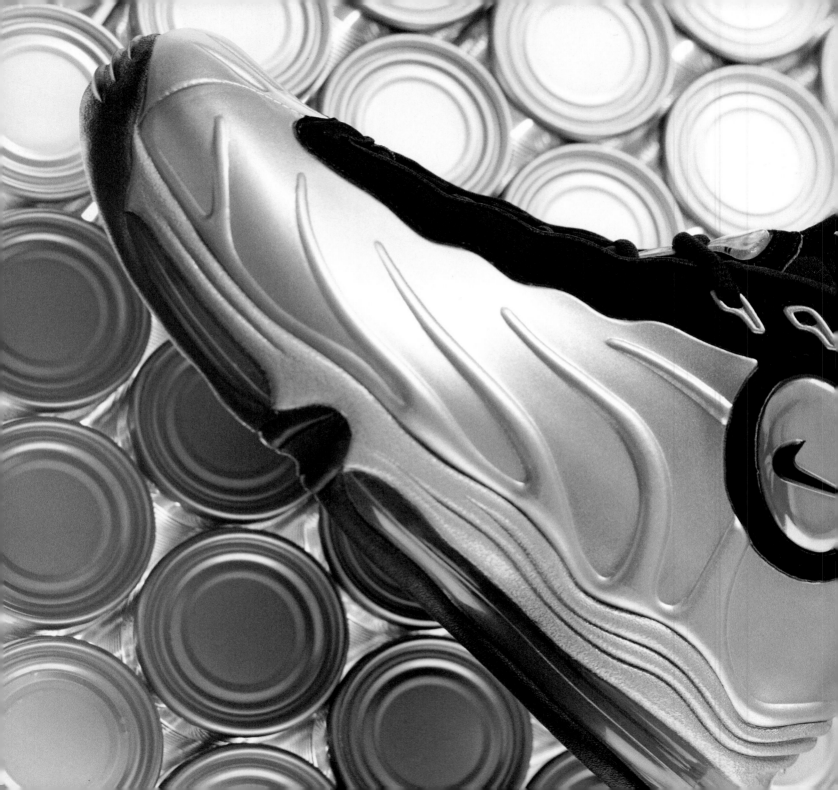

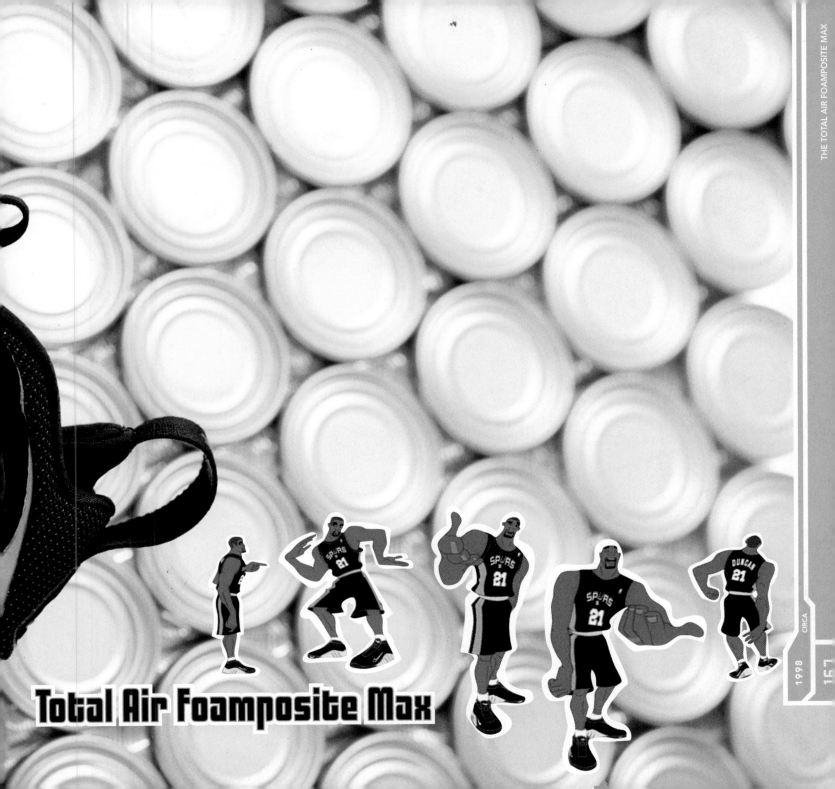

Total Air Foamposite Max

The Air Jordan
XIII

Detail from a Tinker Hatfield inspiration board.

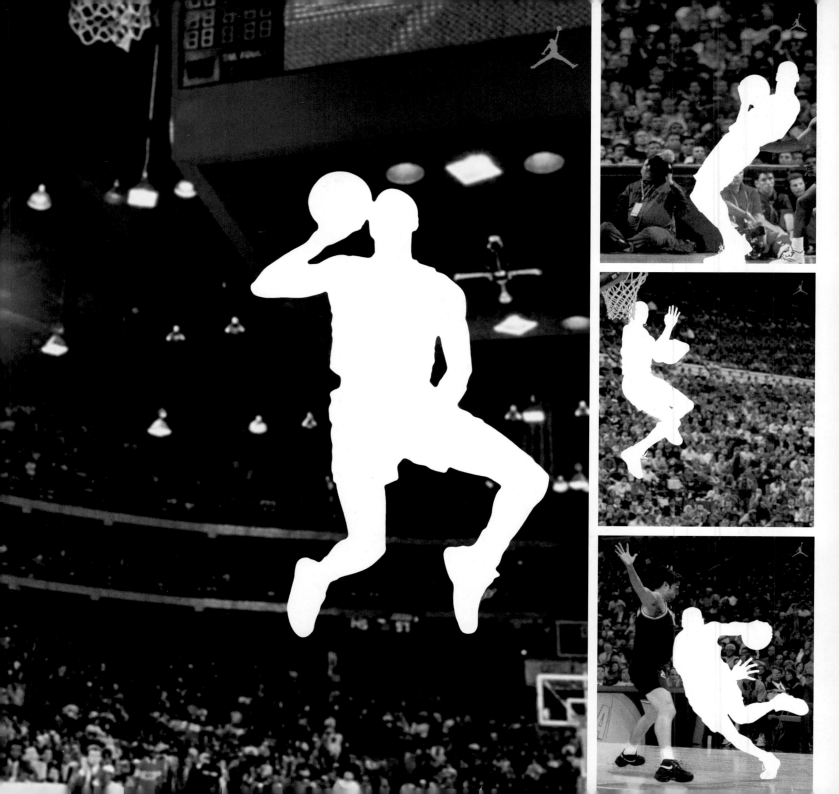

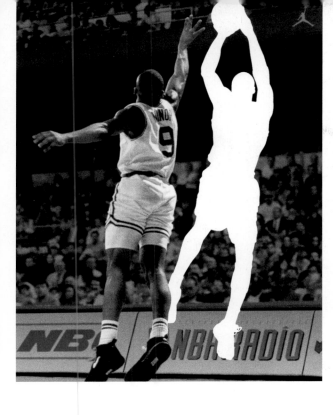

AIR JORDAN XIII

Black Shoe In The
Hour of Chaos

There is a difference between what is considered great and what is known as being important. Most people if given the choice would choose greatness. For those people, this story is for you. In 1998, out of nowhere, Black Cat disappeared. Gone. Went ghost. Retired. 6 rings, no more challenges. What happened to peace? He said it with his last shot in Utah: "Peace, peace, peace, peace..." And this was just the beginning. While the NBA was in a panic (don't forget about the strike), a shoe company, right in the middle of launching the silhouette as a solo brand, had the ungodly task of selling a shoe with no player around to sell it. This was the time for comp to make moves: mass market the new youth movement, commercialize the non-Jordan image, and sell thug life. Soon other players, other styles and other shoes gained popularity. Boots, leather slip-ons, skateboarding shoes, classics. All came into play, all came in to dethrone the king. The members of Brand Jordan known as employees and employer were nervous, they saw their grip fading like one of $'s jumpers. Conversations around the Beaverton office were, "How do we sell this shoe to a fickle, unforgiving public without him to sell it?" Conversations around Brooklyn were, "Am I gon' play myself by rockin' the new Jordans when they come out even though $ ain't ballin', B?" It wasn't supposed to end like this. Season opener. D-day. Drop day. The XIIIs hit the streets 200 miles and running. Breath was bated, hearts were pounding, careers were hanging on strings like loose ends, and a 13-year legacy was at risk. 48 hours passed, the results began to trickle in. Sold. Out. No more in stores, more orders placed. So what he wasn't playing anymore the sales returns read, "anything associated with him gets love." The people had spoken. And although other entities were getting respect from the public and other players for other companies were able to move shoes, Air Jordans were still, well, Air Jordans, whether he played the game ever again or not. This put Jordan, Inc. as a business on that other level. Now he, and the company knew, everything was going to be alright. They learned it wasn't just about what he did on the court, it was more about him, what he represented, stood for and stood in. The XIIIs taught them that. Now do you get the difference between greatness and importance? See historically the XIII gets overlooked when the greatest or the best Jordans are discussed. It disappears like MJ did the year they came out. But if you know the story, you know that theoretically it is possibly the most important Jordan shoe ever made. Which in turn, puts it above the best. The shoe you are looking at, the one designed from the eye of a cat, it didn't change the game, it saved it. It's the Air Jordan that after 13 years made the world recognize that it wasn't always about the basketball legacy he laid down—the shoes had established a legacy on their own.

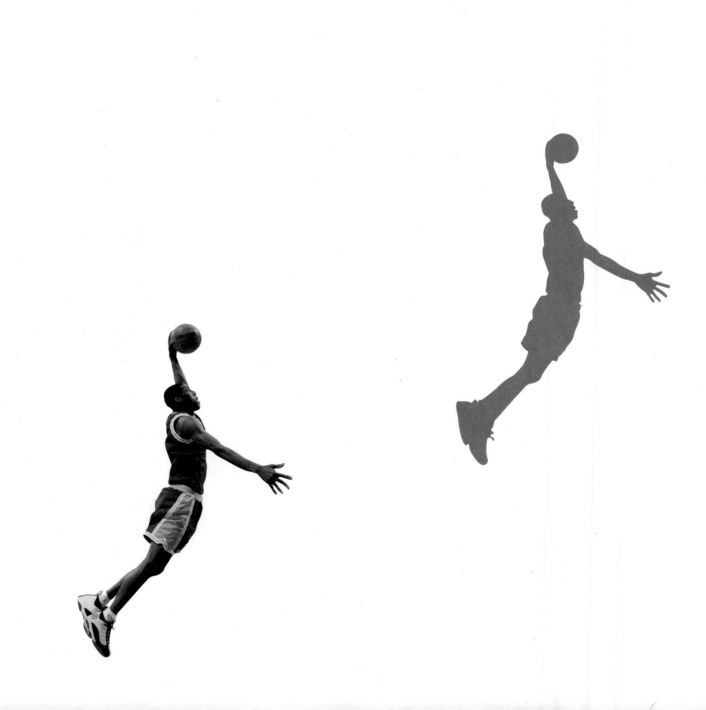

Brand me

MICHAEL FINLEY

DEREK ANDERSON

EDDIE JONES

VIN BAKER

RAY ALLEN

MIKE BIBBY

"Michael Jordan scores 43 in wingtips!" That was the headline on the fictitious gazette run at the end of Jordan CEO's first leap into solo brandism. He (understand that the capitalization of the letter "H" has nothing to do with it being the beginning of a sentence, um, Jordan had gotten that large) had reached a point—in both his professional and business careers—where he had to have his own product. His own line. His own brand. Not just for him, but for the rest of the _____ thing outside of, but still associated with Nike. Note: Dude wasn't stupid. He wan___ _____ ___s on the business side and more athletes who represented the _____ d to be able to see himself without having to look in a mirror. Over ___ d the market. His logo alone had become the third-most recognized _____ any that created his image, but was holding Him back. He pitched _____ n was delivered.

Then Eddie Jones, Vin Baker and Michael Finley (Mike Bibby came ___er that was damn-near All-Star ready. But that wasn't enough. ___trictly about basketball. So he grabbed the best football player ___er and pound-for-pound the world's best boxer Roy Jones Jr. and ___was able to build an image of them around the voices of queens ___he snagged schools: University of Cincinnati, St. John's, Cal, etc. ___anyone else. There became this air of dignity associated with ___he kid still inside of the adults who knew the significance of this ___nd became more than just relevant in some circles; it was ___: to create a brand that could become more than just hot, ___rand Jordan mandatory. Like everything else, he succeeded.

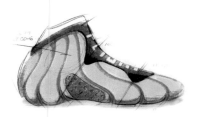

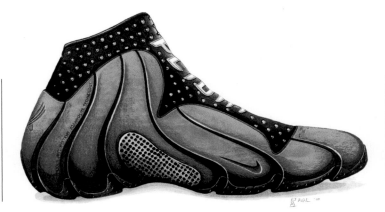

FP $=_Z$ AF³

Flightposite = Air Zoom Flight cubed

For serious ballers only

Once upon a time there were 3 technologists, scientists we'll call them. One had a knife, one had a car, and the other had an onion. They loved basketball; couldn't play, but loved the game. In 1999, due to lockouts and a Jordan retirement, they witnessed the popularity of basketball fading. They sensed the death of the game. So they tried to save it, as only they knew how... through shoes. To advance and enhance the look of the Air Zoom Flight, one of the game's most successful shoes, they rebuilt it, using the knife, the car and the onion as design inspirations and advanced technology as a performance inspiration. "Let's take the pods off the sole and place them at the pressure points of the foot, but make them visible," one of them said. "Better yet, let's totally eliminate the shoe's outer sole and replace it with a 1/2" air bubble midsole cushion inside of the shoe," another suggested. "Yes, that would make the shoe less bulky, sleeker, lighter, but still hold the same responsive and supportive effect as all of the former basketball shoes," a third interjected. So they ran to the lab with bubbles on their brains, these mad scientists.

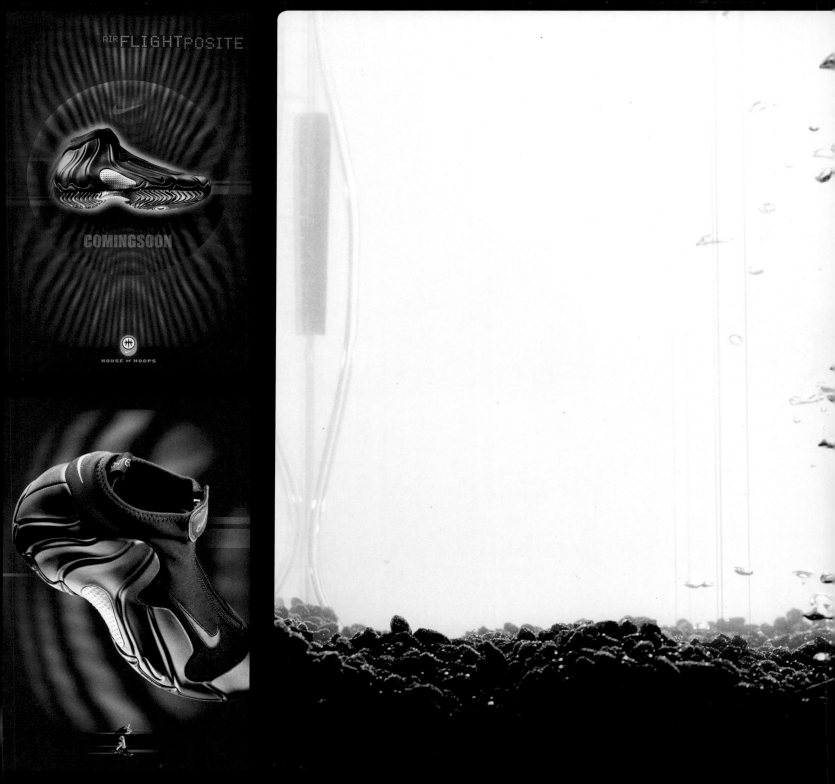

They submerged

days later with "the craziest looking, best feeling basketball shoe" ever created. The Flightposite. Thousands would fall in love; millions would discover that a new era of basketball technology was here to stay. By year 3, the Flightposites were not only off the hook, they were off the shelves, walls, meat racks, heezy-fa'sheezies, everything. They developed a cult following of basketball aficionados. Because only ball players, not ballers, wore these 'Posites. That was the unwritten rule, code of the courts. Which is exactly what the scientists had in mind when they developed this shoe. They knew this would save the game. On every box, they lobbied for a disclaimer: Warning: Dangerous bubbles inside. Only for use by serious ball players. Those that don't possess true game, step off. Do not purchase this shoe. But the company wouldn't do it and the game of basketball stayed unpopular thanks to some other scientist's creation called Tiger Woods. So the 3 scientists went back to the lab to work on the next diabolical plan to save the game. Some say they won't be out until 2008. Others say longer. Until then, long live the bubbles. Long live the bubbles! Long live...

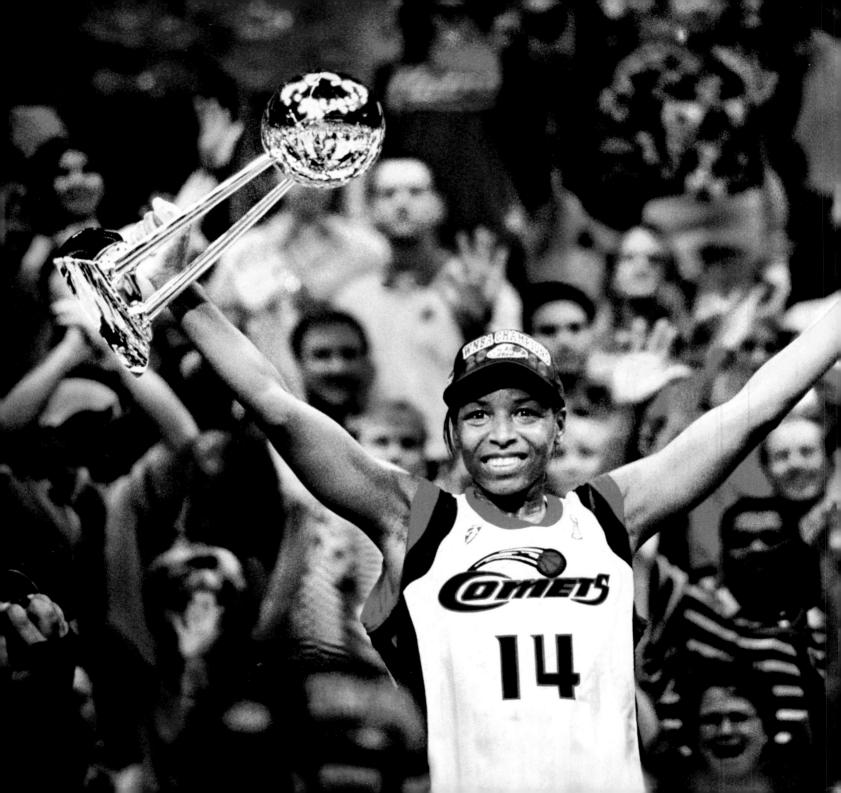

STALEY **LESLIE** **HOLDSCLAW** **THOMPSON**

Cynthia Cooper

TITLE IX? WHATEVER...

She deserved more.

For everything. The blood, sweat, cheers and jeers. For the four championship rings, for the four MVP's. For saving not only a league, but an entire sport. She had help in the form of players like Lisa Leslie and the future of Chamique Holdsclaw, but for the more-than-most part, everything was all on her. So yes, she deserved more. But life for some is unfair. For every Michael Jordan there is one Cynthia Cooper. Someone who does everything (if not more) than her male counterpart, but doesn't get the glory, admiration or love. It hurts sometimes, as she watches her life unfold knowing that what she gave may never be returned. Fans in the millions instead of the hundreds of millions as they should be if she were anything but a woman controlling basketball in a man's world. No logo of her image, no trophy named after her. She deserved these things. She deserved more than that. Cynthia Cooper earned the right to have the world at her disposal. Her face on a $4 bill, a seat in the Texas governor's mansion, an extra star on the flag of the lone star. Those are the types of thangs she deserved for playing the game like she did; for those feather jumpers and hard drives; for making the basketball seem like it had more than two colors; for dominating. Many expressed concern that it was too soon for all of that love to come her way

knowing that if she were a man...world rule. Instead she was given the female treatment, she was considered a great female basketball player instead of a great player. They said that maybe, one day, someone would come along an eclipse her accomplishments in women's basketball. "Wait, " they proclaimed, "soon there will be another Cynthia Cooper." They looked at every WNBA player, they saw promise. But another CC? In this lifetime? Just like one day there will be another Tiger Woods, Marion Jones, and Jerry Rice. Hold ya' breath. The best, yes; perfect, close; but she's not every woman. For all that she was she was not all women's basketball. For the shemale game took on unforethinkable dimensions since America formed its professional league. The game's other half has shown that everything the men can do with imperfection in the air, the women can perform with precision on the floor. Role models and superstarettes have risen like cake mix in a silent kitchen. From Ticha Penicheiro to Dawn Staley to Tina Thompson, the women's game has elevated to heights unseen to the male-dominated retinas. Proving one thing about gender and the game of basketball: It's strong enough to be played by a man but built to be perfected by women.

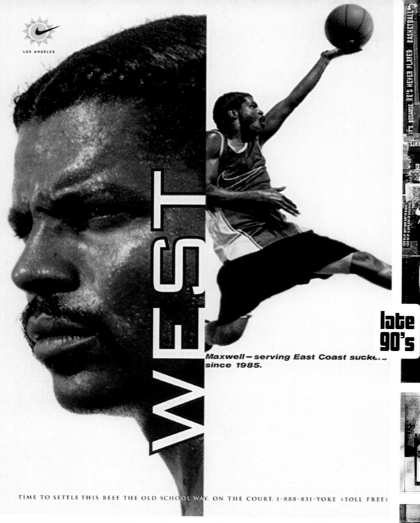

LOS ANGELES

WEST

Maxwell — serving East Coast suckers since 1985.

TIME TO SETTLE THIS BEEF THE OLD SCHOOL WAY. ON THE COURT. 1-888-831-YOKE (TOLL FREE)

LIKE IT WAS JUST A GAME.

PASSION IS NOT ARROGANCE.

HEY BUSTER! ZOOM AIR. FASTEST, MOST RESPONSIVE EVER.

late 90's

AIR MAX 1996 AIR RUPT DO YOU SEE THE CONNECTION

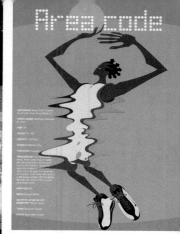

Area code

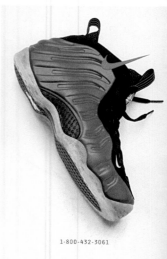

1-800-432-3061

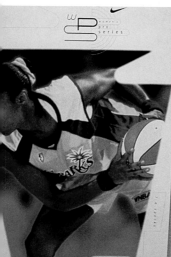

WPS women's pro series

lisa leslie

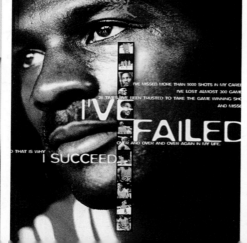

I'VE FAILED

I'VE MISSED MORE THAN 9000 SHOTS IN MY CAREER. I'VE LOST ALMOST 300 GAMES. 26 TIMES I'VE BEEN TRUSTED TO TAKE THE GAME WINNING SHOT AND MISSED.

THAT IS WHY I SUCCEED

OVER AND OVER AND OVER AGAIN IN MY LIFE.

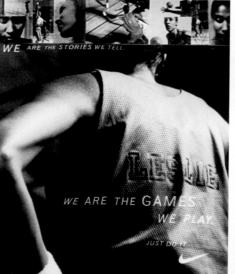

WE ARE THE STORIES WE TELL.

WE ARE THE GAMES WE PLAY.

JUST DO IT

AIR ZOOM FLIGHT FIVE

KIDD

NOW CASTING IN UPCOMING HIGHLIGHT FILMS

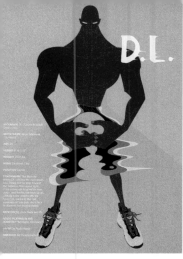

D.L.

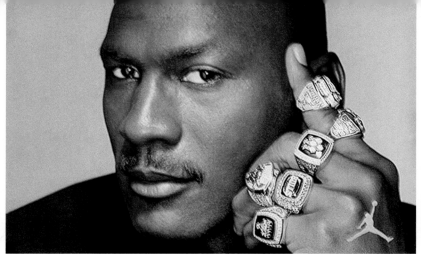

JASON KIDD'S
DRIVING SCHOOL

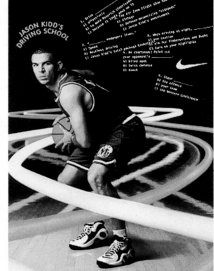

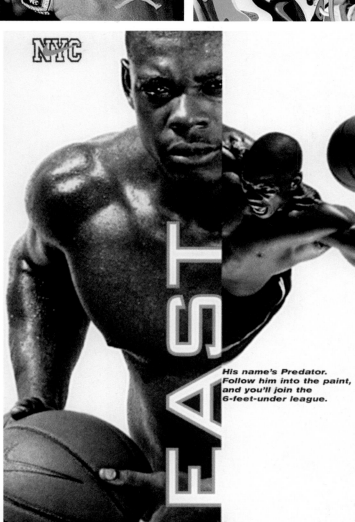

NYC

FAST

His name's Predator.
Follow him into the paint,
and you'll join the
6-feet-under league.

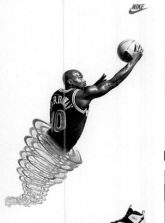

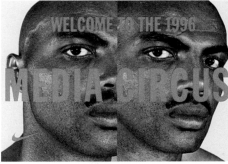

WELCOME TO THE 1996
MEDIA CIRCUS

HAD
NUMBER,
RETIRED.

LISTEN UP:

TIME TO SETTLE THIS BEEF THE OLD SCHOOL WAY. ON THE COURT. 1-888-831-YOKE (TOLL FREE)

"The columns work as a system, not individually." Those are the words of Dick Oldfield, the man who may have the greatest impact on the game of basketball in the 21st century. The most popular, most worn, most requested, stolen, in-demand sneaker in professional ball today are the original Nike Shox BB4; the shoe that introduced the system that Oldfield introduced to Nike's basketball division. An archetype of running technology in the late 80's the idea of adding "shock absorbers" to the heels of shoes didn't reach basketball design until 1999. Because of the wear and tear basketball players put on shoes, the plastic and plates needed to make something of this nature happen wasn't available until then. Ten to twelve different configurations of the system were tested. A one-piece puck was added to hold the entire system together as was a 5th column on the shoe's backside. Then an external heel counter was added where the structure actually rests inside of the plate molding that se-

cures the individual "Shox" and makes them work as one; giving players that trampoline affect, that responsive and snappy ride on the court the system's become worshipped for. "The foam used to make the pods is the same used in car bushings of Formula One race cars," Oldfield will tell you if you ask. "So our thinking was, if it works for high performance cars...." And it has worked very well for the shoes made for basketball. Not only has the system expanded into other shoes, like the Nike Shox 'Stunner and the Nike Shox VC I, for the Nike Shox VC II the system was extended from heel-to-toe. Which will probably make it impossible for any ball player to resist. So how does the perfect concept for basketball footwear get better? "We're trying to make the all shoes with the Nike Shox system lighter," Oldfield says. Now some 8' player is going to get jumped over on a dunk, right?

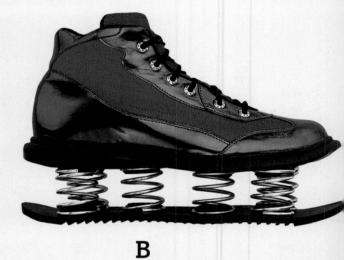

B

NI·KE SHOX

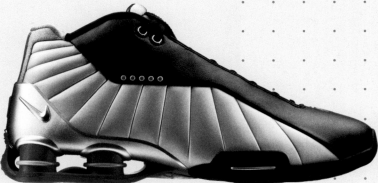

Boi

Boing.

Do they really work?

He was with another shoe company and still undecided on what to do, which way to lead his life. He had just won the 2000 NBA All-Star Weekend dunk contest by doing things, not just never seen before, but dunks that will more than likely never be seen ever again. Let's keep it real: Vince Carter became the greatest dunker dead or alive on that day. And still confusion sat inside of his head. As the season ended and his life's picture became more clear, the gentleman they were starting to call Half-Man, Half-Amazin' signed a new contract for a shoe. He was happy but he needed to do something in the form of a dunk—one better than any he

had performed in Oakland a few months before—to let the people at Nike know how appreciative he was. The company gave him a shoe to test out as he went to Sydney, Australia to play in the games. They told him that the new technology in the shoe would give him more hops. Like he needed that. Anyway, coming down court on a fast break in one of the early games there was a 7-foot-something cat standing in between Vince and the basket. "Let's see if this Nike Shox thing they're talking about in these shoes really works," Vince thought. The next day Vince Carter fictitiously sent a fax over to Mr. Nike. The fax read: Thanks for the shoes. They really work.

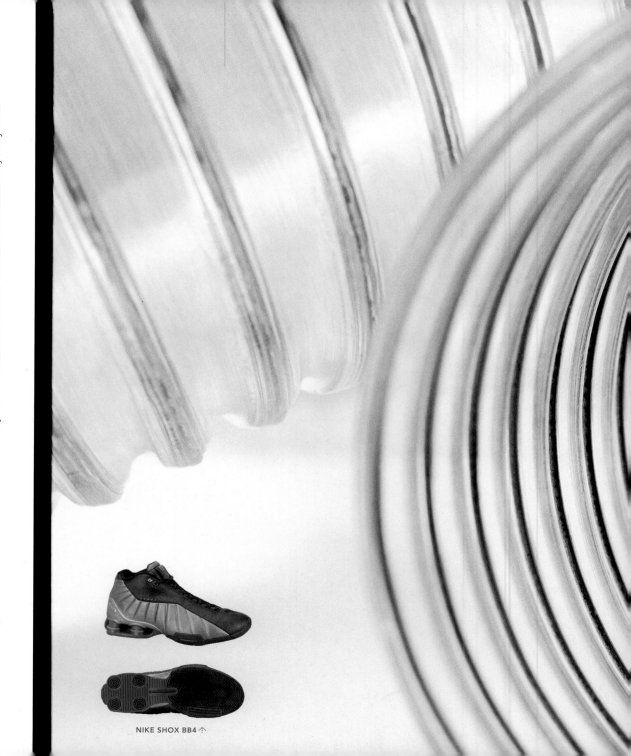

NIKE SHOX BB4

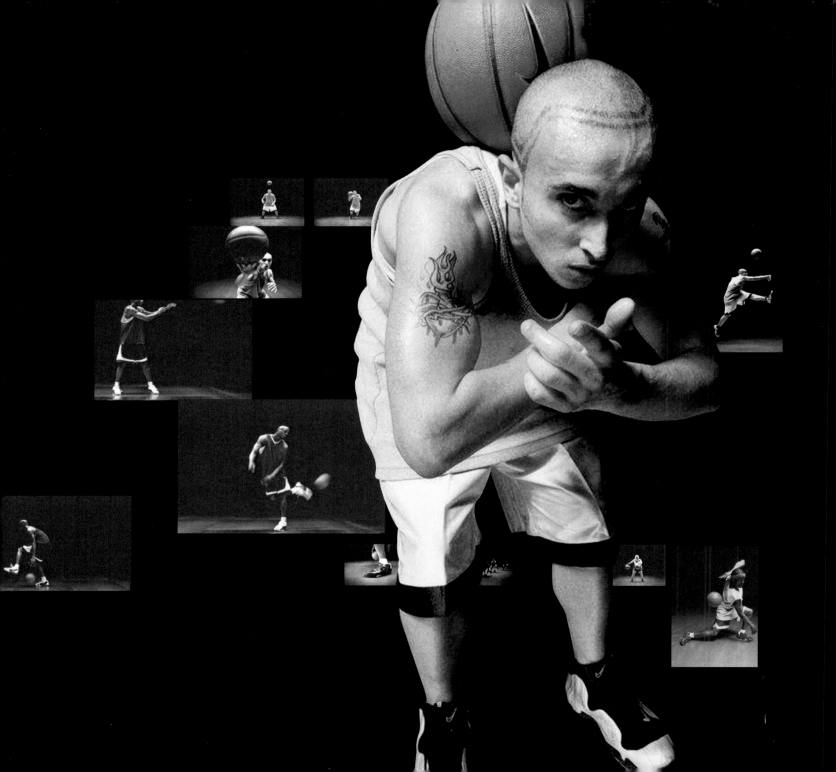

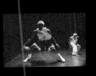

Because Style Isn't Free.

Time named "Freestyle" the best commercial of the year, 2001. 'Nuff said.

Because You've Never Seen A Yellow Alligator..........Air HyperFlight II

"15 different colors!?! This ain't Sherwin Williams or Home Depot, these are shoes!" You could hear them arguing in the next room. Truth? You could have heard them on the next block. Many words flew like the many colors of the shoes they were verbally battling over. The arguers wish to remain unnamed, for that we will keep their identities unknown. There comes a point in every culture's existence where you gotta shake sh*t up. Period. No questions, no arguments. For basketball, this was that point. According to some, the shoe game was getting boring. Retro this, old school that. Mugs needed something different, something out there, something kelis, something bling like the neptune sound. Two things in the past had been true about basketball sneakers: 1) 99.999% of the time they were going to be leather and 2) 99.998% of the time they were only going to be one of five colors: red, blue, gray, black

or white. Now read the sixth sentence again: *There comes a point in every culture's existence....* The Hyperflight Remix was made to do just that: shake up the game, put the industry on its heels (pun on purpose). With so many different colors, mentally disturbed design and a liquidized synthetic outsole, it was the basketball shoe that flew over the cuckoo's nest. Strait white jackets not included. So crazy, studs started traveling around the country or ordering through Eastbay every color to go with every outfit they owned. Like gators, the shoe was invented for the hook up. The TB's (as they became known on the streets) went from having designers and sports marketing insiders arguing over colors to the general public arguing over exactly which color was the lic. Official pimps and playboys (ballers and shot callers), they will forever love the green ones (not shown). There's just something about those green ones.

NIGHTTIME #63-0

GUN POWDER #25-5

METALLICA #82-9

LIGHTS OUT #76-3

CANNONBALL #10-6

BATTLESHIP #13-1

LIPSTICK #09-2

LITTLE WAGON #82-1

RIENDEER NOSE #12-5

BURNT PEEL #82

SUNSHINE #89

PUMPKIN #22

40,000 LEAGUES #63-0

ATLANTIC #75-0

PUDDLE WATER #18-4

DEEP SEA BLUE #78-9

FORD BLUE #88-1

PERIWINKLE BLUE #85-2

ATHENS #44-2

POWDER #00-6

SMURF #09-6

STAINLESS STEEL #04-

PEWTER #36-

CHROME #99-8

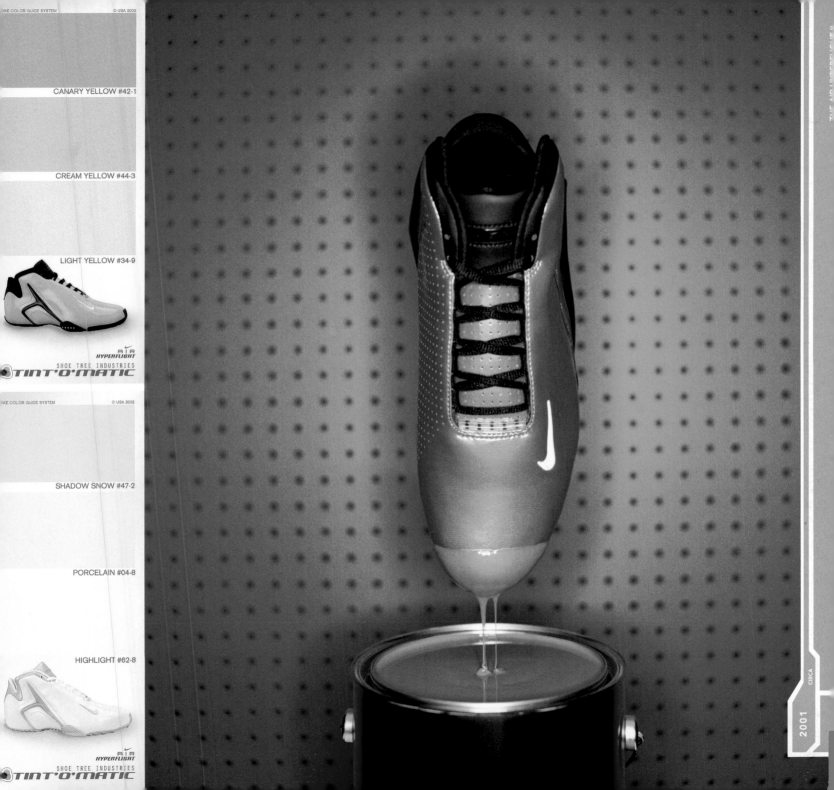

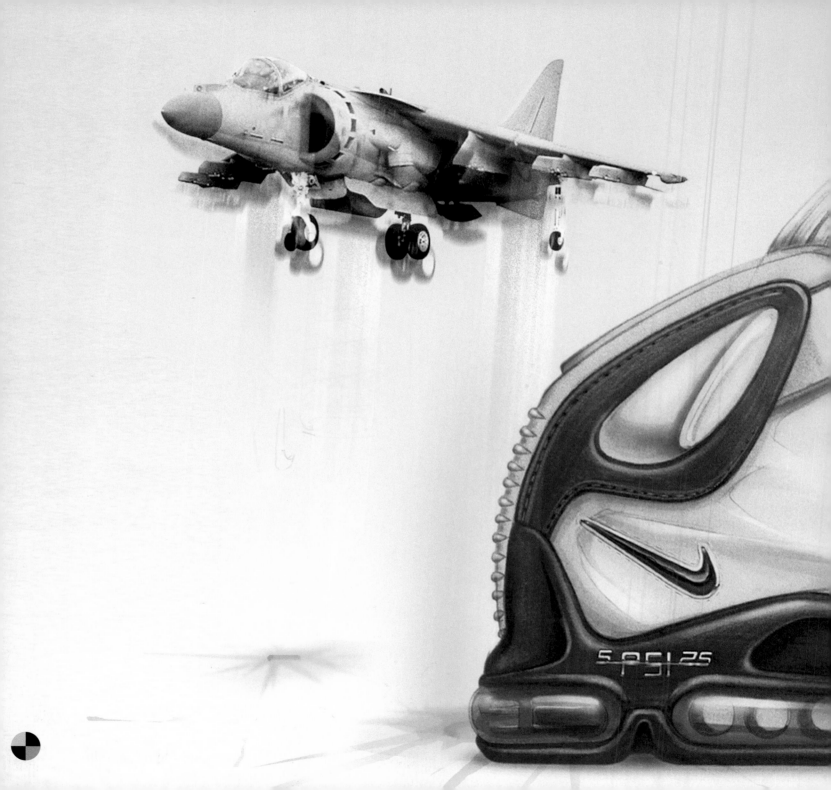

Now That's Levitation, Holmes!

Ever pay attention to a spaceship when it lands? How the lights all illuminate when it hovers to the ground? How the lights circle the whole intergalactic spacecraft? While laying on your back after being dunked on, if you look up at the person descending off of the rim, if you look at their shoes, if that person is wearing Air Max Elites, the first thing that will come to your mind will be, "Damn, that looks like a spaceship about to land on my head." The semi-circular clear midsole built like a hairpin curve that takes up 80% of that area of the shoe's outer sole gives it that "jump jet" (the shoe's original name) resemblance. All leathered-out (except for Paul Pierce, he has the SE edition all-patented leather) like a luxury edition SUV, gleamy outskirts that look like rims, full-length air bubble insole and that "window to its world" invitation to see the thermoplastic pods that sit inside the soul of the sole made kings from all Battlegrounds react at first sight like they'd seen a UFO. One day, just like the Nike Bruin made a galactic appearance in *Back To The Future* and the Blazer in *Like Mike*, the Air Max Elite will be seen in theaters near you come 2026 as the shoe "ballers were flossing at the turn of the century." Until then, if you happen to be on the courts, playing, trying to hold your own, if at some point you happen to be on your ass, looking directly up at the bottom of someone's shoes after getting dunked on, and they just happen to be wearing the Air Max Elite, you'll be happy because the first thing you'll say while the sole gets closer to your grill is, "Damn, that looks like a Christmas tree about to land on my head."

5 PSI 25

SOLE RESEARCH

JUMP JET
The Harrier Jump Jet was part of the performance and visual inspiration behind the Air Max Elite. Although the bottom of the shoe does resemble the shape of a Christmas tree, in actuality, the design replicates the shape of the pilot's windshield. Perfect for overhead fly-bys.

2002

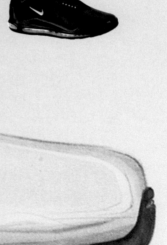

@ 10.3.00

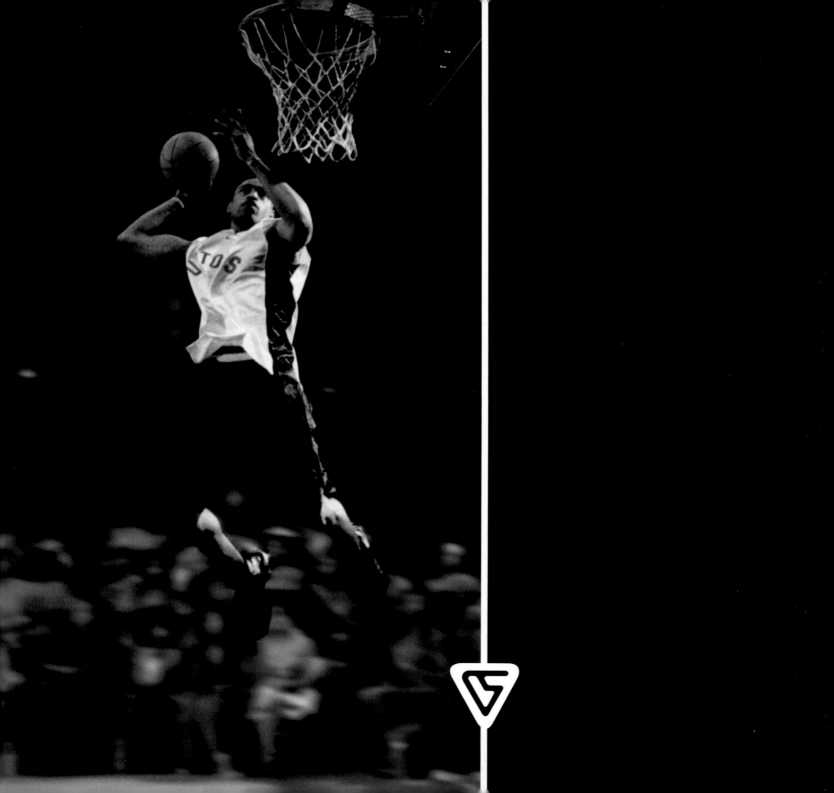

Keep That Funk Alive!

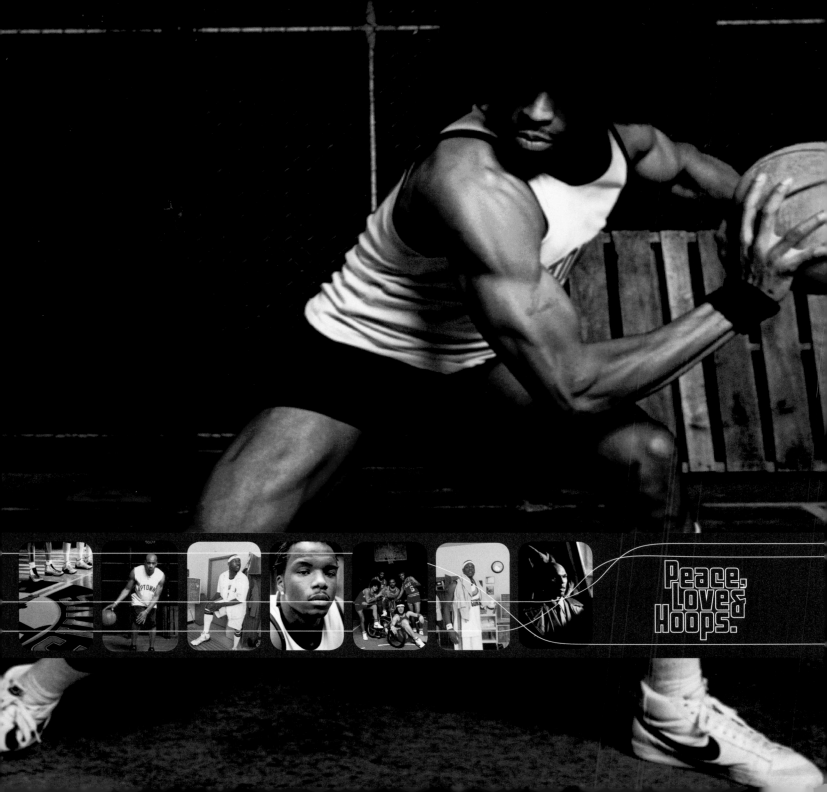

Peace,
Love &
Hoops.

NIKE SHOX VC ↑

1975, 155th Street Harlem
Doc-tor Funk! Doc-tor Funk! Doc-tor Funk! ...

The Legend of Dr. Funk. No one knows exactly when he was born. Some say '77 others claim he's not that old school. "Dr. Funk is new school, dude" the young ones holla back at the veterans. But the old heads go back to 1975 and tell the story of how one day at 155th Street when the Uptowns were losing a crucial game. Then out from behind the fence and through the stands came this hooded caped crusader. Doing the "Harlem shake" on defenders before launching 25-footers, taking shots off the backboard double-handed and doing an alley-oop windmill dunk with his head 3-feet above the rim to win the game. The only thing the old-timers couldn't describe were the shoes on Dr. Funk's feet. They had never seen anything like them before back then. "They looked like something from Lovetron or the moon," one old man said who saw that game. "They looked like vinyl and had a zipper, no laces and some funny looking logo at the top, it said VC or something like that." VC? The new jacks lose it. Hysterical. "They think Dr. Funk is Vince Carter!" They laugh every time they hear these stories. The G's just shake their heads. For they are the ones who know the legend of Dr. Funk is no laughing matter. "One day," the same old man says, "they'll believe. One day."

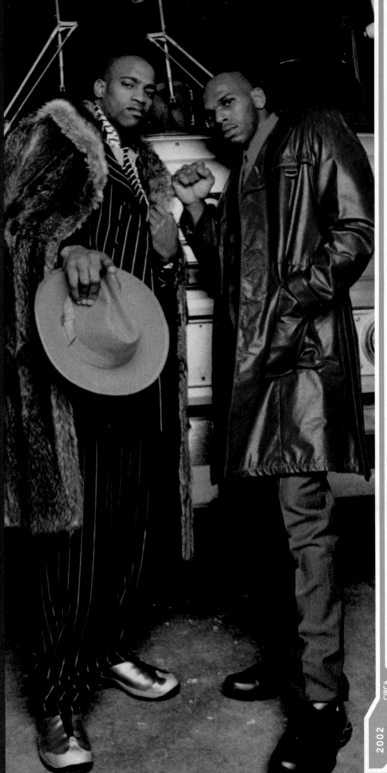

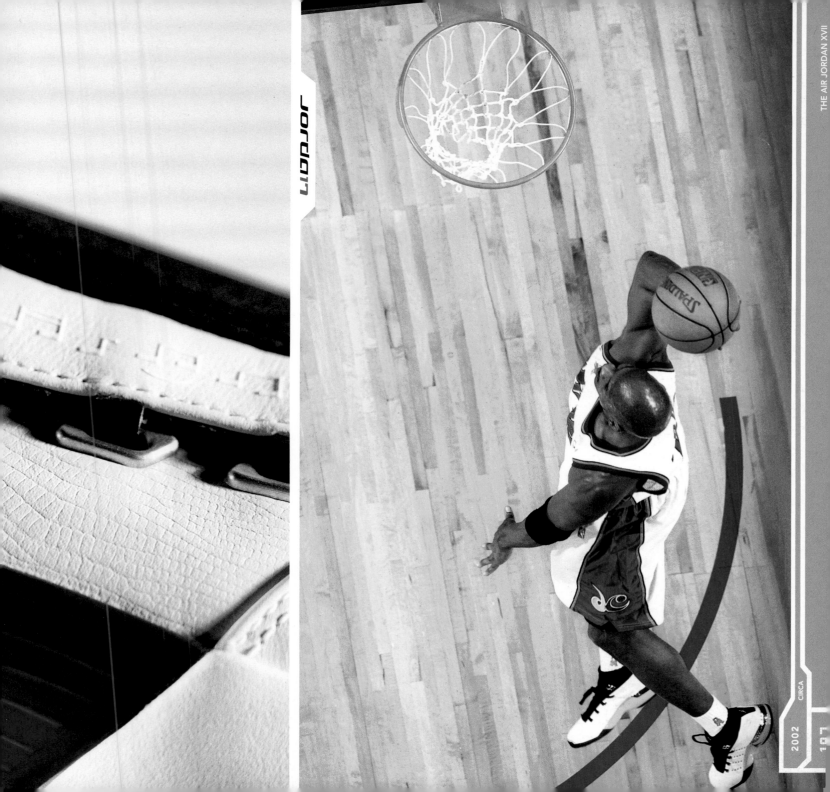

February 9, 2002
ALL RHYTHM, NO BLUES
VOLUME 17
RAY ALLEN

AIR JORDAN
XVII

DARIUS & Q DUET TO YOU
JUMPMAN23.COM
VOLUME XVII

>> DARIUS MILES & QUENTIN RICHARDSON "DUET TO YOU" (30 SECONDS)

The Jordan XVII

XVII BLACK XVII SPECIAL EDITION XVII WHITE

>>RAY ALLEN "ALL RHYTHM, NO BLUES" (30 SECONDS) >> 00:52:03

>> 00:00:03 >> 00:00:07 >> 00:00:12 >> 00:00:: ᴜᴜ:00:27 >> 00:00:29

Just to Get a Rep

The price tag scared folks. $200! "They're just gym shoes!" Hear the screams? They didn't know. These are not just gym shoes. They are Jordans. The Return. There is a difference. For every grown man that has spent upwards of $500 on a pair of wingtips, or close to a G on some gators or $3000 on those black Italian leather, zip-up-the-side, square-toed, ultra trendy Chukka that only gets worn 6 times a year, please shut up. This is a basketball thing, y'all wouldn't understand. Plus, it's a Jordan thing. Classy. With class. Came in a chrome case. There was a peel on the heel that acted as a born-on date, a seal, to keep the shoes fresh until they hit the streets. Removable, clip-on plate to shield the lacing system and only came in the colors to match $'s new Washington Wizards uniform. Ahh, yes this was the Return shoe. The one for comeback No. 2. Different situation, different type of game he was going to play, different kick he was about to kick it in. But this time, for the first time, he didn't go solo with the introduction and sales. For the Jordan Series of shoes was no longer about just Jordan. To reach the audience that missed his first two shows (1984-93 and 1995-98), CEO Jordan used Roc L.A. Familia (Clippers) members Darius Miles and Quentin Richardson to do the honors. Behind classic Gang Starr beats and rhymes they flew through the air in 30-second spots that brought the old and the new together like never. Marketing magnificent, branding brilliance. But then there was still that $200 price tag in a sluggish, post-9/11 economy. F'getaboutit, didn't matter, because as per usual the people found a way— as they always have—to give MJ back the love he's always given them. No doubt, you can definitely call the Jordan XVII a comeback. You can call it an expensive one. But wasn't the Return worth it?

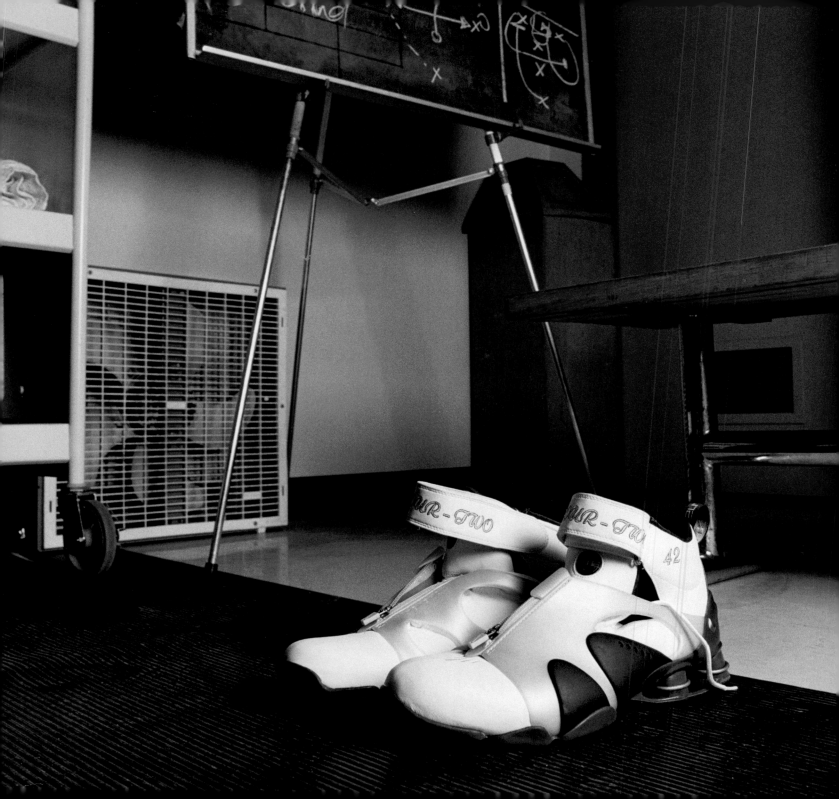

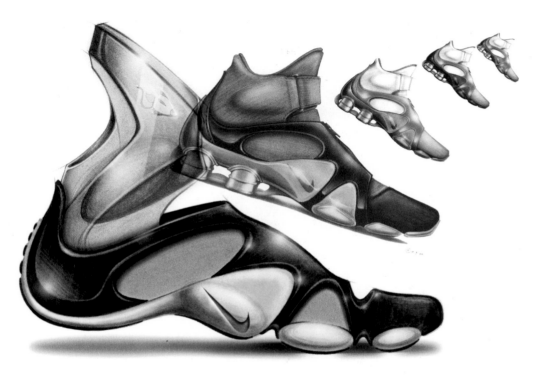

Nike Shox Stunner

"Everything, including the kitchen sink."

When designer Jeff Henderson said those words he wasn't talking about the Stunners, but he should have been. Look. Just look. What do you see? Everything, but the kitchen sink. If you take 30 years of Nike Basketball and put it into one shoe—all of the technology, all of the designs, materials, fabrics, color schemes, successes and failures—this is what you'll end up with. The Stunner. The shoe game's Frankenstein. A freak of design nature. The brother from several mothers. One of the most difficult shoes to produce. Made to move the crowd as well as the sales needle in retail. Ingredients: Take the strap idea from the Air Force Is and Air Revolutions, borrow the sock fabric design from the Air Jordan VII, take the zipper concept from the Zoom and Ndestrukt series, sample the Nike Shox bottom plate from the BB4's and the center outsole from the Zoom Flight Five, throw in a dash of the sandal concept and fit from the Huarache. Done. The $6M shoe has been built. Only to be served straight on basketball courts, no chasers or side dishes. The unofficial "ball 'til you fall" shoe, the official shoe of the Roswell Rayguns and 2002 collegiate champion University of Maryland Terps (actually the Stunner was made specifically for the NCAA tournament). Maybe, instead of using the down South slang Stunner for the shoe, they should have tweaked it a bit, kept it dirty and called the shoes Air Gumbo because like the dish, it's got every-thang in it. Fear of the Turtle? Please. Y'all better fear this here Stunner. It's cash money, fawly.

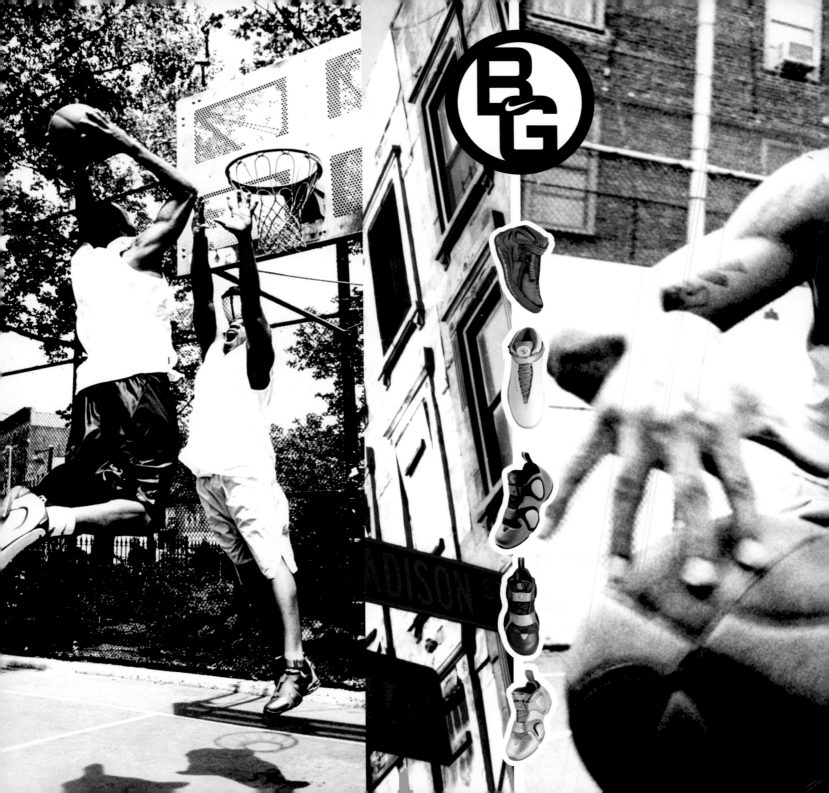

Street Poetry

The next level. Sometimes in order to move ahead of the game, one has to go back to where the game was given life. With street basketball becoming Madison Ave.'s new rage, someone had to take it back to the truth. Give respect to more than just the game and big-up the hollowed grounds that over the past 50 years has turned more unheard of neighborhood nobodies into national household names than the post office. These places are called the Battlegrounds. They are not just a part of hoop history, they are the history. Saint Cecilia in Detroit and Saint Augustine in North Carolina; The Hole in Brooklyn and The Dome in Baltimore; Franklin Park in Chicago and Wilson Park in Compton. So many more exist. These are the places that are so often overlooked because when the history of basketball is being told it is all about the professionals and not the profession; all about the game but never where the game is being played; all about the Benjamins and nothing about the Banniker Parks. So we give love to the Battlegrounds, letting them know that we will never forget their contribution to the game. For without them there would be no Pee Wee Kirkland or Jumping Jacky Jackson or Joe Hammond, nor would there be any dunk contests, trash talking, transition game or video mix tapes. Ethically, without the Battlegrounds, there might not have ever been a game to write about. Or love.

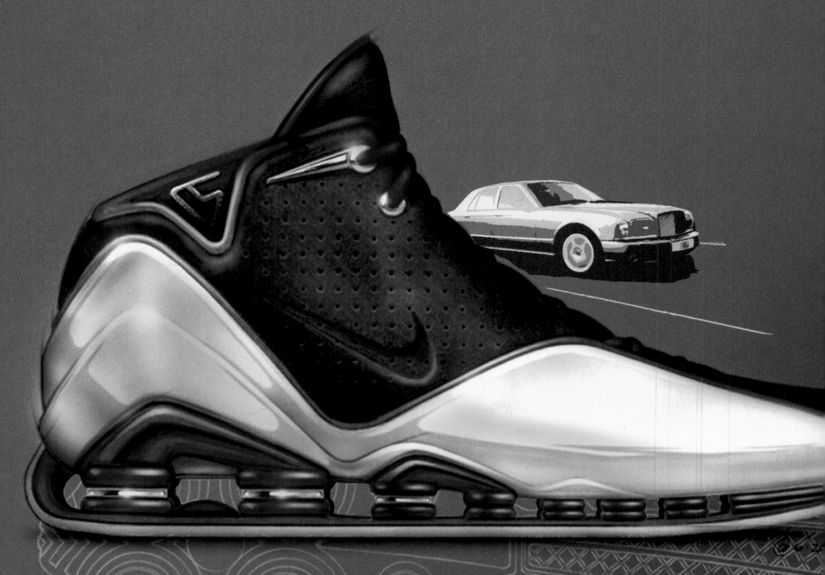

Whip Appeal.

Ever looked inside of a Bentley? Not the interior, but inside, under the hood. Not many do. Like everyone they're caught up in the trendy, excessive, Robb Report floss factor that Bentleys have become known for outside of the Hamptons. Here's a little secret: the Bentley is really a sports car. It has one of the most technically advanced performance engines ever built for an automobile. On any given Sunday, Monday, Tuesday, Wednesday, etc. it can out perform any and every sports vehicle ever made. It's a SS stuck in a RR body. Want to know where the inspiration for the VC Shox II came from? You just read it.

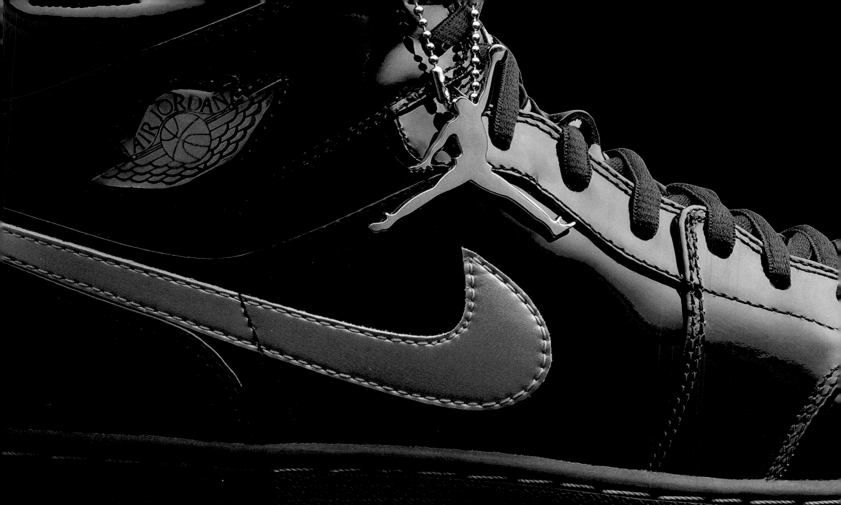

AF1's Customized

Ever seen those Air Force I Gucci-kitted kicks that came straight outta Taiwan but only seen in Harlem? Or how 'bout those Jordans, the first ones, made out of black Italian leather that only 5 people have? Or, or, what about those, uh, those Stunners with "forty-two" (Jerry Stackhouse) or "BD1" (Baron Davis) stitched across the strap? How could you not run the spot with a pair of either one of these joints on your feet, or better yet in your crib? In the world of podiawear, membership takes a back seat to exclusivity. "Be the first on your block, the first in your hood!" If you are a true baller, "be the first in the city or area code" to have on what no one else can claim. Roll up into the right set, the right event, right party, right game, it's over. The hardest rollers will steady clock you, give you eye props; the A-list women will sweat you, give your eyes candy. "Oh, this establishment has a dress code? No gym shoes." Well, garcon, did you check out these? "Yes, that was a table for two. Make it four please." Customized, one-of-a-kind, classic sneaks demand the velvet rope treatment every time they hit the pavement. It's a special feeling, a special existence that becomes addictive to those who experience life's benefits of owning items of

this nature. And that's the beauty of it all, having that feeling of rareness, that feeling of total individuality where no other individual has what you got. But most times it comes at a price. Cost and fakeness are the prices paid for faux customization. The fly s#*t that hits the streets don't come from the factory dressed like that, not with the brown vinyl LV spread across the swoosh and toe box. Like white walls and white trains are to graffiti artists, all-white Nikes have become the jealous one's true envy. But check the 20th Anniversary Is or the Is with NYC embroidered in red across the strap or with the Puerto Rican flag on the outside heel panel, them's authentic. Or the Jordan III reissues from 1994 with brown snakeskinned outskirts. Get deeper into the area of customization and find how some LE Flightposite III's have cityscapes and local area codes stitched inside the shoe's tongue or a LE pair of Bruins with Nike written in Japanese going down the back seam. Customized jumpers (old terminology for shoes) are the upper class, the royalty, of the shoe game. It gives anyone who owns a pair a feeling of how the other half lives. And ain't that kinda how life is supposed to be anyway?

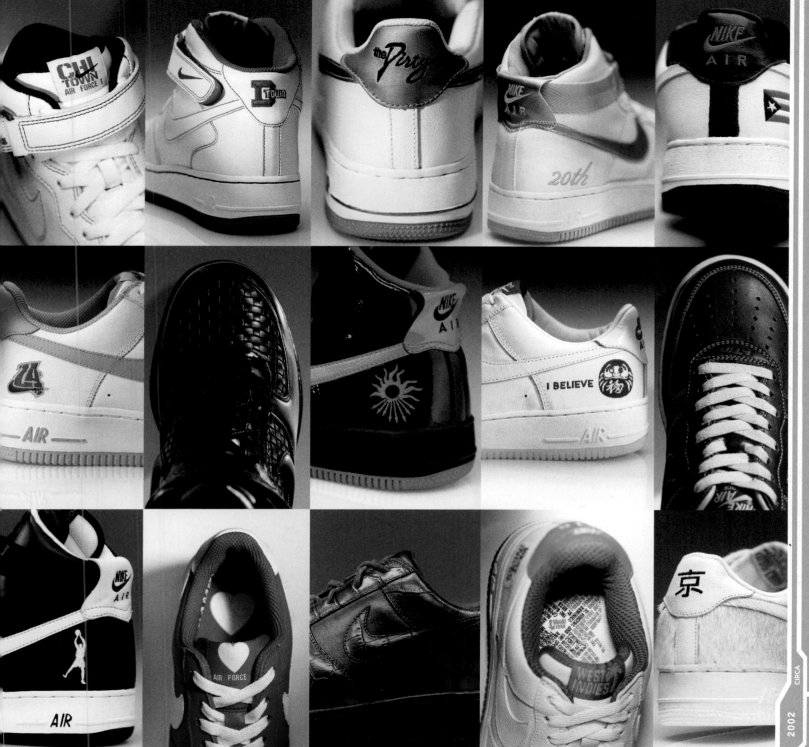

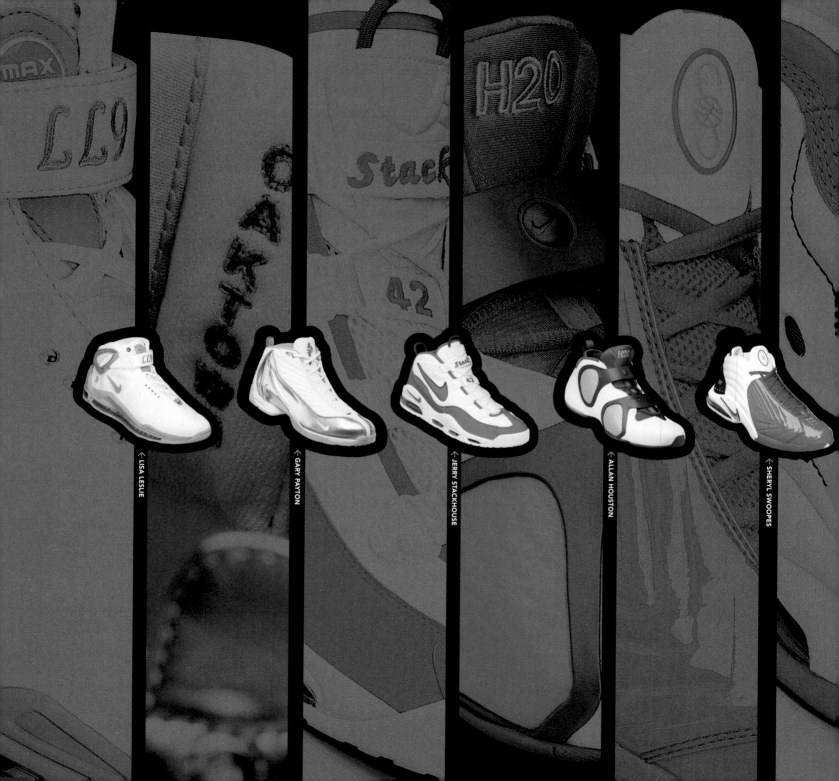

LISA LESLIE

GARY PAYTON

JERRY STACKHOUSE

ALLAN HOUSTON

SHERYL SWOOPES

Player Customized

CYNTHIA COOPER

DERRICK FISHER

JASON KIDD

CHAMIQUE HOLDSCLAW

PAUL PIERCE

They say possession is 9/10's of the rule. Your own personalized kicks? That's the other 1/10th.

A Shoe's Humidor

There exist these people called "heads." They live in various spots (city, states, countries) all over the world and they live (and die) for one thing and one thing only: kicks. These "heads" collect shoes, particularly gym shoes, specifically Nike. Some of their names may be familiar: Bobbito Garcia, Russ Bengston, "Hawaii" Mike Salman, Mir Joe Iqbal, Yoichiro Kitadate, you. Others are more obscure, lesser known to other sneaker addicts, they are the closet freaks. On a bad day a sneaker head owns or has in his possession no less than 200 pairs of kicks. Different styles, different colors of the same shoe, different editions of different shoes, all the same size. A true head can tell you every detail (down to the original launch dates and stitch patterns) about every gym shoe ever made. And although most heads are "into" running shoes ("only for comfort"), basketball shoes dramatically overwhelm their collections and drive their passion. The shoe game to them is religious to some degree, outsiders call it "obsessive." But more than why these "heads" do what they do, the biggest, most FAQ is "how": How do they keep so many kicks so fresh so clean for so long? Enter the shoebox. Over the years, the boxes the shoes come in by Nike have changed. Similar in style, size and color, but small adjustments in design have made them essential in the collection of classic kicks. From 1975 to the late 90's the boxes were two pieces, standard cardboard, orange, regular (the originals had Nike plastered large on 5 of the 6 panels, while the second tier was more brand ID subtle with a pinstriped bottom). Then, as shoes began to get more complex and word got out on how many "heads" were in global existence, the company started altering its box design to fit the needs of those that keep their kicks forever. From 1998 until today more sophisticated and heavier "cardboard" was used, beige was added, air holes used for carrying purposes were added, the seal on the lid was tighter. The preservation of pleasure principle called shoes had finally reached the point of becoming a science. Heads stored their shoes in these boxes. Like humidors. They kept each shoe wrapped in thin plastic (some still keep the original paper) and sometimes (for the ultra heads) they put them in refrigerators just under room temperature. Then the Nike Shox hit the market. Radical change in box. Radical change of box. Bigger, bulkier, and color flipped: aqua green and blue were the new skittles. The heads now had a variety. Then the XVIIs came along, no box; they came in the silver case, investment banking-style. The box game was about to be changed forever. The "heads" collectively let it be known that they still wanted back the boxes. "The orange boxes keeps the shoes better," they claimed. So the true box game remains. From 2002 on, the basicality of box design for basketball sneakers will be the same with slow evolution led by the demands and needs of sneaker "heads" worldwide. Trivial? That's what you are thinking, but you're wrong. The history of the shoebox in this game is just as significant as the shoes that go in them. The shoebox: a major element in the science known as kicksology.

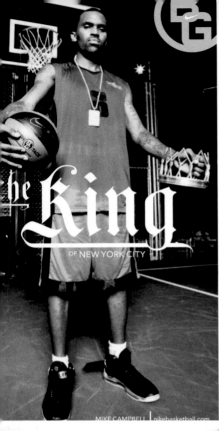

the King

OF NEW YORK CITY

MIKE CAMPBELL | nikebasketball.com

CARTER 15 PIERCE 34 DAVIS 1

early 00's

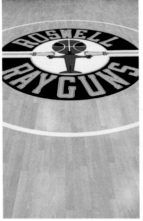

ROSWELL RAYGUNS

PICKED DAILY
AIR FLIGHT
DETERMINATIONS

BRACKETVILLE FARMS
Fresh
FROM OUR FARMS
TO YOUR COURT

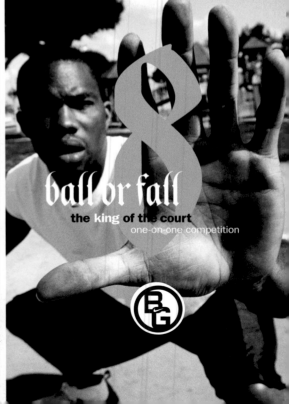

ball or fall
the king of the court
one-on-one competition

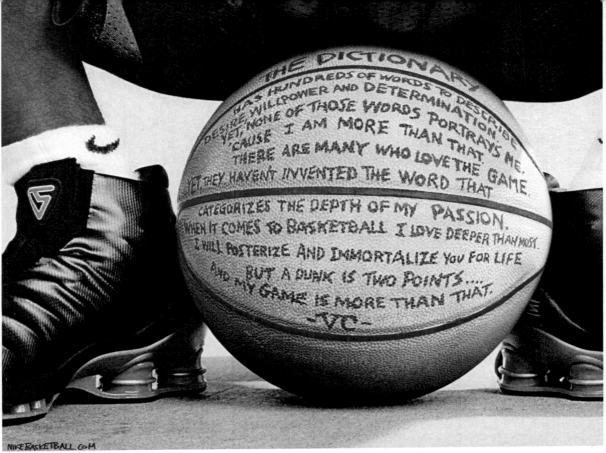

THE DICTIONARY HAS HUNDREDS OF WORDS TO DESCRIBE DESIRE, WILLPOWER AND DETERMINATION, YET, NONE OF THOSE WORDS PORTRAYS ME. 'CAUSE I AM MORE THAN THAT. THERE ARE MANY WHO LOVE THE GAME, YET THEY HAVEN'T INVENTED THE WORD THAT CATEGORIZES THE DEPTH OF MY PASSION. WHEN IT COMES TO BASKETBALL I LOVE DEEPER THAN MOST. I WILL POSTERIZE AND IMMORTALIZE YOU FOR LIFE BUT A DUNK IS TWO POINTS.... AND MY GAME IS MORE THAN THAT. -VC-

NIKEBASKETBALL.COM

THE **king** of L.A.

ERRON MAXEY | nikebasketball.com

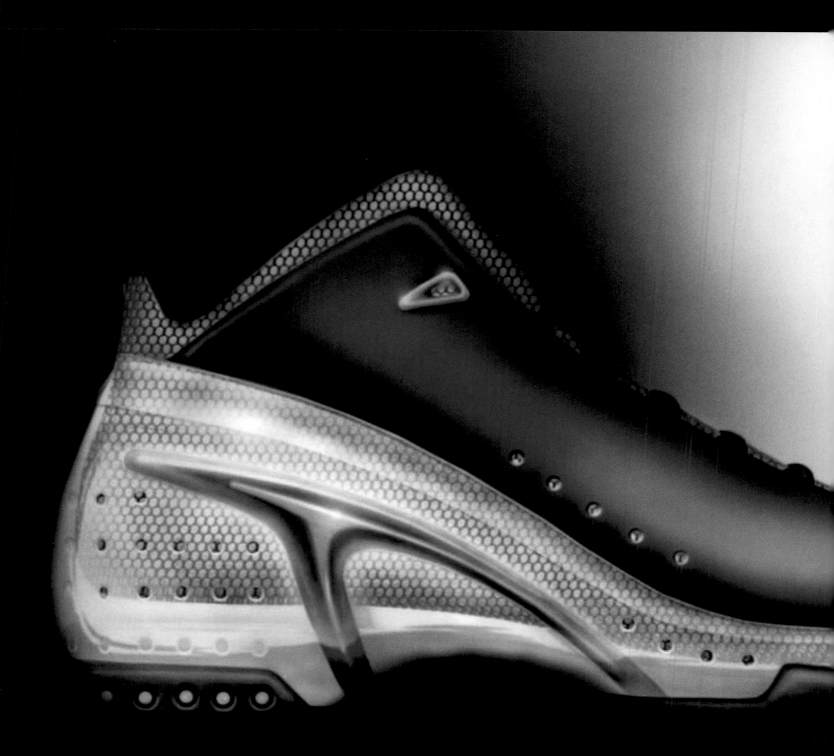

The Future Is Clear

"The key to the game is to get the Nikes before they come out." - Anonymous

Every now and then whenever a revolutionary shoe comes out of the camp, you'll hear someone say, "Nike's about to get they loot on." This saying usually indicates big sales for a particular product. 3 and a half years ago when the Air Zoom Ultraflight (prototype named the Clear Shell), was originally constructed and shown to a small focus group chosen to evaluate future Nike product, some kid blurted out those words while he held an early concept model in his hand. But something was missing, a performance feature. So back to the lab the shoe went. Phrenology. It's the roots of the shoe game. Still y'all don't get it, but you will. The roots of the Ultraflight rest in the mythical ideology of Cinderella. The designer (Aaron Cooper) and the advanced innovation group wanted to create a basketball version of the glass slipper. The evolution of the Hyperflight is what they sought. A lighter shoe made out of an innovative synthetic stretch leather that acts as a lining molded into a clear plastic shell that allows the inside of the shoe to be on display. If the shoe was an engine it'd be funky cold like the Modena; if it were a point guard it would be Gary Payton, Jason Kidd and Baron Davis all wrapped into one sample size 13. It's the shoe that is both on time and ahead of its time at the same time. In the words of that kid from the focus group, "This shoe (Ultraflight) is so dope it needs to be in rehab."

@ 3·1·01

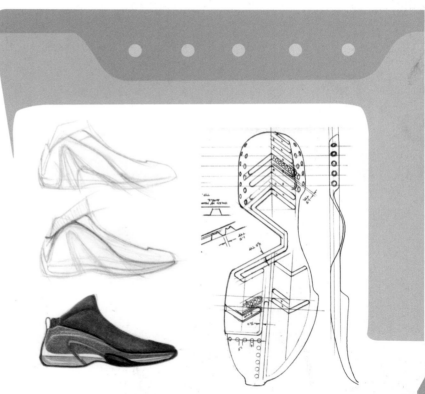

1972 —— 1980

Nike Shoe Chronology

Bruin
(LEATHER)

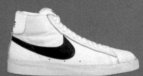

Blazer
(LEATHER)

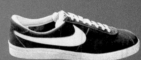

Bruin
(SUEDE)

Blazer Lo
(LEATHER)

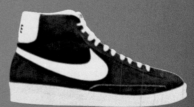

Blazer
(SUEDE)

INDEX

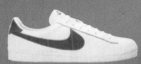

Franchise Lo
(LEATHER)

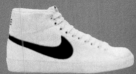

All Court Canvas Hi

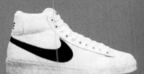

Lady All Court High Top Canvas

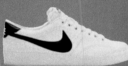

Lady All Court Canvas

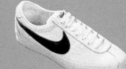

MVP Lo
(MESH)

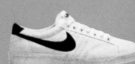

All Court
(CANVAS)

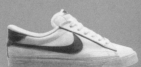

Lady Bruin
(LEATHER)

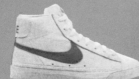

Lady Blazer
(LEATHER)

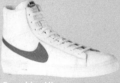

Franchise Hi
(LEATHER)

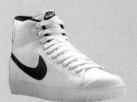

Blazer
(LEATHER)

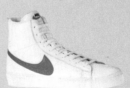

Lady Franchise
(LEATHER)

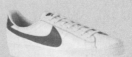

Lady Franchise
(LEATHER)

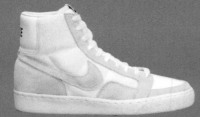

Dynasty High
(LEATHER AND MESH)

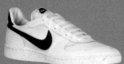

Gamebreaker Lo
(LEATHER AND CANVAS)

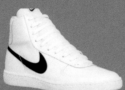

Gamebreaker Hi
(LEATHER AND CANVAS)

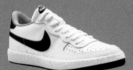

Legend Lo
(LEATHER)

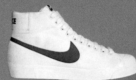

3-Pointer Hi
(CANVAS)

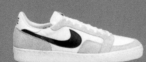

Dyansty
(LEATHER AND MESH)

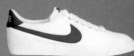

3-Pointer Lo
(CANVAS)

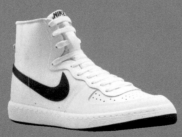

Legend
(LEATHER)

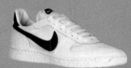

Air Force I
(LEATHER)

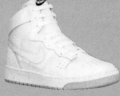

Air Train Hi
(LEATHER AND MESH)

Double Team Hi
(LEATHER)

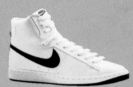

Penetrator Hi
(LEATHER)

Penetrator Lo
(LEATHER)

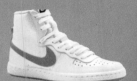

Lady Gamebreaker Lo
(LEATHER)

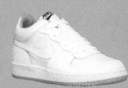

Glory 3/4
(LEATHER)

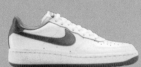

Air Force I Lo
(LEATHER)

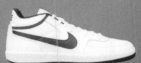

Lady Legend Hi
(LEATHER)

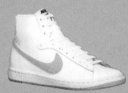

Recognition Hi
(LEATHER)

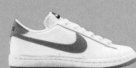

Recognition Lo
(LEATHER)

Challenge Court
(NYLON MESH)

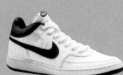

Sky Force Canvas 3/4

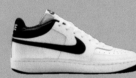

Sky Force 3/4
(LEATHER)

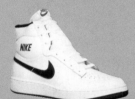

Sky Force Hi
(LEATHER)

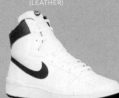

Fortress Hi
(LEATHER)

Airship Hi
(LEATHER)

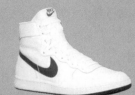

Legend High Canvas

SHOE CHRONOLOGY

Penetrator
(SUEDE)

Penetrator GT
(LEATHER)

Penetrator S
(LEATHER)

Penetrator
(SUEDE)

Penetrator GT
(LEATHER)

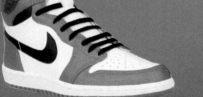

Air Jordan I
(LEATHER)

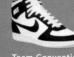

Team Convention
(LEATHER)

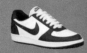

Team Convention
(LEATHER)

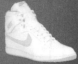

Convention
(LEATHER)

Big Nike High
(LEATHER)

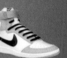

Terminator High
(LEATHER)

Convention
(LEATHER)

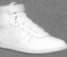

Big Nike Pro
(LEATHER)

Legend S Leather

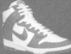

Dynasty High
(LEATHER)

Big Nike 3/4
(LEATHER)

Nike Dunk
(LEATHER)

AJKO
(CANVAS)

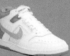

Big Nike Low
(LEATHER)

Nike Dunk Low
(LEATHER)

Legend
(CANVAS)

Air Jordan I
(LEATHER)

Bruin Soft
(LEATHER)

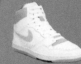

Court Force
(LEATHER)

Court Force
(LEATHER)

Miami Court Lo
(CANVAS)

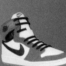

Miami Court Hi
(CANVAS)

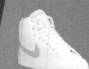

Air Jordan II
(LEATHER)

Air Jordan II
(LEATHER)

Delta Force AC
(LEATHER)

Delta Force AC High
(LEATHER)

Delta Force AC
(LEATHER)

Air Force Hi II
(LEATHER)

INDEX

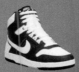

Team Delta Force AC
(LEATHER)

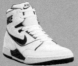

Air Assault Hi
(LEATHER)

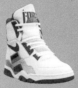

Stratus High
(LEATHER)

Air Force STS
(LEATHER)

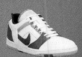

Air Force Lo II
(LEATHER)

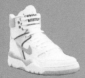

Air Force III High
(LEATHER)

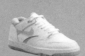

Sky Force
(LEATHER)

Sky Force
(LEATHER)

Air Flight Low
(LEATHER)

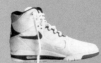

Air Flight
(LEATHER)

Air Alpha Force Lo
(LEATHER)

Air Delta Force Hi
(LEATHER)

Air Delta Force 3/4
(LEATHER)

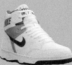

Driving Force High
(LEATHER)

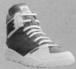

Outbreak II
(CANVAS)

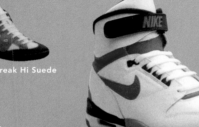

Outbreak Hi Suede

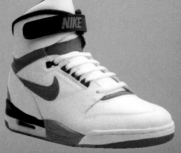

Air Revolution
(LEATHER)

Driving Force Low
(LEATHER)

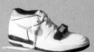

Air Alpha Force II
(LEATHER)

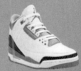

Outbreak Hi
(CANVAS)

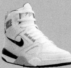

Air Solo Flight
(LEATHER)

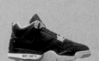

Air Jordan IV

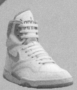

Air Jordan III
(LEATHER)

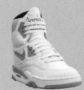

Air Transition High
(LEATHER)

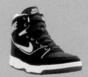

Air Ascension High
(LEATHER)

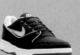

Wingmate High
(CANVAS)

Wingmate Low
(CANVAS)

Kiara II Low
(LEATHER)

Air Delta Force Low
(LEATHER)

Air Delta Force ST 3/4
(LEATHER)

Air Delta Force ST High
(LEATHER)

Air Delta Force ST Low
(LEATHER)

SHOE CHRONOLOGY

Air Solo Flight '90
(LEATHER)

Air Force STS
(LEATHER)

Air Ascension II High
(LEATHER)

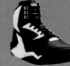

Air Ultra Force
(LEATHER)

Strategy High
(LEATHER)

Air Jordan V
(LEATHER)

Air Pressure
(LEATHER)

Air Force 180
(LEATHER)

Air Ultra Force High
(LEATHER)

Air Ultra Force 3/4
(LEATHER)

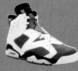

Air Ultra Force Low
(LEATHER)

Air Jordan VI
(LEATHER)

Air Command Force
(LEATHER)

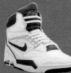

Air Flight '90
(LEATHER)

Air Force Five
(LEATHER)

Chronicle 3/4
(LEATHER)

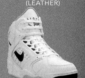

Air Flight Lite
(LEATHER)

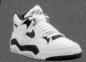

Air Bound
(LEATHER)

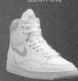

Court Profile High
(LEATHER)

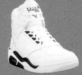

Air Flight
(LEATHER)

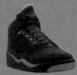

Air Flight Lite Low
(LEATHER)

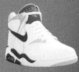

Air Flight Low
(LEATHER)

Quantum Force High
(LEATHER)

Quantum Force Low
(LEATHER)

Air Force Five
(LEATHER)

Air Force Low
(LEATHER)

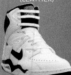

Air Force High
(LEATHER)

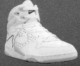

Agenda
(LEATHER)

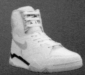

Air Transition II High
(LEATHER)

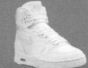

Air Ascension Force
(LEATHER)

Air Transition Force
(LEATHER)

Air Mach Force High
(LEATHER)

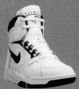
Air Sabre Flight High
(LEATHER)

Air Sabre Flight Low
(LEATHER)

Air Ballistic Force Mid
(LEATHER)

Air Ballistic Force High
(LEATHER)

Air Force High
(LEATHER)

Air Force Mid
(LEATHER)

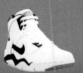
Air Mach Force 3/4
(LEATHER)

Air Mach Force Low
(LEATHER)

Air Magnum Force 3/4
(LEATHER)

Air Magnum Force Low
(LEATHER)

Air Sonic Flight High
(LEATHER)

Air Sonic Flight Mid
(LEATHER)

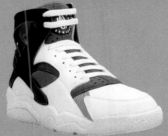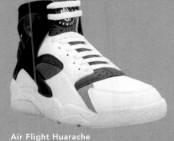
Air Flight Huarache
(LEATHER)

Air Bound
(LEATHER)

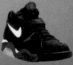
Air Force 180 Low
(LEATHER)

Air Sonic Flight
(LEATHER)

Air Raid II
(LEATHER)

Air Jordan VII
(LEATHER)

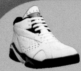
Air Bound
(LEATHER)

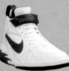
Air Radicate
(LEATHER)

Driving Force Mid
(LEATHER)

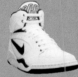
Court Force Mid
(LEATHER)

Court Force Low
(LEATHER)

Air Flight 3/4
(LEATHER)

Air Dynamic Flight
(LEATHER)

Air Jordan VIII
(LEATHER)

Air Maestro
(LEATHER)

Air Solo Flight
(LEATHER)

Air Raid
(LEATHER)

Air Sonic Flight
(LEATHER)

Air Sheer Force Mid
(LEATHER)

Air Check
(LEATHER)

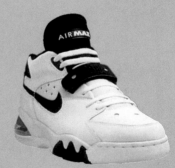
Air Force Max
(LEATHER)

Air Transition Force II High
(LEATHER)

Air Direct Flight
(LEATHER)

Air Ascension Force High
(LEATHER)

Driving Force Low
(LEATHER)

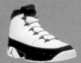
Air Jordan IX
(LEATHER)

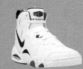
Air Assist High
(LEATHER)

Air Strong High
(LEATHER)

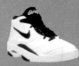
Air Up
(LEATHER)

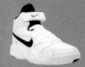
Air Sheer Force Mid Plus
(LEATHER)

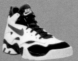
Air Prevail
(LEATHER)

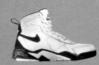
Air Boot
(LEATHER)

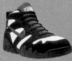
Air Authority
(LEATHER)

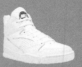
Ultra Force Mid
(LEATHER)

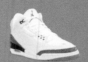
Air Jordan III Retro
(LEATHER)

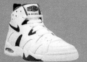
Air Commitment
(LEATHER)

Air Prop Mid
(LEATHER)

Air Force Max CB
(LEATHER)

Ultra Force Low
(LEATHER)

Strategy Mid (W)
(LEATHER)

Air Unlimited
(LEATHER)

Air Press Mid
(LEATHER)

Air Maestro II Low
(LEATHER)

Air Maestro Mid
(LEATHER)

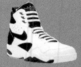
Air Maestro High
(LEATHER)

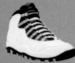
Air Jordan X
(LEATHER)

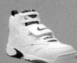
Air Flight 3/4
(LEATHER)

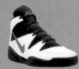
Determination Mid
(LEATHER)

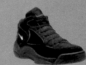
Air Hops
(LEATHER)

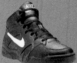
Validate Mid
(LEATHER)

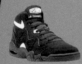
Air Assist Mid
(LEATHER)

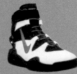
Air Drill
(LEATHER)

Air Darwin
(LEATHER)

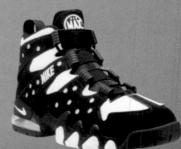
Air Max² CB
(LEATHER)

Air Swift
(LEATHER)

Air Pound
(LEATHER)

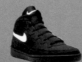
Basic Original Basketball
(LEATHER)

The Bomb Force
(LEATHER)

Air 2 Strong Hi
(LEATHER)

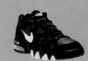
Air 2 Strong Mid
(LEATHER)

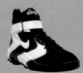
Air Up High
(LEATHER)

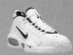
Air Ascend
(LEATHER)

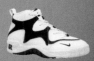
Air Burn (W)
(LEATHER)

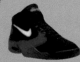
Air Up
(LEATHER)

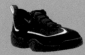
Air Lambaste
(LEATHER)

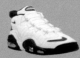
Air Max Sensation
(LEATHER)

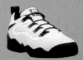
Air Darwin Low Canvas

Air Role Ndestrukt
(LEATHER)

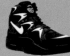
Air Baja 341
(LEATHER)

Air Uptempo
(LEATHER)

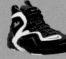
Air Go LWP
(LEATHER)

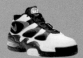
Air Max² Uptempo Low
(LEATHER)

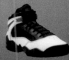
Air Proof
(LEATHER)

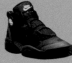
Air Tight
(LEATHER)

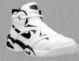
Air Dvst8
(LEATHER)

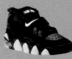
Air CB 34
(LEATHER)

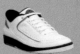
Air Jordan II Retro Low
(LEATHER)

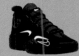
Air Flight One
(LEATHER)

Air Yoke
(LEATHER)

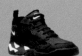
Air Straight
(LEATHER)

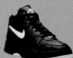
Franchise '95
(LEATHER)

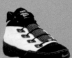
Air Ndestrukt
(LEATHER)

Air Ndestrukt Low
(LEATHER)

Air Point
(LEATHER)

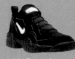
Air Tenacity
(LEATHER)

Air Tenacity Plus
(LEATHER)

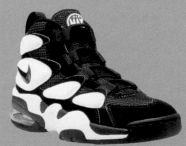
Air Max² Uptempo
(LEATHER AND MESH)

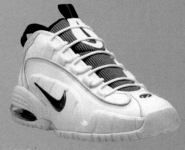
Air Penny
(LEATHER)

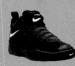
Penatrator
(LEATHER)

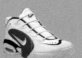
Air Wayup
(LEATHER)

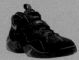
Air Gone
(LEATHER)

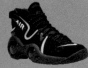
Air Zoom Flight High
(LEATHER)

Sweet Lew
(LEATHER)

Air Flight
(LEATHER)

Air Much Uptempo
(LEATHER)

Air More Uptempo
(LEATHER)

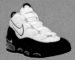
Air Max Uptempo
(LEATHER)

Air Worm Ndestrukt
(LEATHER)

Air Role Ndestrukt
(LEATHER)

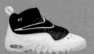
Air Shake Ndestrukt
(LEATHER)

Air Jordan Low
(LEATHER)

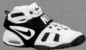
Air Modify Force Mid
(LEATHER)

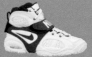
Air Modify Force High
(LEATHER)

Air Rupt (W)
(LEATHER)

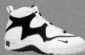
Air Burn
(LEATHER)

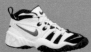
Air Pummel Force
(LEATHER)

Air Audacity
(LEATHER)

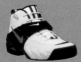
Air School Force
(LEATHER)

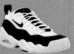
Air School Force Low
(LEATHER)

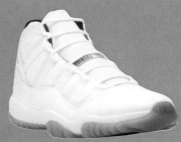
Air Jordan XI
(BALLISTIC MESH AND LEATHER)

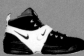
Air Swoopes (W)
(LEATHER)

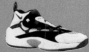
Air Swoopes II
(LEATHER)

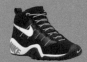

Air Rattle Ndestrukt
(LEATHER)

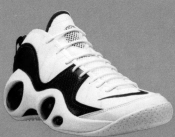

Air Zoom Flight
(LEATHER)

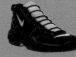

Air Tenacity Low Canvas

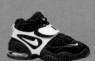

Air Thrill Flight
(LEATHER)

Air Adjust Force Mid
(LEATHER)

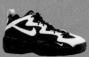

Air Flight Lite
(LEATHER)

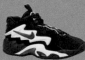

Air Flight Max
(LEATHER)

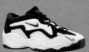

Air Flight Low
(LEATHER)

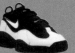

Air Versatile Low
(LEATHER)

Air Rout (W)
(LEATHER)

Air Lambaste
(LEATHER)

Validate (W)
(LEATHER)

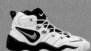

Air Pummel Force 3/4
(LEATHER)

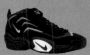

Air Maestro
(LEATHER)

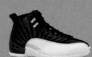

Air Jordan XII
(LEATHER)

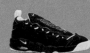

Air Money
(LEATHER)

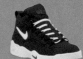

Air Pulverize
(LEATHER)

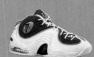

Air Penny
(LEATHER)

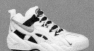

The Bomb Force
(LEATHER)

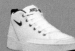

Inside Force
(LEATHER)

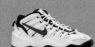

Air Kybash
(LEATHER)

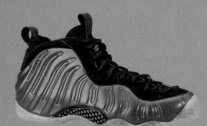

Air Foamposite I
(SYNTHETIC)

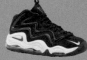

Air Pippen
(LEATHER)

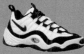

Air B-que (W)
(LEATHER)

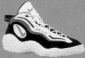

Air Groovin' Uptempo
(LEATHER)

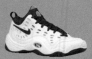

Air Grill
(LEATHER)

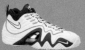

Air Zoom Flight Five
(LEATHER)

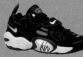

Air Hops Flight
(LEATHER)

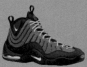

Air Bakin
(LEATHER)

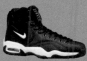

Air Alonzo
(LEATHER)

Air Swoopes Zoom
(LEATHER)

Air Max Madness
(LEATHER)

Air Max Upthere
(LEATHER)

Air CB 34 '97
(LEATHER)

Air Movin' Uptempo
(LEATHER)

Air Movin' Uptempo Low
(LEATHER)

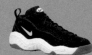

Air Rise Uptempo
(LEATHER)

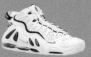

Air Max Uptempo
(LEATHER)

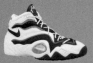

Air Flight Turbulence
(LEATHER)

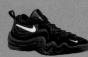

Air Gaucho Flight
(LEATHER)

Game Force
(LEATHER)

Air Melt
(LEATHER)

Rim Breaker
(LEATHER)

Air Force Ots
(LEATHER)

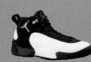

Air Jumpman Pro
(LEATHER)

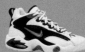

Air Craft
(LEATHER)

INDEX

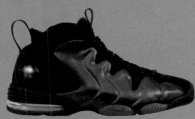

Air Penny III
(LEATHER)

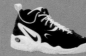

Air Offend
(LEATHER)

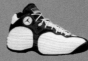

Air Jordan Team
(LEATHER)

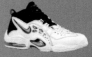

Air MZ3
(LEATHER)

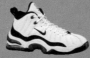

Air Metal Force
(LEATHER)

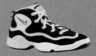

Nike Twine
(LEATHER)

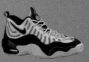

Air Scald
(LEATHER)

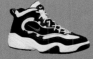

Air Evolve Flight
(LEATHER)

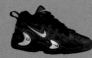

Air 'Ogant
(LEATHER)

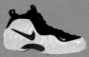

Air Foamposite Pro
(SYNTHETIC)

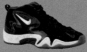

Air Winged Flight
(LEATHER)

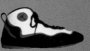

Air Jordan Trainer
(LEATHER)

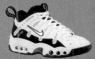

Air Machine Force
(LEATHER)

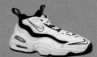

Air Purache
(LEATHER)

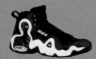

Air Crash Force
(LEATHER)

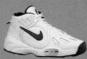

Air Point Flight
(LEATHER)

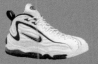

Air Total Max Uptempo
(LEATHER)

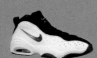

Air Hype Uptempo
(LEATHER)

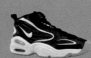

Air Pure Uptempo
(LEATHER)

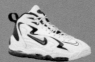

Air Absolute Max Uptempo
(LEATHER)

Air Hover Uptempo
(LEATHER)

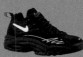

Air Cruz Uptempo
(LEATHER)

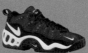

Air Dozer Force
(LEATHER)

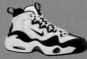

Air Isolate
(LEATHER)

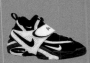

Air College Force Mid
(LEATHER)

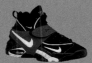

Air College Force High
(LEATHER)

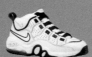

Air Super CB
(LEATHER)

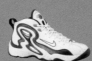

Air Hawk Flight
(LEATHER)

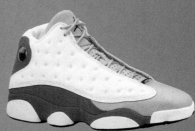

Jordan XIII
(LEATHER)

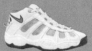

Air Live Hoop
(LEATHER)

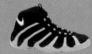

Air Breathe Hoop
(LEATHER)

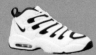

Air Sleep Hoop
(LEATHER)

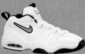

Air Hype Uptempo Low
(LEATHER)

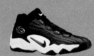

Air Props Uptempo
(LEATHER)

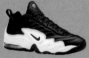

Air Max Uptempo 3.0
(LEATHER)

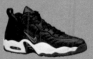

Air Scorin' Uptempo
(LEATHER)

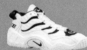

Air Force Press
(LEATHER)

Air Force Lite
(LEATHER)

Air Force Lite
(LEATHER)

Air Penny IV
(LEATHER)

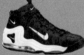

Air Max Battle Force
(LEATHER)

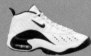

Air Doom Force
(LEATHER)

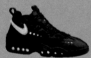

Task Force
(LEATHER)

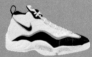

Air Rev
(LEATHER)

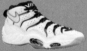

Air 1.0 Flight
(LEATHER)

Air Assist Flight
(LEATHER)

Air Sly Flight
(LEATHER)

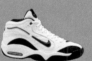

Air Double Down (W)
(LEATHER)

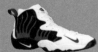

Air Zoom LLS (W)
(LEATHER AND MESH)

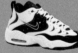

Air Relate
(LEATHER)

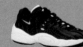

Air Leathalow
(LEATHER)

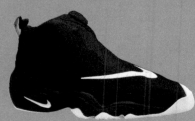

Air Zoom Flight (The Glove)
(MESH)

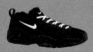

Hype Low Canvas

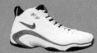

Air Pippen II
(LEATHER)

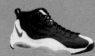

Air Garnett
(LEATHER)

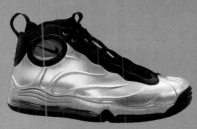

Total Air Foamposite Max
(SYNTHETIC)

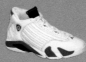

Air Jordan XIV
(LEATHER)

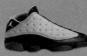

Air Jordan XIII Low
(LEATHER)

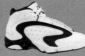

Women's Jordan
(LEATHER)

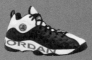

Jordan Team XI
(LEATHER)

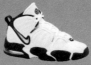

Air Uptempo Max
(LEATHER)

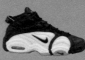

Air Operate Uptempo
(LEATHER)

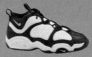

Air Versatile Uptempo
(LEATHER)

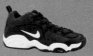

Air Versatile Low Uptempo
(LEATHER)

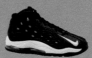

Air Max Shake 'Em Up
(LEATHER)

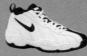

Air Focus
(LEATHER)

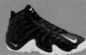

Air Run 'Em Up
(LEATHER)

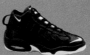

Air Post' Em Up
(LEATHER)

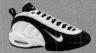

Air Brake-U-Down Uptempo
(LEATHER)

Air Fly-By-U Uptempo
(LEATHER)

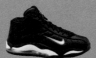

Air Team Max Zoom
(LEATHER)

Air Swoopes IV
(LEATHER)

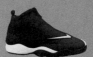

Air Son of Glove
(MESH)

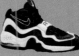

Air Deliver Force
(LEATHER)

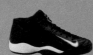

Air Team Dime
(LEATHER)

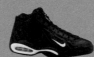

Air Team Face Up
(LEATHER)

Jordan P.R.E.P.
(LEATHER)

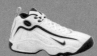

The Low Post
(LEATHER)

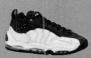

Air CB4 II
(LEATHER)

Air Zoom T-Bug Flight
(LEATHER AND MESH)

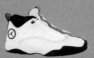

Jumpman Pro Quick
(LEATHER)

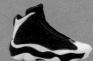

Jumpman Pro Strong
(LEATHER)

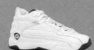

Jumpman Pro II
(LEATHER)

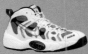

Air Flight Deny (W)
(LEATHER)

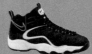

Air Flight Lite
(LEATHER)

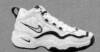

Air Flight Suit
(LEATHER)

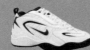

Air Ultralite Flight
(LEATHER)

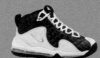

Total Air 9 (W)
(LEATHER)

Nike Shoe Chronology

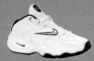
Air Phast (W)
(LEATHER)

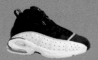
Air Max L9 (W)
(LEATHER)

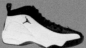
Jumpman Team Post
(LEATHER)

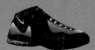
Air Garnett III
(LEATHER)

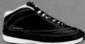
Jordan Lite
(LEATHER)

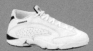
Jordan Sweet Fade
(LEATHER)

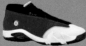
Jordan XIV Low
(LEATHER)

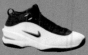
Air Pippen 3
(LEATHER)

Air Zoom S5 (W)
(LEATHER)

Air Zoom Inside (W)
(LEATHER)

Air Holistic Uptempo
(LEATHER)

Air Vis Zoom Uptempo
(LEATHER)

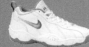
Air Focus Low (W)
(LEATHER)

Air Focus Low Nylon (W)
(LEATHER)

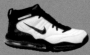
Air Aggress Force
(LEATHER)

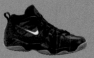
Assert Force
(LEATHER)

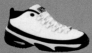
Air Incredibly Strong
(LEATHER)

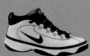
Air Impeccably Strong
(LEATHER)

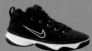
Air Illicitly Strong
(LEATHER)

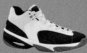
Air Illegally Strong
(LEATHER)

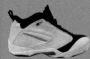
Jumpman Quick 6
(LEATHER)

Air Flight Experience
(LEATHER)

Air Catalyst (W)
(LEATHER)

Air Holistic Uptempo Low
(LEATHER)

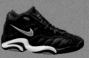
Air Protean Uptempo
(LEATHER)

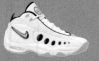
Air Afterburner Flight
(LEATHER)

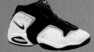
Air C14 (W)
(LEATHER)

Air S5 II
(LEATHER)

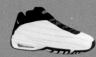
Air Wheresyagame
(LEATHER)

Air Showmegame (W)
(LEATHER)

Air F.A.N. Force
(LEATHER)

Jordan XV
(LEATHER)

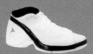

Jumpman Team J
(LEATHER)

Jordan 3 Percent
(LEATHER)

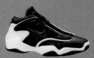

Air All Biz
(LEATHER)

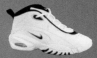

Air Flight Showbiz
(LEATHER)

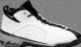

Air Force Jumbrific
(LEATHER)

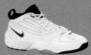

Air Force Gigansive
(LEATHER)

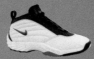

Air Achieve Force
(LEATHER)

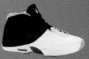

Jumpman Vindicate
(LEATHER)

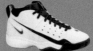

Air Team Unified
(LEATHER)

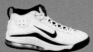

Air Team Max Zoom II
(LEATHER)

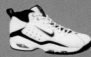

Air Team Unite
(LEATHER)

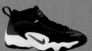

Air Duration
(LEATHER)

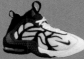

Air Tuned Swoopes
(LEATHER)

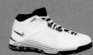

Air Tuned Force
(LEATHER)

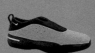

Team Supreme
(LEATHER)

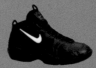

Air Classic
(LEATHER)

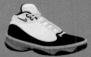

Air Immensely Sleek
(LEATHER)

Air Zoom GP
(LEATHER)

Air Powermatic
(LEATHER)

Air Jamgasmic Flight
(LEATHER)

Air Speedy Flight
(LEATHER)

Air Speedy Flight Plus
(LEATHER)

Air Stimulus Flight
(LEATHER)

Air Flight Vroomlicious
(LEATHER)

Air Bringyagame
(LEATHER)

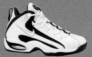

Air Take U In (W)
(LEATHER)

Air Howsyagame
(LEATHER)

You Can't Stop Me Force
(LEATHER)

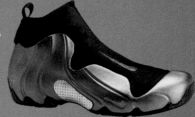

Air Flightposite
(SYNTHETIC)

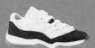
Air Jordan 11 Snake Low
(LEATHER)

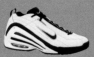
Air Force Strong
(LEATHER)

Air Force Authority
(LEATHER)

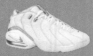
Air Force Carbide
(LEATHER)

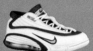
Air Team Max Highup (W)
(LEATHER)

Air Team Vis
(LEATHER)

Air Team Max Flyup
(LEATHER)

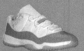
Air Jordan 11 Retro Low
(LEATHER)

Air Team D
(LEATHER)

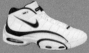
Air Team Max Lite
(LEATHER)

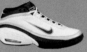
Air Team Max Full Court
(LEATHER)

Air Team Bukatsu
(LEATHER)

Air Team Super Max
(LEATHER)

Air Flight Notion
(LEATHER)

Air Flight Persistence
(LEATHER)

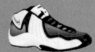
Air Flight '00
(LEATHER)

Air Flight '00 Low
(LEATHER)

Air Flight Perception Low
(LEATHER)

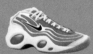
Air Flight Motion
(LEATHER AND MESH)

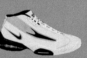
Air Flight Disrupter
(LEATHER)

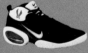
Air Flight Sensation
(LEATHER)

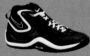
Air Flight Superb (W)
(LEATHER)

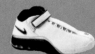
Nike Big Air Flyer
(LEATHER)

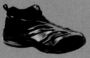
Duncan
(LEATHER AND MESH)

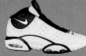
Air Flight C14 (W)
(LEATHER)

Air Flight Perception
(LEATHER)

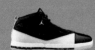
Air Jordan XVI
(MESH AND LEATHER)

INDEX

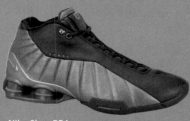

Nike Shox BB4
(LEATHER)

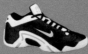

Air Double Face Low
(LEATHER)

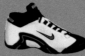

Air Double Face
(LEATHER)

Air Flight Spectacular (W)
(LEATHER)

Air Team Holistic Low
(LEATHER)

Air Pippen IV
(NYLON)

Air Flight Determination
(MESH)

Jumpman Select
(LEATHER)

Jumpman Swift 6
(LEATHER)

Jumpman Team Masterpiece
(LEATHER)

Jumpman Team Showcase Mid
(LEATHER)

Air Lenny Dee
(LEATHER)

Air Vinnie Gee
(LEATHER)

Air Neo Classic
(LEATHER)

Air Darwin Lite
(LEATHER)

D5
(LEATHER)

Air Zoom GP II
(LEATHER)

Air Delta Force
(LEATHER)

Air Sequential
(LEATHER)

Air Jordan IV Retro
(LEATHER)

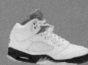

Jordan V Retro
(LEATHER)

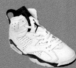

Jordan VI Retro
(LEATHER)

Air Flightposite KG
(SYNTHETIC)

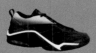

Air Valor Force Low
(LEATHER)

Air Valor Force
(LEATHER)

Air Bounder Force
(LEATHER)

Air Ptp'er
(LEATHER)

Air Flightposite III
(SYNTHETIC)

Air Pippen V
(SYNTHETIC)

Air Props II
(LEATHER)

Air Effectivity Max
(LEATHER)

Influence
(LEATHER)

Presto Cage
(LEATHER)

Air Flight Max II
(LEATHER AND MESH)

Air Alert
(LEATHER)

Jumpman Camp 23
(LEATHER)

Jumpman Pro Shake
(LEATHER)

Jumpman Team Elite
(LEATHER)

Jumpman Team Shogun
(LEATHER)

Air Swoopes VI (W)
(LEATHER)

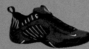
Air Direct Flight
(LEATHER)

Solo Slide
(SYNTHETIC)

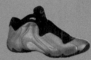
Air Solo Flight
(SYNTHETIC)

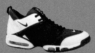
Air Max So Good (W)
(LEATHER)

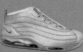
Air Total Max II
(LEATHER)

Air Dura Comfort
(LEATHER)

Air Dura Max
(LEATHER)

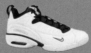
Air Max Priority (W)
(LEATHER)

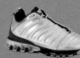
Air P-Phaze
(SYNTHETIC)

Air C-Phaze
(LEATHER)

Air V-Phaze
(LEATHER)

Air Overlook
(LEATHER)

Air Force Authentic
(LEATHER)

Trooper Force Lite
(LEATHER)

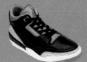

Air Jordan III Retro
(LEATHER HIGH TOP)

Jordan I Retro
(LEATHER)

Air Jordan I Retro Plus
(LEATHER)

Air Futuristic
(LEATHER)

Jordan Pure
(LEATHER)

Air Signature Player
(SYNTHETIC)

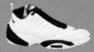

Nike Props Lite
(LEATHER)

Nike Props Lite Slip-On
(MESH)

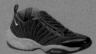

Nike Props Lite
(MESH)

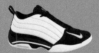

Air Flight Superb II (W)
(LEATHER)

Air Zoom GP III
(MESH)

Air Jet Flight
(LEATHER)

Air Check'em
(LEATHER)

Air Demand
(LEATHER)

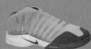

Air Flight Lite II
(MESH)

Air Podposite
(SYNTHETIC)

Air Posterize
(SYNTHETIC)

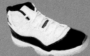

Air Jordan 11 Retro
(LEATHER)

Air Jordan XVI Lo
(LEATHER)

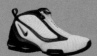

Nike Shox Mique (W)
(LEATHER)

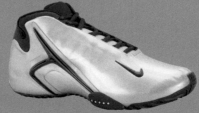

Air Hyperflight
(SYNTHETIC)

Air Pure Profile Max
(LEATHER)

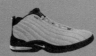
Air Max Chosen
(LEATHER)

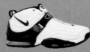
Air Max Invincible
(LEATHER)

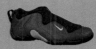
Air Solo Flight Slip-On
(SYNTHETIC)

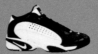
Air Team Franchise (W)
(LEATHER)

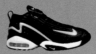
Air Team Ultimate (W)
(LEATHER)

The Big Ups
(LEATHER)

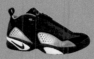
Air Recognize
(LEATHER)

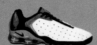
Nike Shox VC Low
(LEATHER)

Zoom Flight Turbine
(LEATHER)

Playerposite
(SYNTHETIC)

Air Swoopes Premier (W)
(LEATHER)

Air Payton IV
(LEATHER)

Air Pure Assist
(LEATHER)

Air Team Tradition
(LEATHER)

Air Purposite
(SYNTHETIC)

Air Podposite Low
(SYNTHETIC)

Air Flight Wings
(LEATHER)

Nike Shox VC
(SYNTHETIC AND MESH)

Air Loposite
(SYNTHETIC)

Air Showcase Max
(LEATHER)

Nike Shox Limitless
(LEATHER)

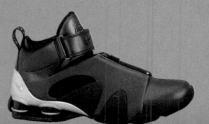
Nike Shox Stunner
(LEATHER AND MESH)

Air Max Future Flight
(LEATHER)

Air Max Elite
(LEATHER)

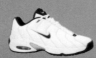
Air Down Low
(LEATHER)

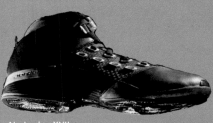

Air Jordan XVII
(LEATHER)

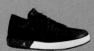

Nu-Retro AJ1 Low
(LEATHER)

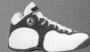

Jordan Team 1
(LEATHER)

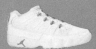

Jordan 9 Retro Low
(LEATHER)

Jordan XVII Mule
(LEATHER)

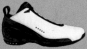

Air Zoom Ultraflight
(LEATHER)

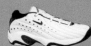

Levitate Low
(LEATHER)

Jump J Madness
(LEATHER)

Air Downtown
(LEATHER)

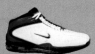

Air Max Finisher
(LEATHER)

Air Show Stopper
(LEATHER)

Air Finger Roll
(LEATHER)

Air Modify
(LEATHER)

Ultraposite
(SYNTHETIC)

Air Jordan XVII Plus
(LEATHER)

Air Jordan XVII Low
(LEATHER)

Air Break 'Em Down
(LEATHER)

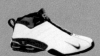

Nike Shox Supremecy
(LEATHER)

Air Flight Supreme
(LEATHER)

Flightlite
(LEATHER)

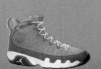

Air Jordan IX Retro Mid
(LEATHER)

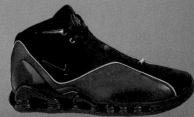

Nike Shox VC II
(LEATHER)

Credits

Photographers

AP Wide World Photos	32, 33	Dana Lixenberg	173,198
Arscentia	122-123	Dennis Manarchy	96
Butch Belair	132	Melodie McDaniel	180
SteveBonini	95(2)	Modern Dog Communications	139
Richard Burbridge	181	Karen Moskowitz	114
Eric Butler	176	Jean Moss	100-101
Rich Clarkson & Associates	33	Ancil Nance	95
Richard Corman	97	Gary Nolton	75,96,Gatefold
Lee Crum	97(2),114(3)	Jeff Riedel	173
Kevin Davies	132	Peter Rose Photography	146
Frank Denman	22	Bob Peterson	72-73,96,97,102,105
Duomo/William Sallez	170	Doug Petty	42,114
Duomo/Ben Van Hook	170	Jose Picayo	106,107
dizinno.com	114(3),115, 132,181	Hans Pieterse	114,115,121,135
David Emmite	213	Reisig & Taylor	173
Mark Ebsen	172-173,180	Mark Seliger	181
Nelson Farris	66,67	Martin Thiel	213
Getty/NBAE	10,12,13,23,43(2),58,59,70,78-79,	Bill Thorburn Design/Alex Tylevich	181
	108(3),109,115,116,117,129,	David Sawyer	2-3,4,26-27,38-39,50-51,60-61,70-71,
	130-131,135,142,143,147,152,		74-75,80-81,94,109,118-119,126-
	158,164,170,178-179,180,197,205		127,128,133, 134,138,145,150-151,
Hans Gissinger	144,152,180(2),181		154-155,158,161,166,168,176-177,
Guzman 1994	42		184-185,191,193,196,197
Gary Hush	84-85	Peggy Sirota	180
John Huet	139,180,181	Pete Stone	102(2),103,114(2),115(2),132,173
Fred Ingram	115	Bill Sumner	96,97,121
Walter Iooss	88-89,96	Dan Winters	181
Michael Jones	180	Christian Witkin	160,165
George Kalinsky	56-57	Weiden & Kennedy	70,76-77,103,104-105,106,110-111,
Tammy Kennedy	212,213		114,120,121(3),124-125,135,140-141,
Kolsky Rose Advertising Photography	23		144,154,156-157,160,165,173,180(2),
Chuck Kuhn	5,6(3),7,15,16-17,36,38(2),44-45,		181(2),183,198-199
	46(3),47(3),53,54, 55, 62-63,68-69,95	Michael Wong	181,186-187,192,194-195,200,
Lamb & Hall	88		202-203,212(4),213(4)

SOLE PROVIDER
30 Years of Nike Basketball

First edition, 2002

Published in the United States by
powerHouse Books,
a division of powerHouse Cultural Entertainment, Inc.
180 Varick Street, Suite 1302,
New York, NY 10014-4606
telephone 212 604 9074, fax 212 366 5247
e-mail: nike@powerHouseBooks.com
web site: www.powerHouseBooks.com

Library of Congress Cataloging-in-Publication Data:

Jackson, Robert.
 Sole Provider : 30 Years of Nike Basketball
text by Robert "Scoop" Jackson.-- 1st ed.
 p. cm.
 ISBN 1-57687-161-4
 1. Basketball--United States--Economic aspects.
2. Sports sponsorship--United States. 3. Nike (Firm) I. Nike (Firm)
II. Title.

GV885.513 .J33 2002
796.323--dc21

2002029049

Hardcover ISBN 1-57687-161-4

Creative Direction: Ray Butts, Nike Brand Design
Design: VehicleSF
Color Separation: Arscentia
Printing and Binding: Artegrafica, Verona

A complete catalog of powerHouse Books and Limited Editions is
available upon request; please call, write, or jam on our web site.

10 9 8 7 6 5 4 3 2 1

Printed and bound in Italy